TRAVELLING THROUGH
THE EYE OF HISTORY

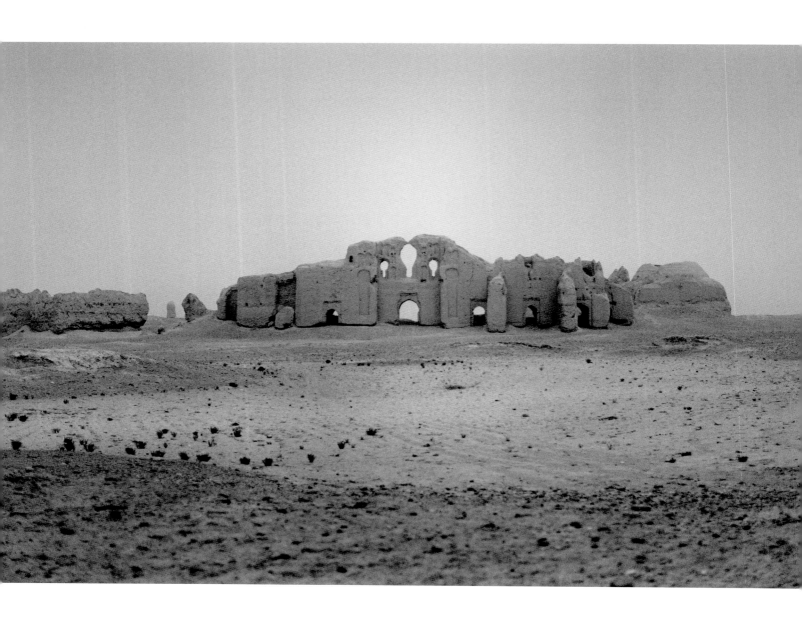

GHAZNAVID RUINS | LASHKARGAH | AFGHANISTAN 2001

TRAVELLING THROUGH
THE EYE OF HISTORY

DANIEL SCHWARTZ

ON THE COVER: THE ROAD TO TAJIKISTAN [FRONT] AND THE
ROAD TO CHINA [BACK] | SARY TASH | KYRGYZSTAN 2004

FIRST PUBLISHED IN IN 2009 IN HARDCOVER
IN THE UNITED STATES OF AMERICA
BY THAMES & HUDSON INC., 500 FIFTH AVENUE,
NEW YORK, NEW YORK 10110

THAMESANDHUDSONUSA.COM

LIBRARY OF CONGRESS CATALOG CARD NUMBER 2008937297

ISBN 978-0-500-54290-3

CONCEPT BY DANIEL SCHWARTZ
DESIGN BY MARTIN ANDERSEN / ANDERSEN M STUDIO
WWW.ANDERSENM.COM

PRINTED AND BOUND IN GERMANY BY STEIDL

TRAVELLING SHOULD PERMIT THE SUBTLE PROPERTIES OF THE SOUL
TO BE DISCOVERED, AND ITS FOOLISHNESS AND ARROGANCE TO BE CAST OUT.
BECAUSE ONE MAY SCARCELY UNDERSTAND WHAT THIS IS WITHOUT TRAVELLING.

UMAR IBN MUHAMMAD SUHRAWARDI (1145–1234), *AWARIF AL-MA'ARIF*

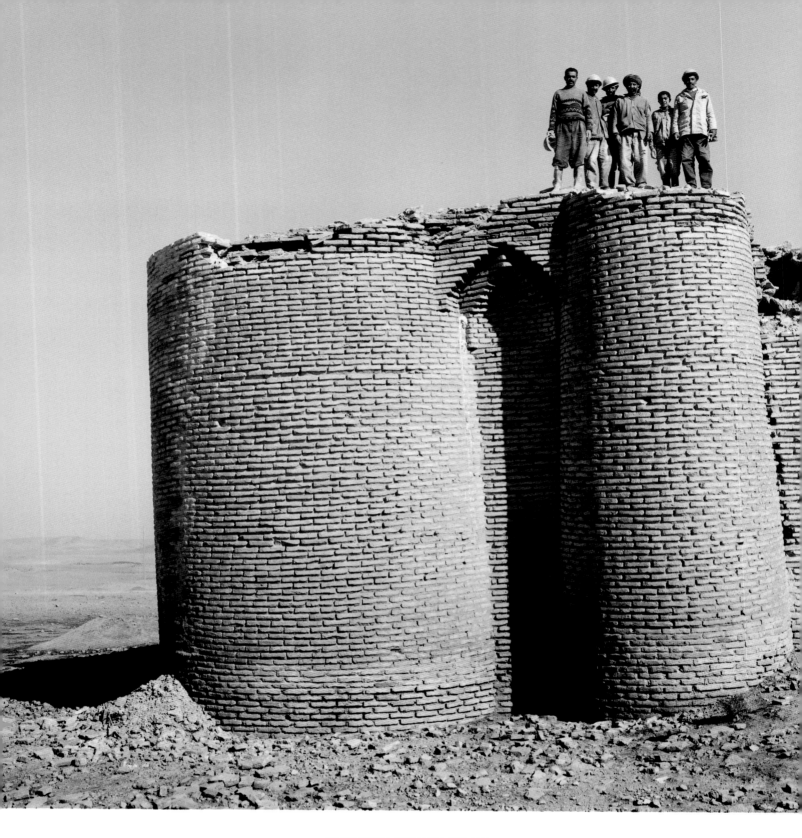

SELJUK RUINS | KHORASAN | IRAN 1995

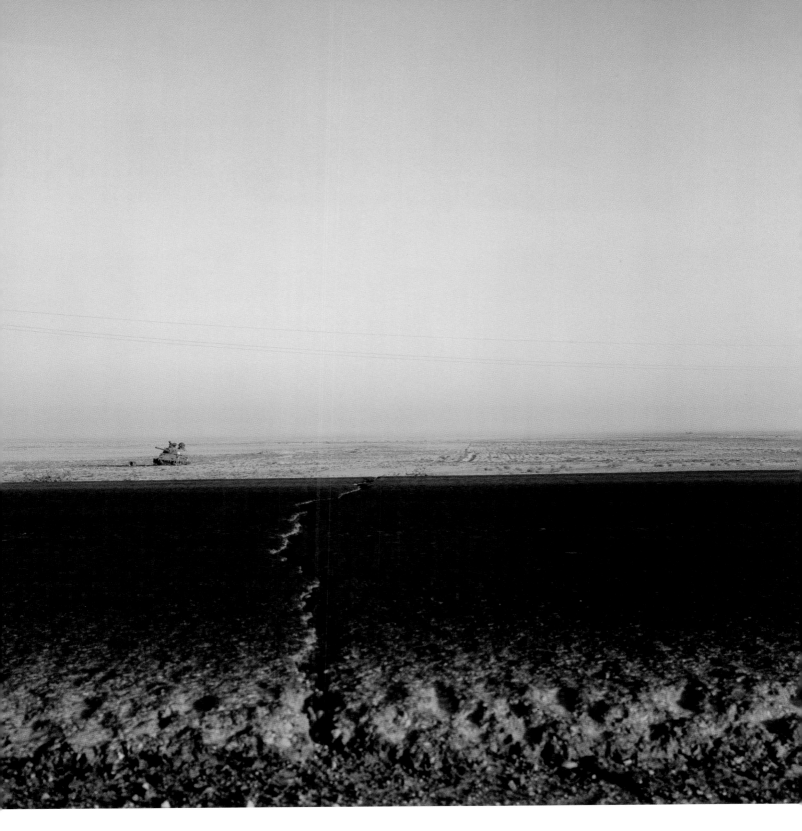

ROAD TO MAZAR-E SHARIF | AFGHANISTAN 2002

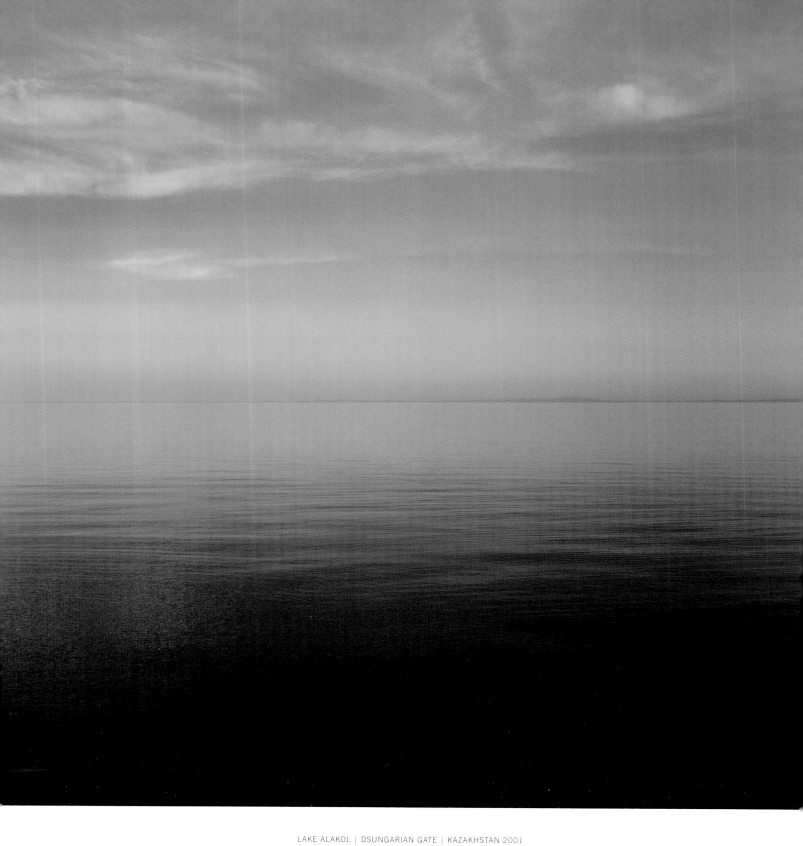

LAKE ALAKOL | DSUNGARIAN GATE | KAZAKHSTAN 2001

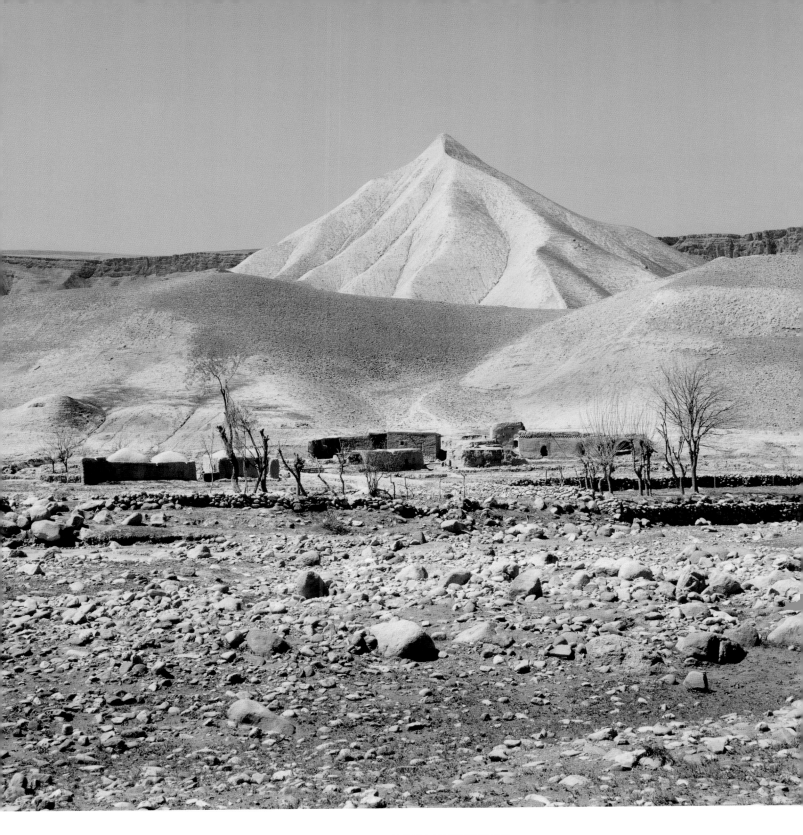

IN THE TIME OF DROUGHT | BADGHIS | AFGHANISTAN 2001

MY WORK IS IN THE HISTORY OF PLACES

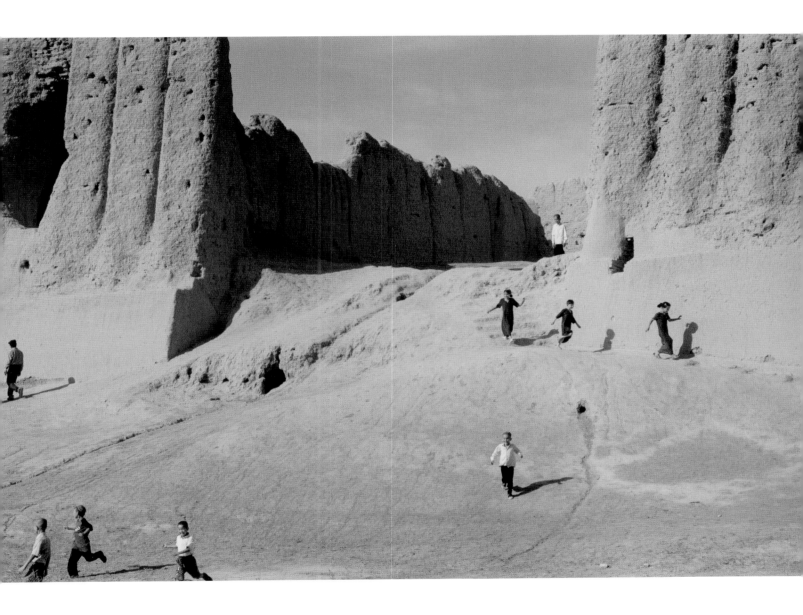

14

APPROACHES

WHAT I CAME TO SEE

WATERSHED | KARAKORAM HIGHWAY | PAKISTAN 2001

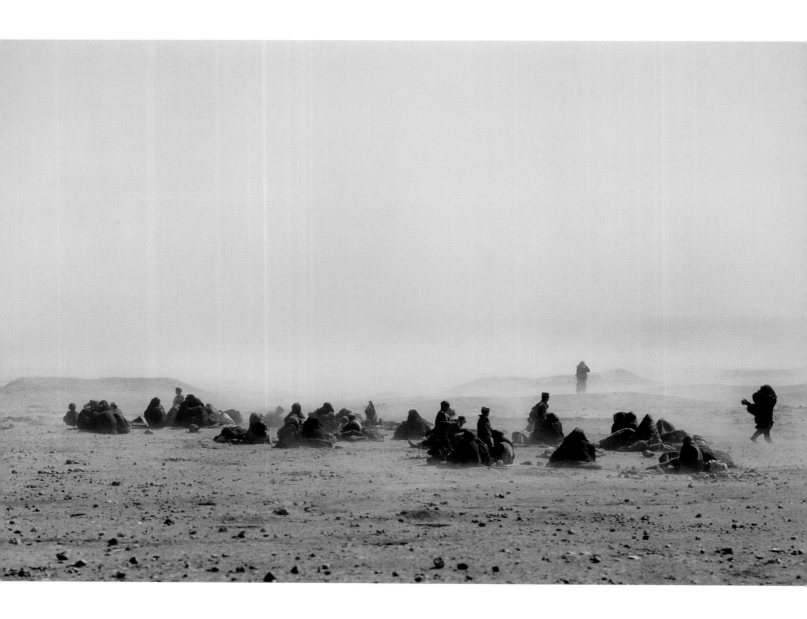

PEOPLE DISPLACED BY THE DROUGHT | HERAT | AFGHANISTAN 2001

WHAT WAS ACTUALLY THERE

20

SUPPOSEDLY FACTUAL EVENTS UNFOLDING

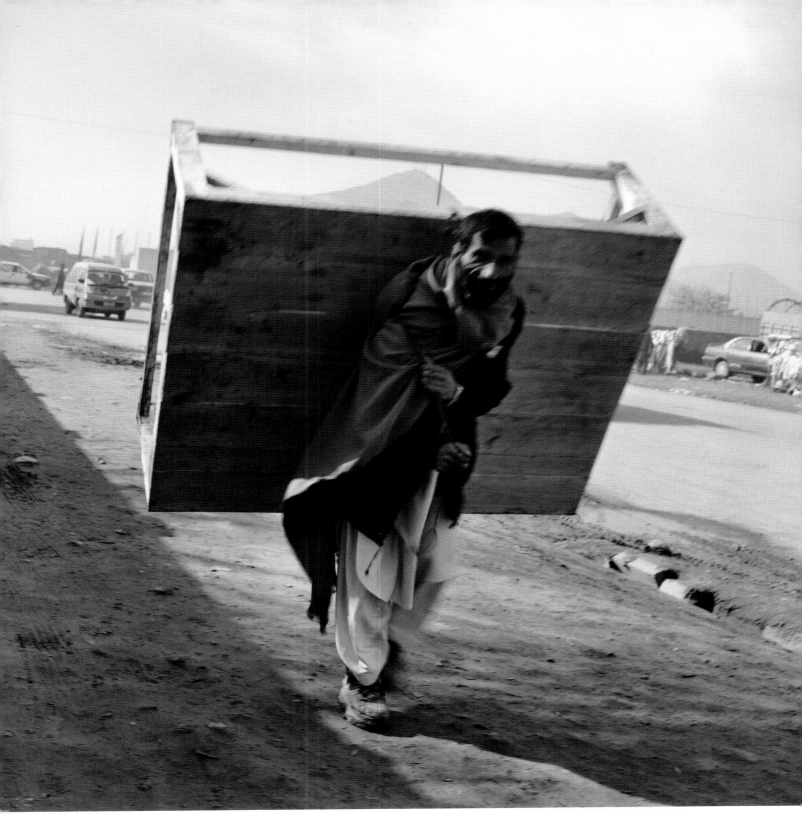

BAZAAR DAY | KABUL | AFGHANISTAN 2006

TRAVELLING LIBRARY

READING MAPS LEADS TO BOOKS

DRAWING ON BOOKS TO UNDERSTAND THE ROADS

TRACING ROADS TO SEE BEYOND THE LINES

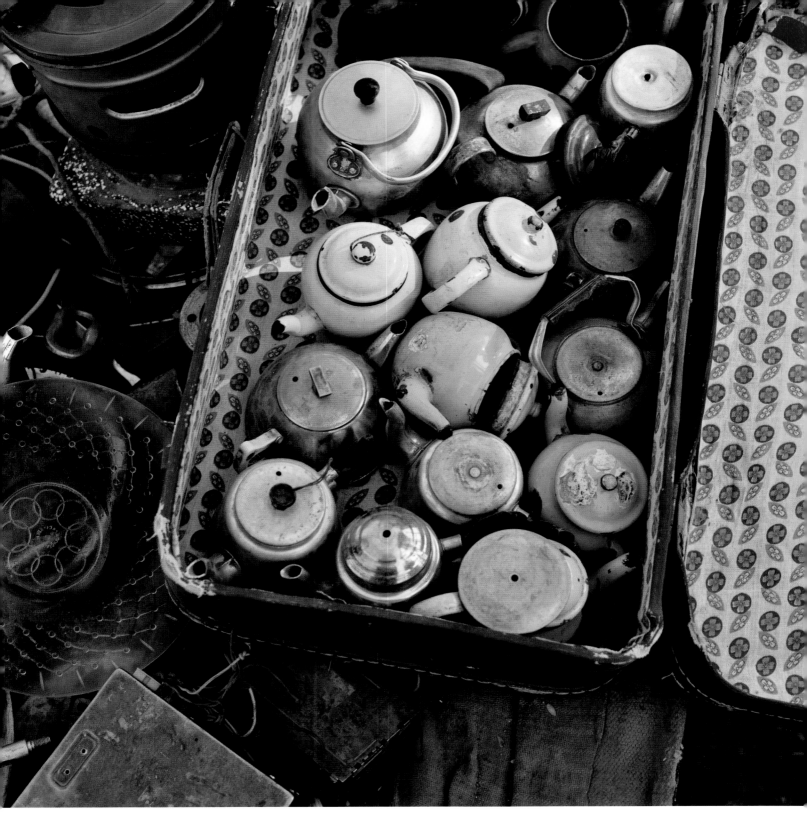

TEAPOT TYPOLOGY | MAZAR-E SHARIF | AFGHANISTAN 2002

COMPLEX STORIES TO RELATE

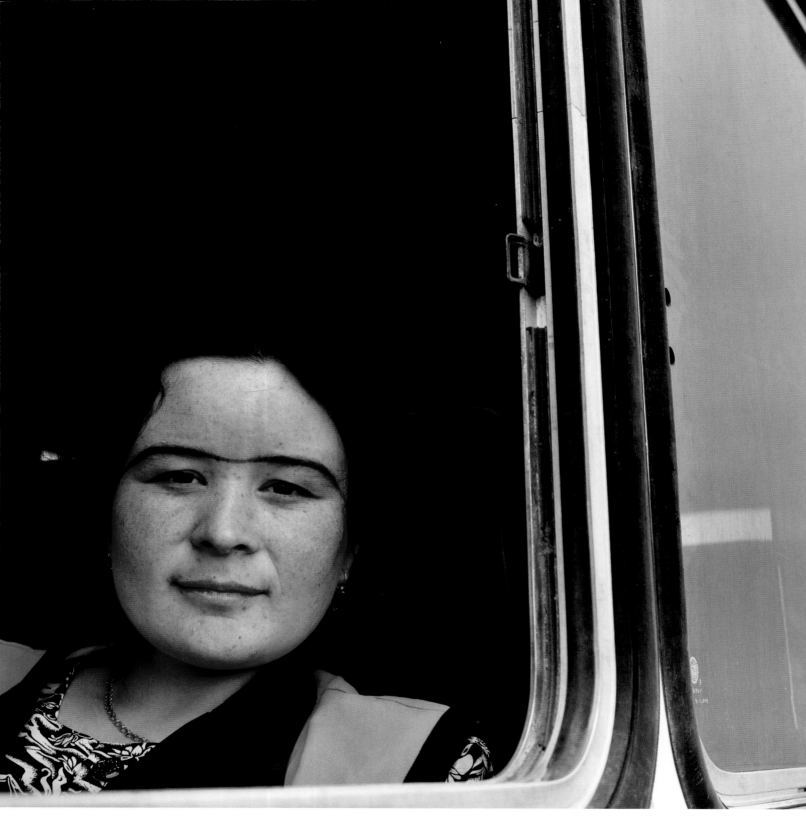

SILK ROAD SWEEPER | XINJIANG | CHINA 2001

BEHIND THE CONTOURS

OF A CONVENIENTLY DIVIDED EURASIAN CONTINENT

THE LINES OF SOME FACES

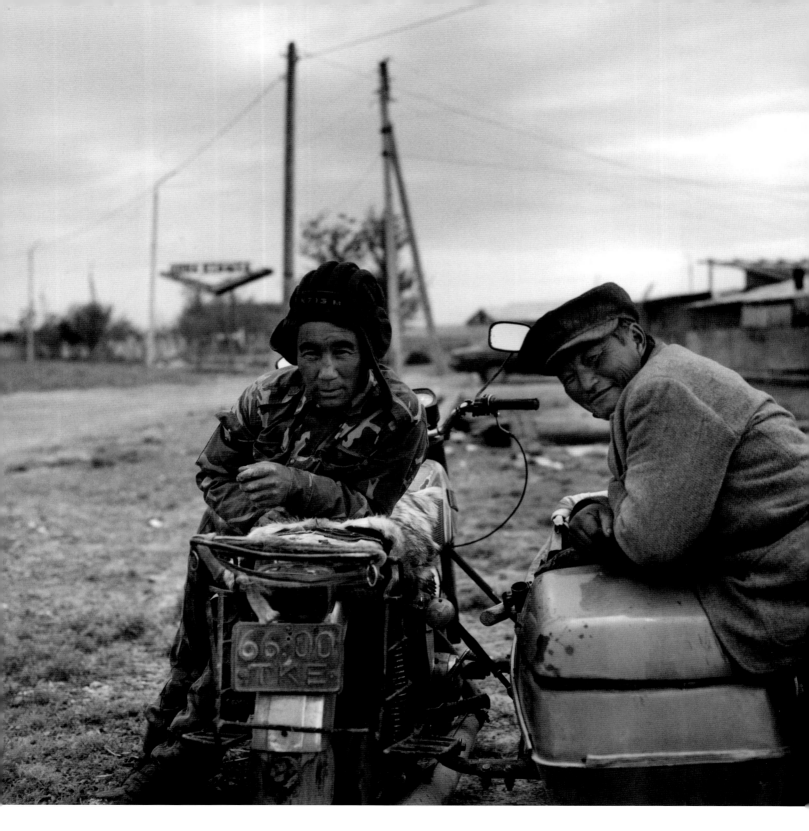

ENTREPRENEURS | DSUNGARIAN GATE | KAZAKHSTAN 2001

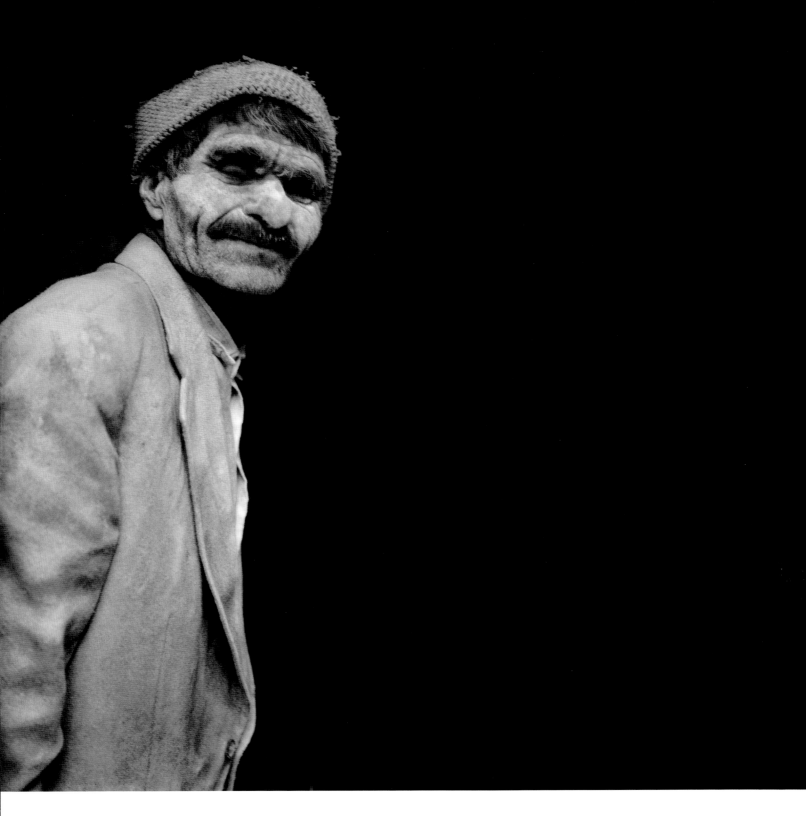

THE MILLER | KUHBONAN | IRAN 1995

ONE IMAGE
ASKING
FOR THE NEXT

THE VENDOR | BUKHARA | UZBEKISTAN 2002

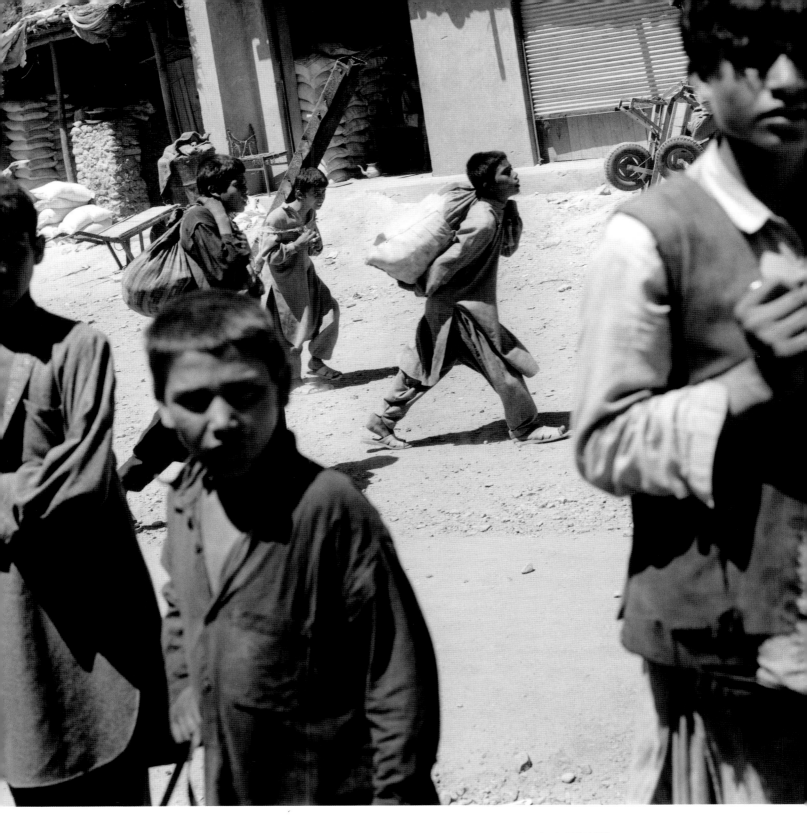

LAST STAGE OF THE CENTRAL ASIAN SCRAP METAL ODYSSEY TO PAKISTAN | TORKHAM | AFGHANISTAN 1998

ENCOUNTERS OVER THE COURSE OF THE YEARS

ANTIQUE DEALER
ARCHAEOLOGIST
BEGGAR
BORDER GUARD
BRICK MAKER
CAMEL HANDLER
COMBATANT
CONVERT
COTTON PICKER
DANCER
DRUG ADDICT
FORCED RESETTLER
FOREIGN MINISTER
FRAUDSTER
FRUIT SELLER
GRAVE DIGGER
HAWKER
HORSE DEALER
INFORMANT
MARTYR'S MOTHER
MIGRANT WORKER
MILITANT
MILLER
MINDER
MONEY CHANGER
MULLAH
NOMAD
OFFICIAL
PILGRIM
PRISONER
PROSPECTOR
REFUGEE
RUBY MINER
SCHOLAR
SHAMAN
SHEPHERD
SMUGGLER
SUFI
SURVEYOR
TELEPHONE OPERATOR
TRAIN CONDUCTOR
TRAVELLING SALESMAN
TREASURE HUNTER
TRUCK DRIVER
UN REPRESENTATIVE
WEDDING GUEST

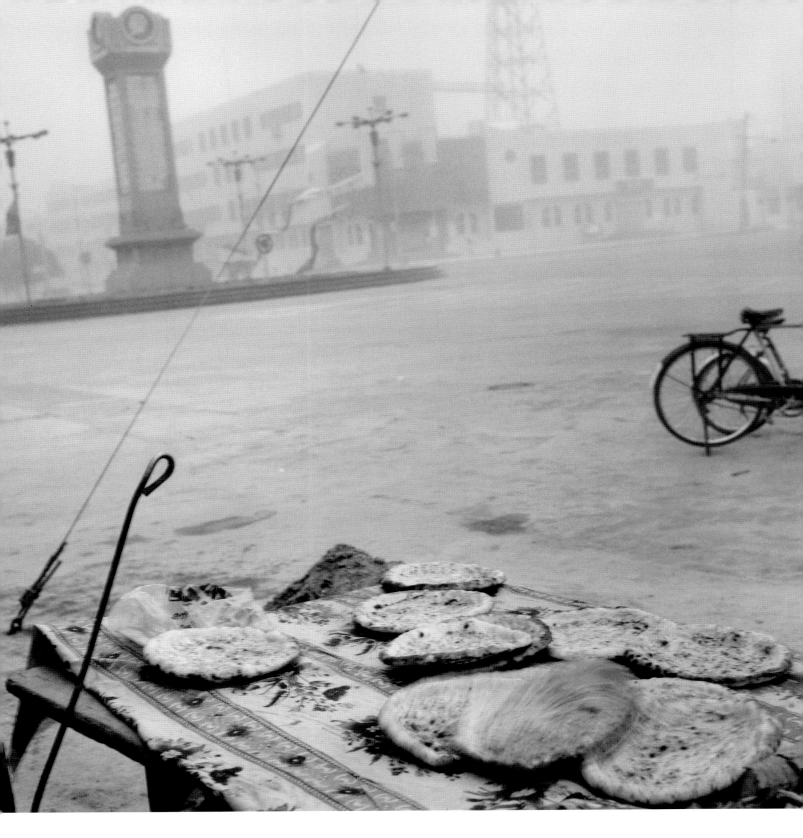

AT THE BAKERY | XINJIANG | CHINA 2001

NAMES	OCCUPATIONS
OF	OF
AUTHORS	INDIVIDUALS
WHOSE	WHOSE
WORKS	GAZE
I	I
READ	MEET
ALONG	ALONG
THE	THE
ROUTES	ROUTES
THEY	THEY
DESCRIBE	SURVEY

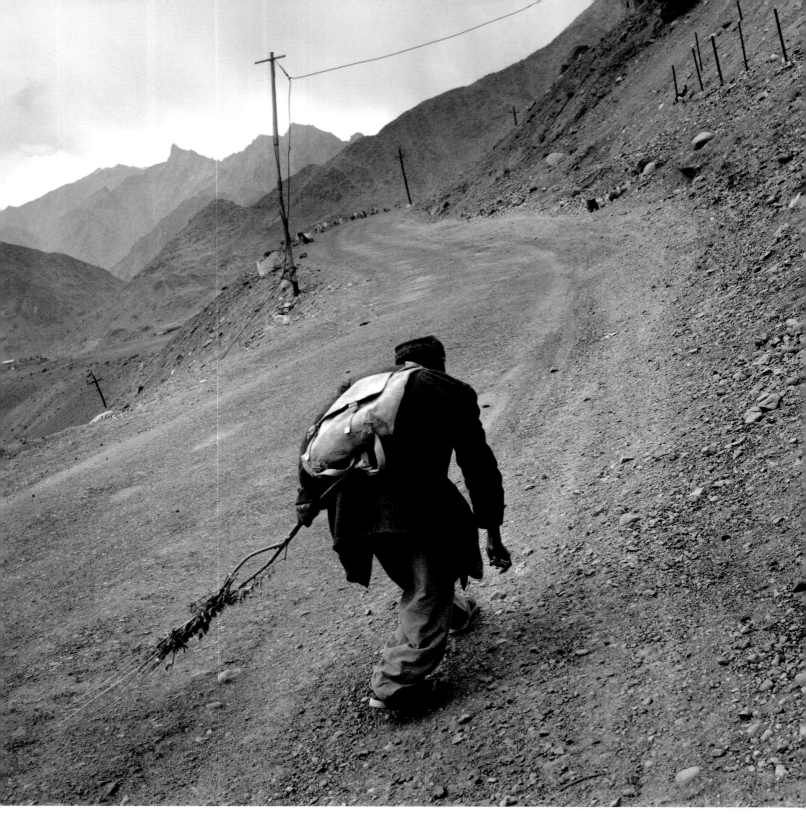

SWEEPING THE MILITARY ROAD | KARGIL | KASHMIR | INDIA 2000

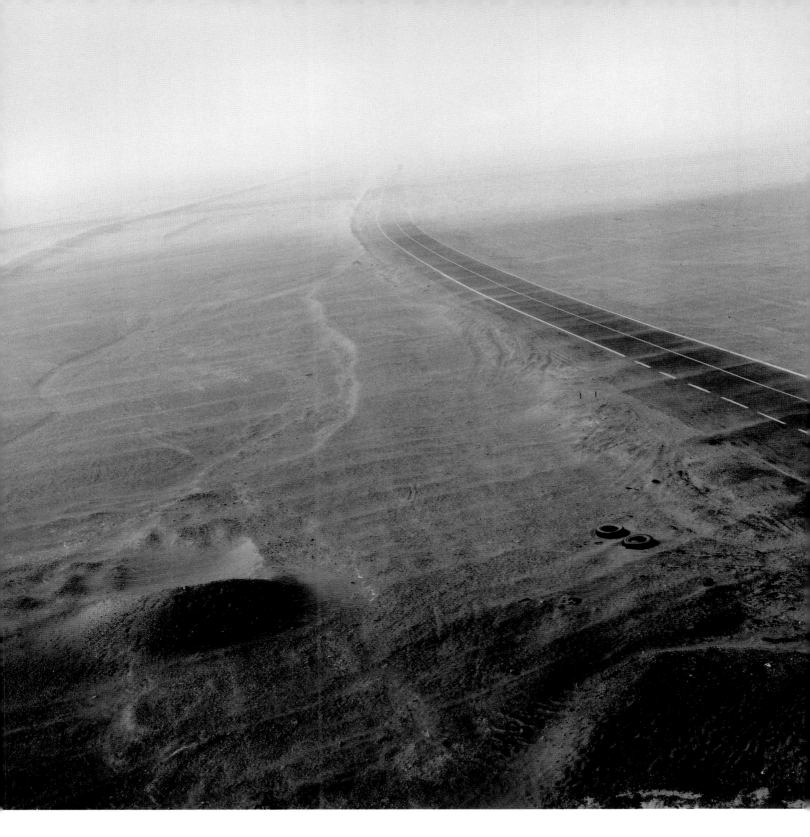

SANDSTORM | BELUCHISTAN | IRAN 1995

VOYAGES AT SEA
NOTHING
BUT WATER

WANDERINGS ON LAND
NOTHING
BUT HISTORY

44

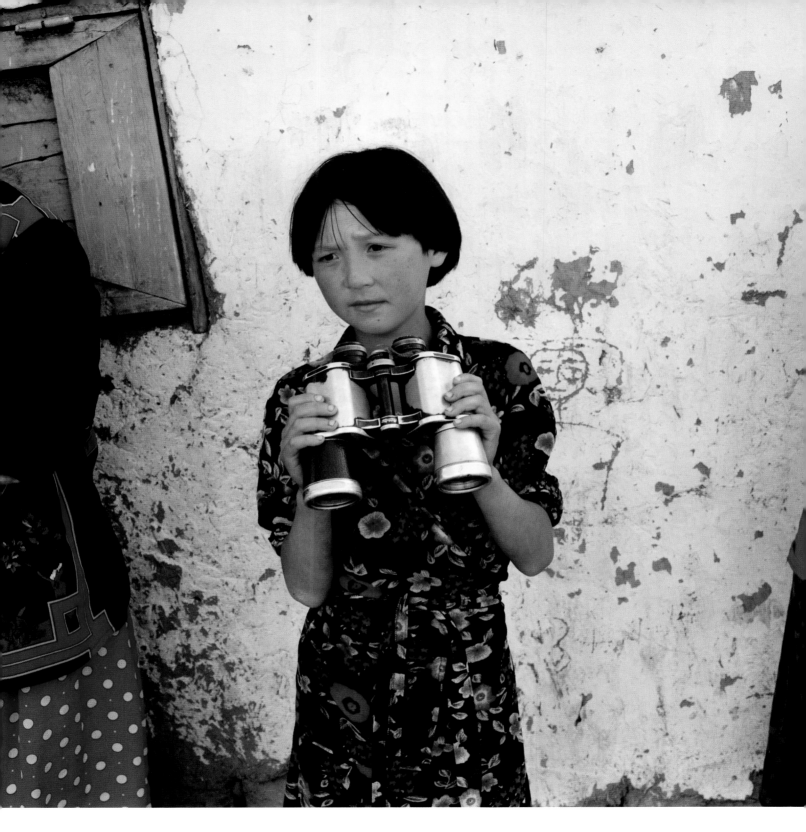

IN PTOLEMY'S SECOND PROJECTION
THE CASPIAN SEA BEING
THE ONLY FEATURE IN CENTRAL ASIA

MY ONLY LINKS TO PTOLEMY'S WORLD
BEING TWO CROSSINGS OF
THE CASPIAN SEA

48

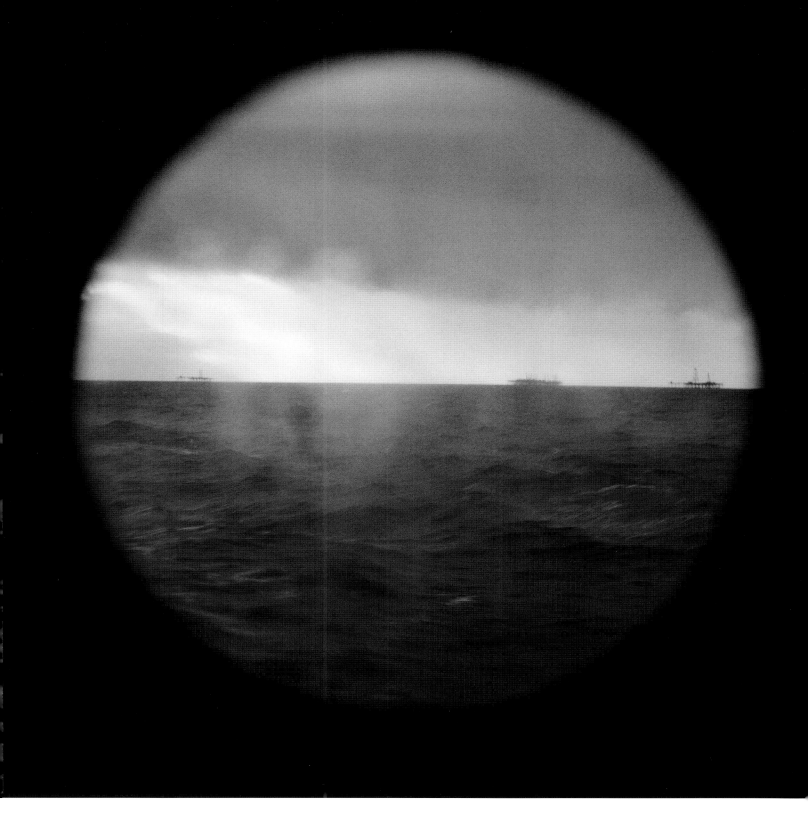

OIL PLATFORMS | CASPIAN SEA | AZERBAIJAN 2007

50

RETURN TO THE CROSSROADS

DESCENT FROM THE PAMIR HIGHWAY INTO THE ALAI MIGRATION CORRIDOR

RUSSIAN BORDER SECURITY TROOPS AT WINDY CHECKPOINT SEARCH FOR AFGHAN OPIUM

THE FAINT SOUNDS OF CIVIL WAR IN TAJIKISTAN

GARM VALLEY ROAD VIA ANCIENT STONE TOWER CLOSED

PASSING THROUGH SARY TASH AT DUSK AND SNOWFALL ON TALDYK PASS

EIGHT YEARS LATER

CONCRETE ARCH ACROSS THE ASCENT ROAD FROM OSH UP TO TALDYK PASS

RED VOLGA DOOR FRAME SIGNALLING STRANDED KAZAKH TRUCK LOADED WITH SCRAP METAL

DURING THE DESCENT INTO THE ALAI CORRIDOR SARY TASH UNDER GLOWING SHEETS OF COPPER SKY

STAYING AT A HOUSE BUILT BY PRISONERS

CHINA ROAD TO KASHGAR VIA ANCIENT IRKESHTAM SILK ROAD CUSTOMS POST OPEN

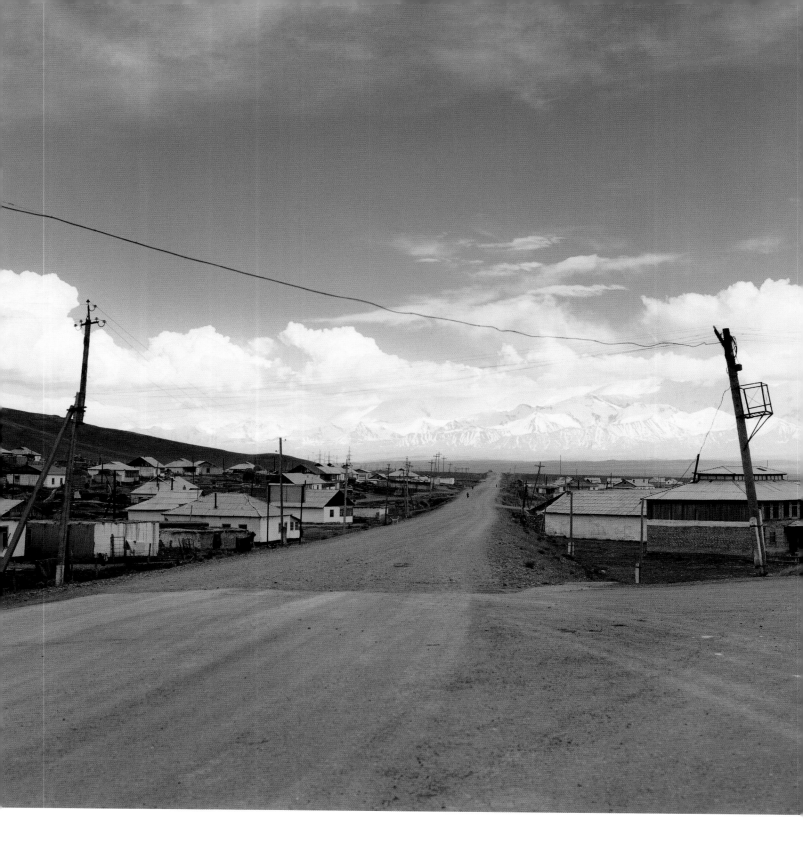

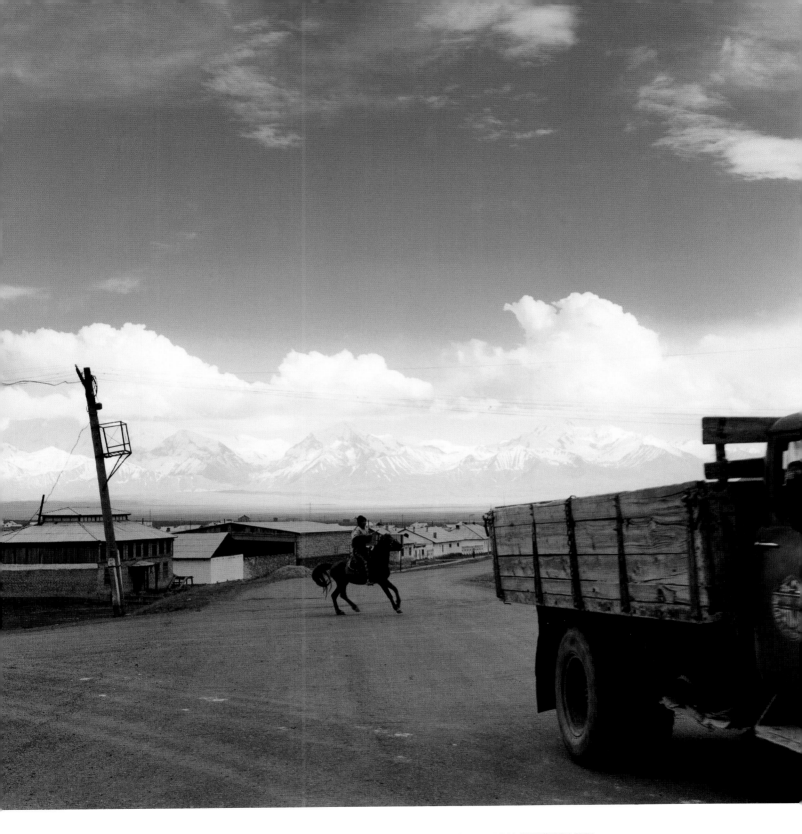

THE ROAD TO CHINA [LEFT] AND THE ROAD TO TAJIKISTAN [ABOVE] | SARY TASH | KYRGYZSTAN 2004

HEARTLAND

ARRIVAL IN CENTRAL ASIA | TURKMENBASHI | TURKMENISTAN 2005

IT IS NOT CLEAR WHO POSSESSES THE WEATHER OF CENTRAL ASIA

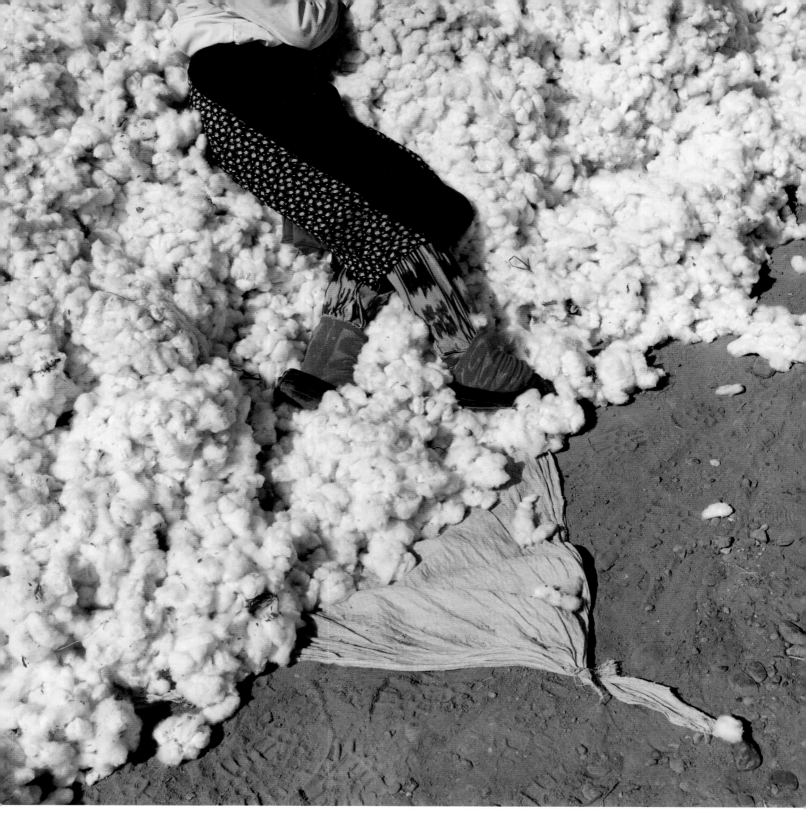

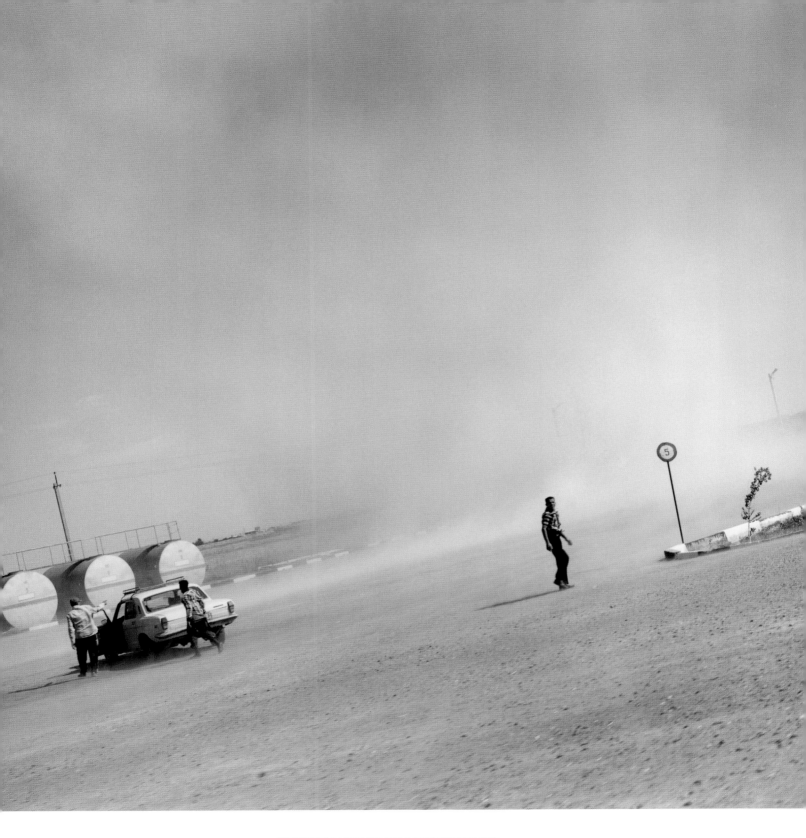

SANDSTORM | LEBAP WELAYAT | TURKMENISTAN 2005

62

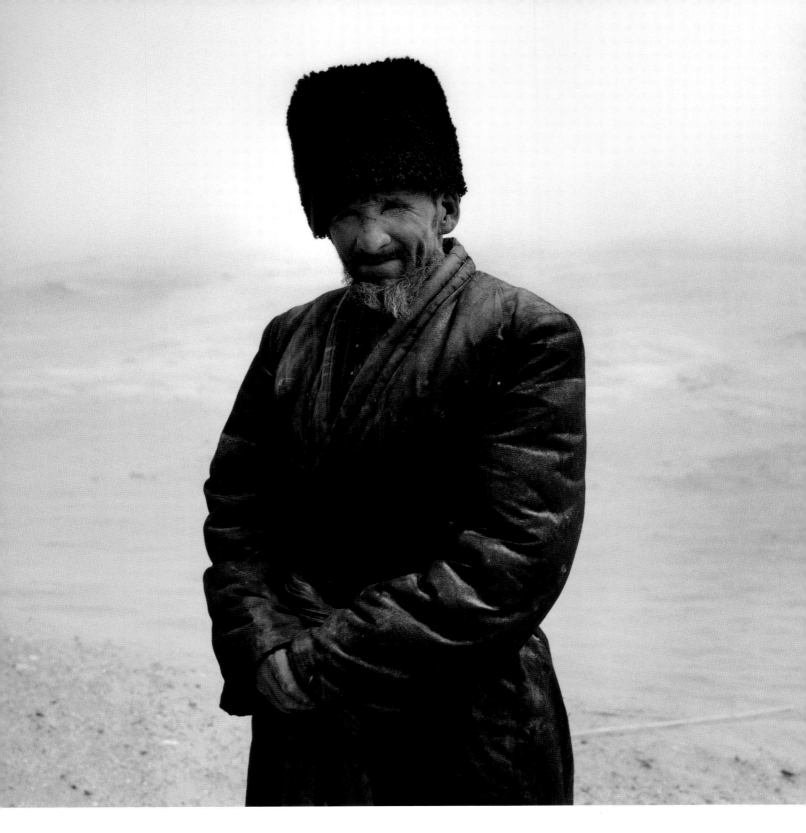

UIGHUR TRUCKDRIVER | XINJIANG | CHINA 2001

64

ECOLOGIES

FOLLOWING WATER WHEREVER IT CAN BE FOUND

STAYING WITH WATER WHERE IT IS

GUARDING HUMANITARIAN AID | BADGHIS | AFGHANISTAN 2001

KITCHEN | OSH | KYRGYZSTAN 2004

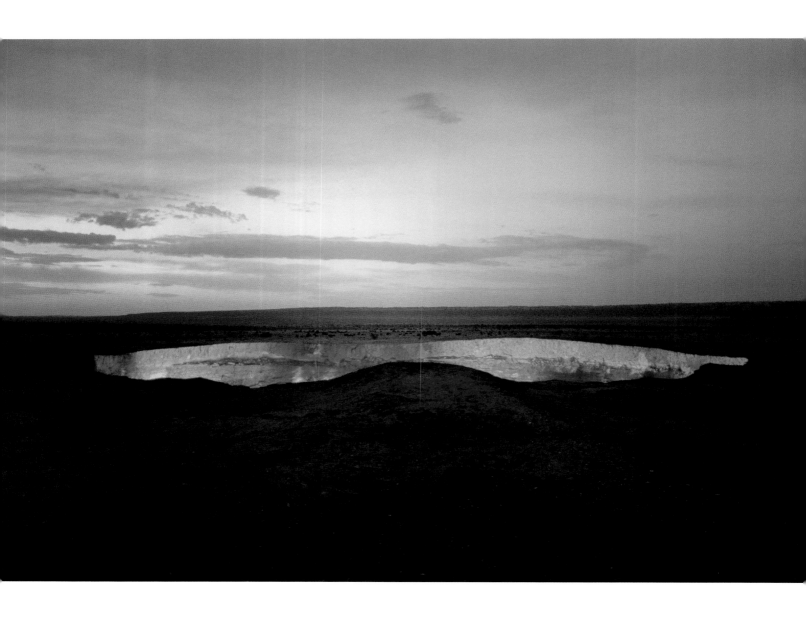

GAS CRATER | KARAKUM | TURKMENISTAN 2005

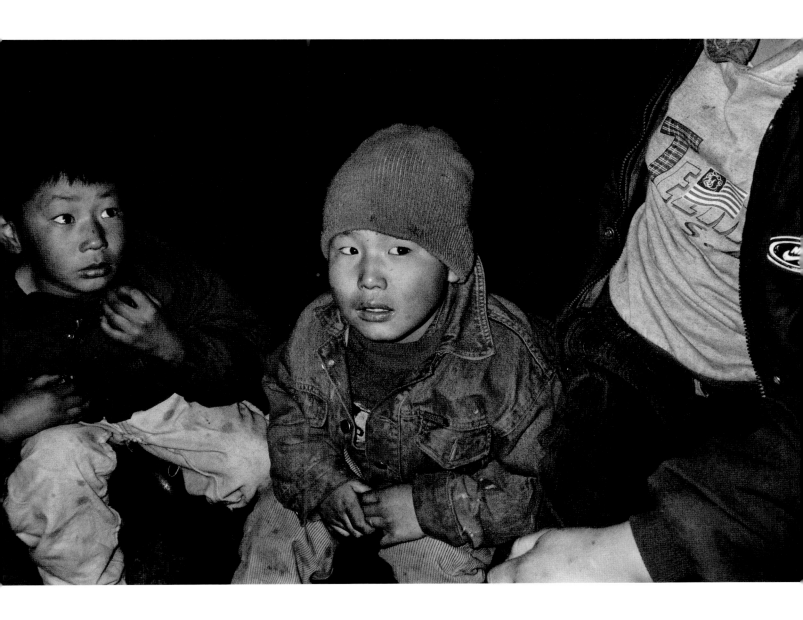

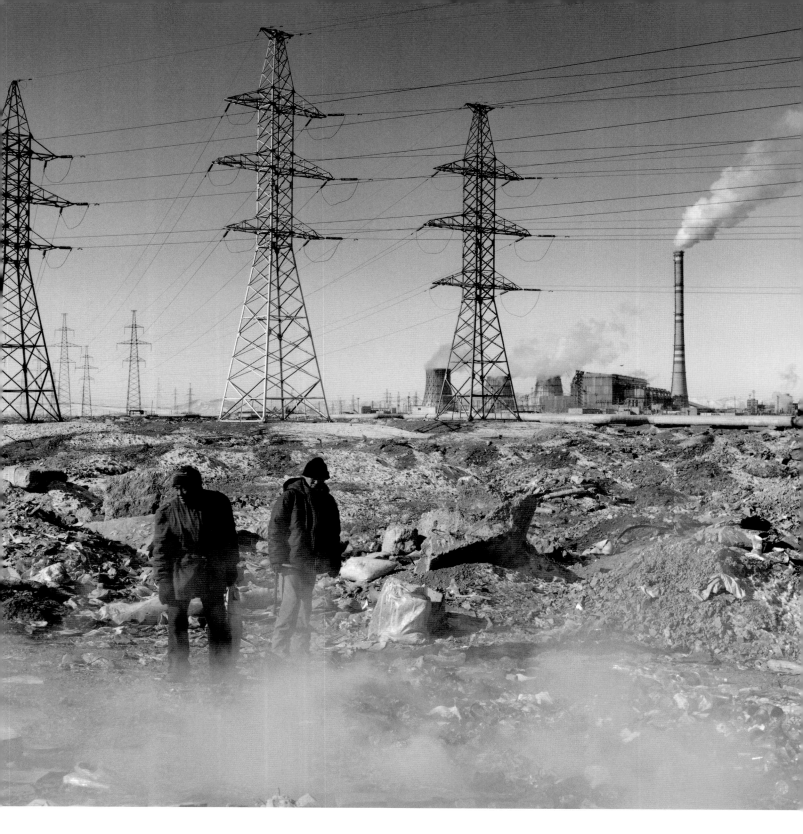

POWER STATION | ULAANBAATAR | MONGOLIA 2000

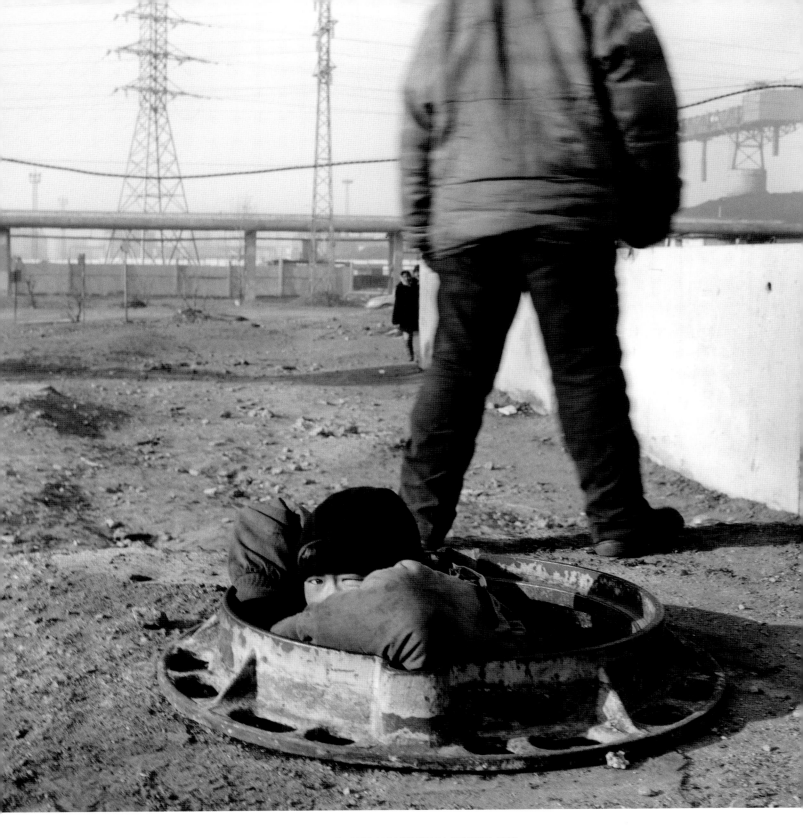

CHILDREN OF THE CAVERNS | ULAANBAATAR | MONGOLIA 2000

CERTAIN MOMENTS OF SURFACE CALM

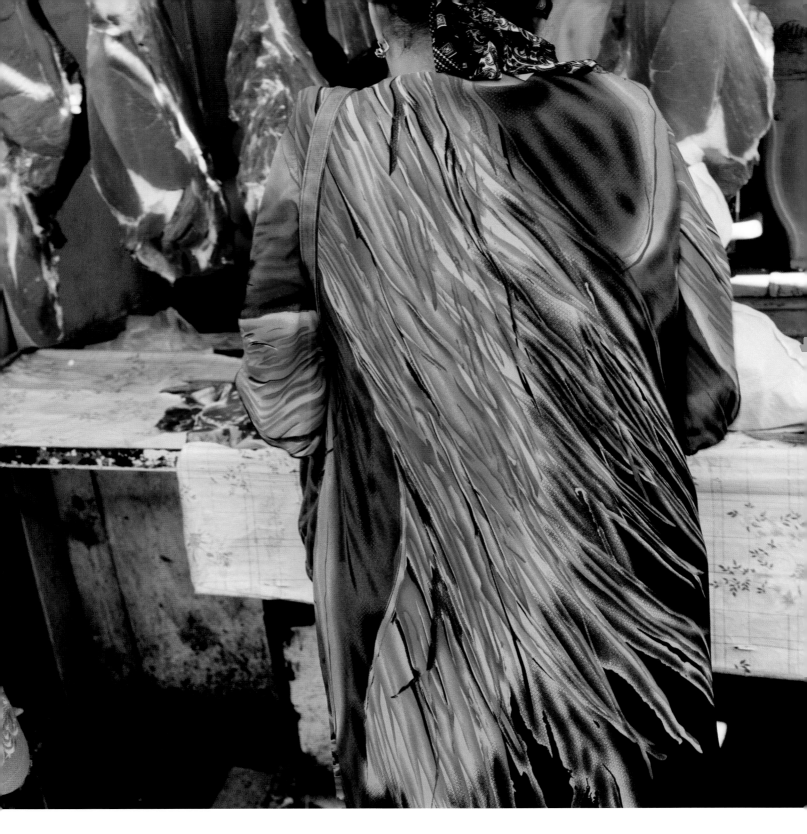

BAZAAR DAY | OSH | KYRGYZSTAN 2004

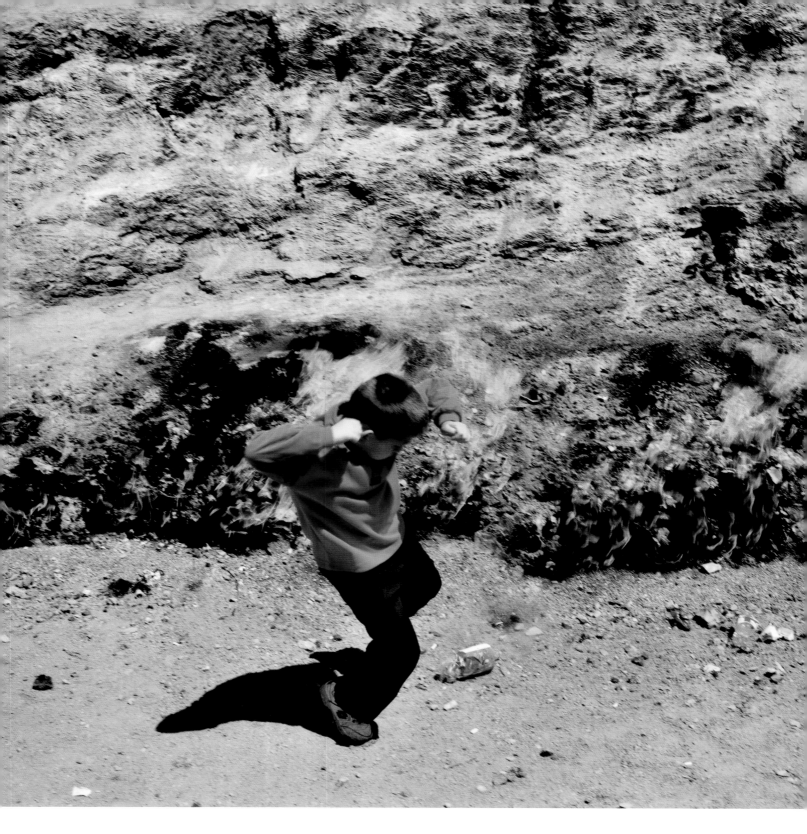

ZOROASTRIAN FIRE | ABSHERON | AZERBAIJAN 2005

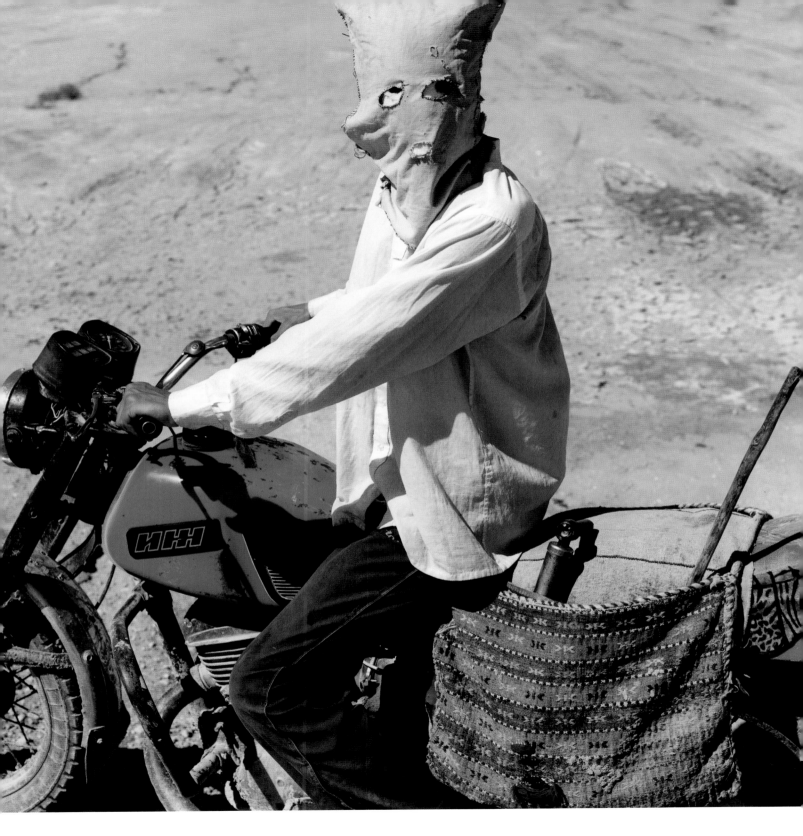

EN ROUTE ACROSS THE MISIRIAN PLATEAU | TURKMENISTAN 2005

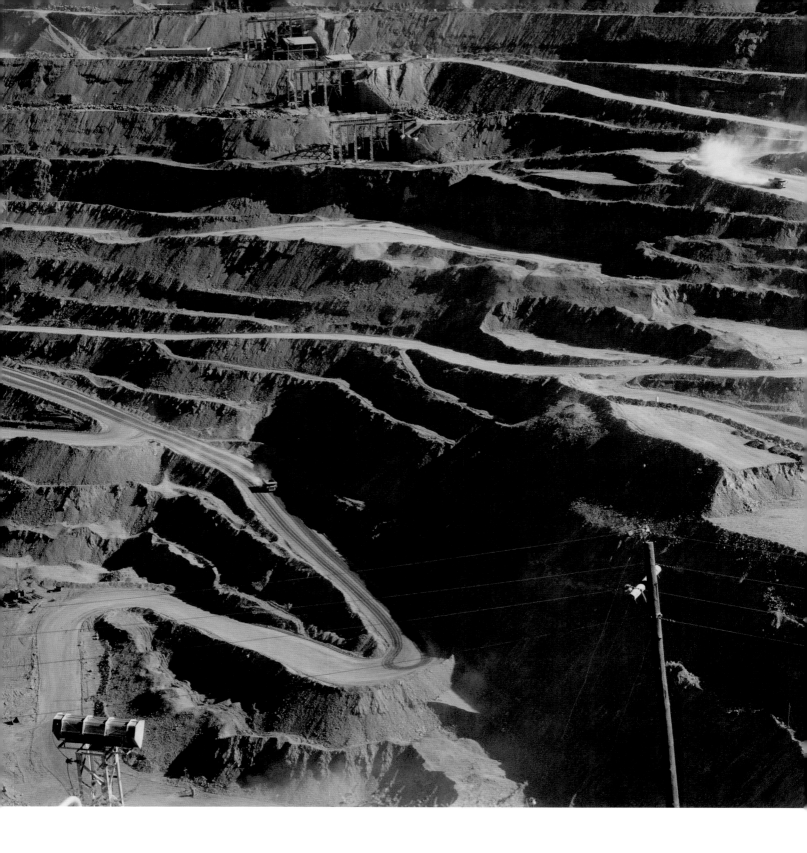

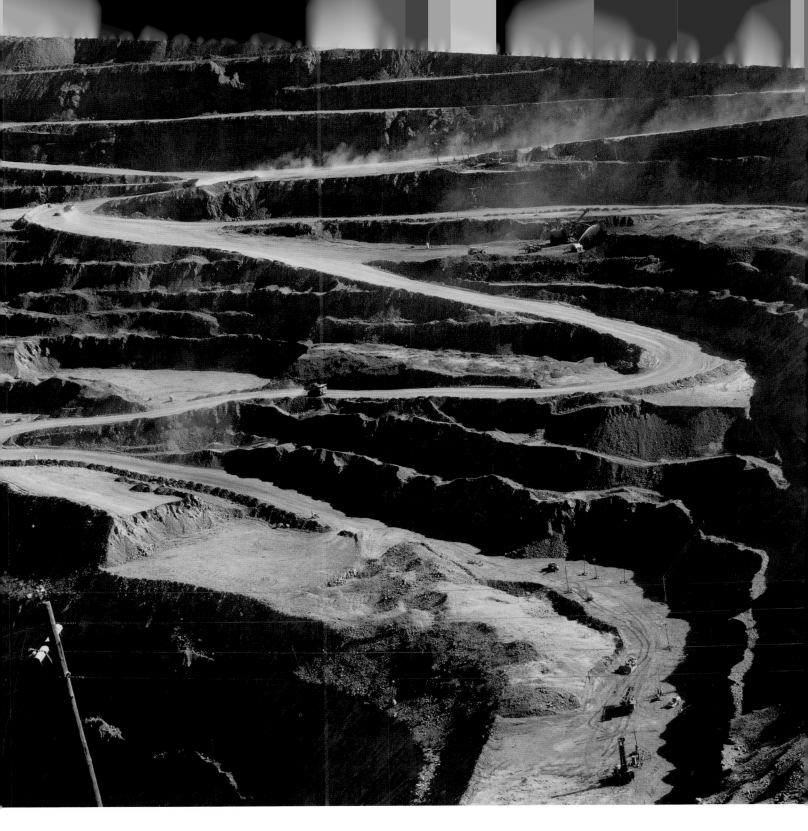

MURUNTAU GOLD MINE | KYZYLKUM | UZBEKISTAN 2002

78

ONE OF THE LARGEST KNOWN HYDROTHERMAL GOLD DEPOSITS IN THE WORLD. SITUATED WITHIN THE SOUTHERN TIAN SHAN FOLD AND TRUST BELT. HOSTED BY LOWER GREENSCHIST GRADE SEDIMENTARY ROCKS OF THE EARLY PALAEOZOIC BESAPAN SUITE. MAIN STAGE GOLD PRESENT WITHIN A NETWORK OF STEEP QUARTZ VEINS. DISPLAYING A COGENETIC RELATIONSHIP WITH ARSENOPYRITE. DEPOSIT ALSO SPATIALLY ASSOCIATED WITH TWO LATE CARBONIFEROUS TO EARLY PERMIAN GRANITIC INTRUSIONS. ORIGIN OF DEPOSIT STILL DEBATED

GROWTH IS A SELF-LIMITING BUSINESS

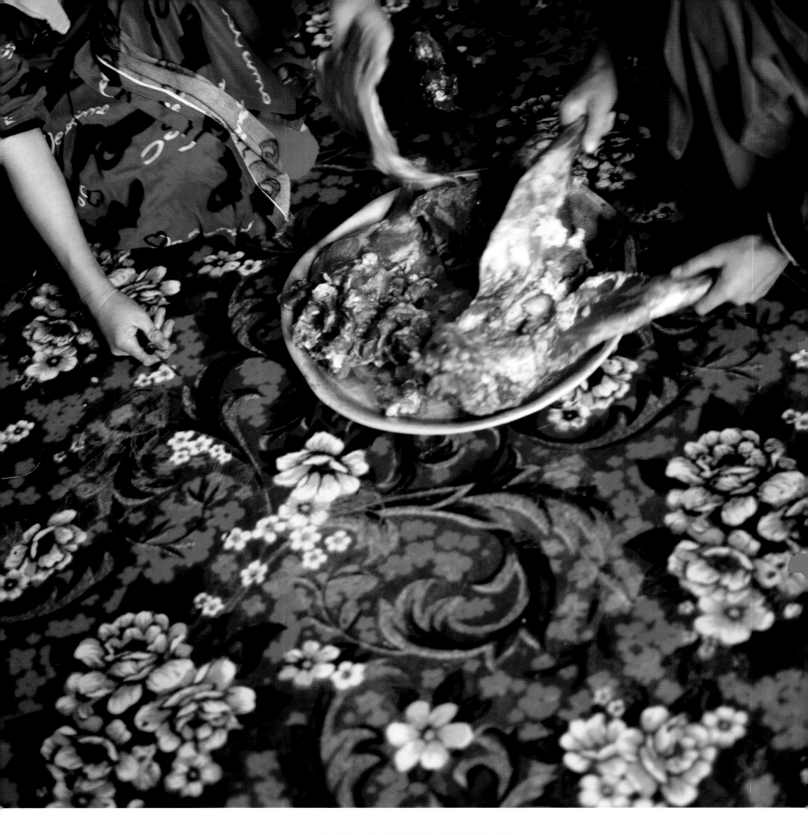

THE MEAL | ALAI CORRIDOR | KYRGYZSTAN 2004

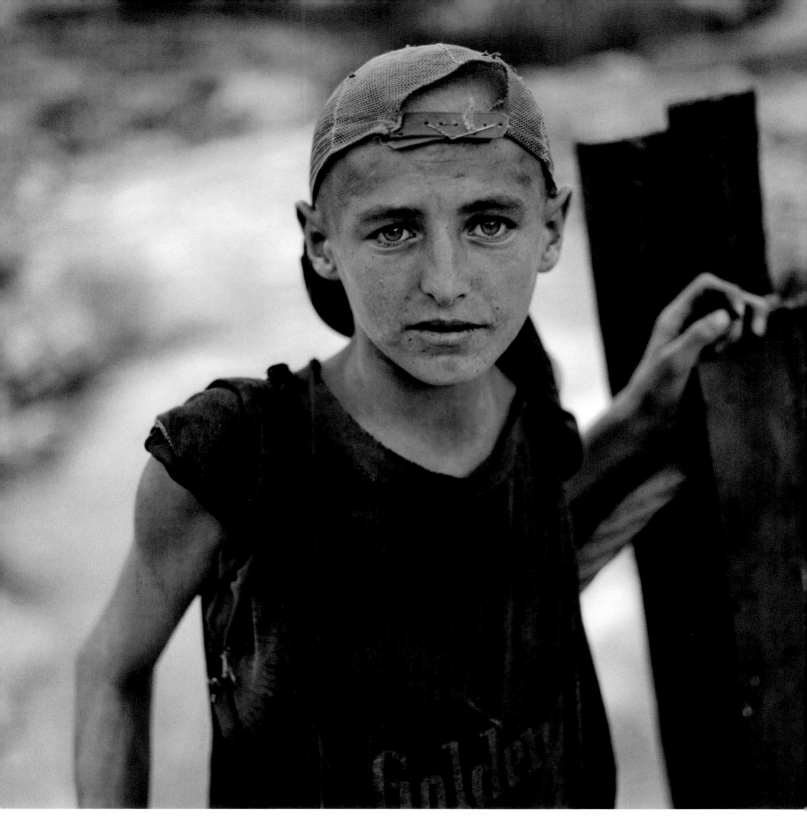

HUNGER | BADAKHSHAN | TAJIKISTAN 1996

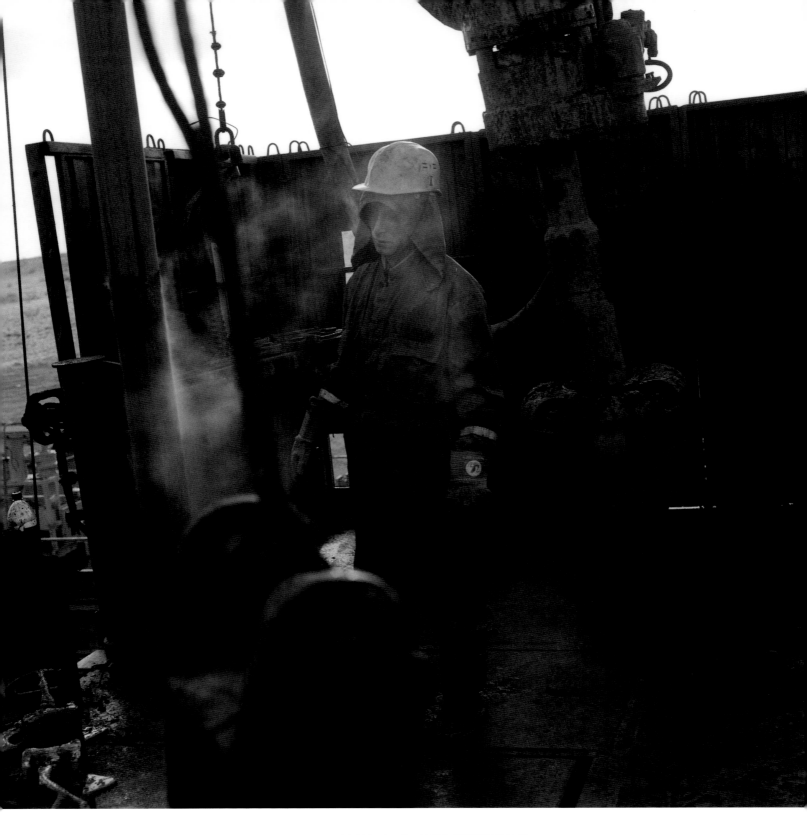

DRILLING FOR OIL | KYZYL-ORDA | KAZAKHSTAN 2007

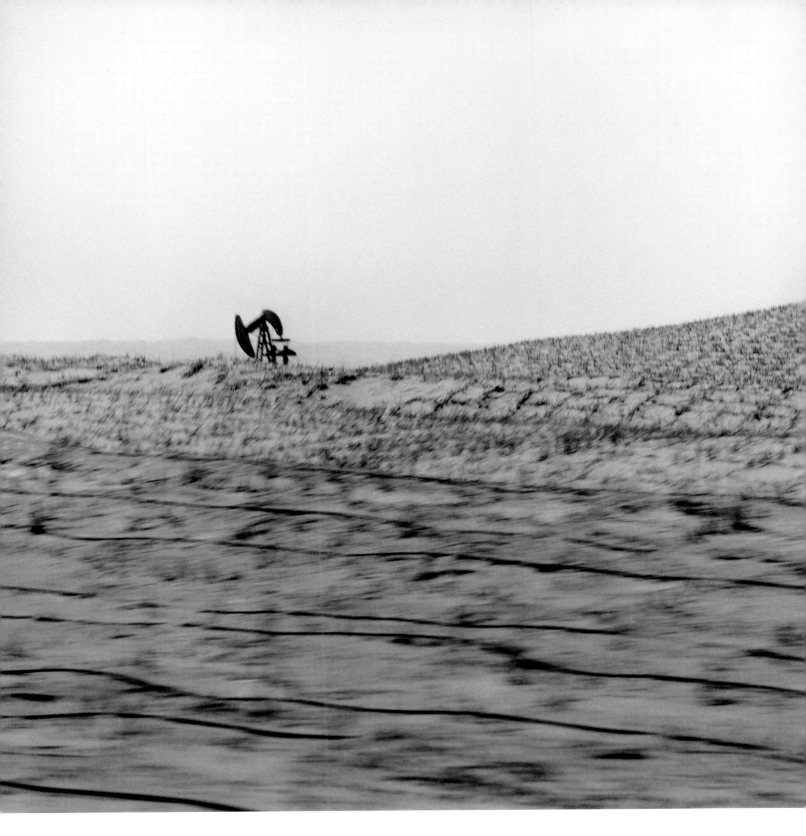

OILFIELD | TAKLAMAKAN | XINJIANG | CHINA 2001

ENTERING SAMARQAND | UZBEKISTAN 2002

WARES FOR THE TANG

ALFALFA
ALOES WOOD
AMBER
BILE
BORAX
CAMPHOR
CARDAMOM
CORAL
CRYSTAL
DATES
DEERSKIN
EBONY
FEATHERS
FELT
GINSENG
GLASS
GRAPES
HONEY
HORSEHIDES
HUMAN HAIR
INDIGO
IVORY
JADE
JASMINE OIL
JEWELS
LACQUER
LAPIS LAZULI
LOTUSES
MALACHITE
MYRRH
NARCISSUS
NUTMEG
OAK GALLS
PEARLS
POTASSIUM NITRATE
RESINS
RHINOCEROS HORN
SANDALWOOD
SAFFRON
SALT
SNAIL KOHL
SULPHUR
TORTOISE SHELL
WHITE WALNUTS
WATER LILIES
WAX

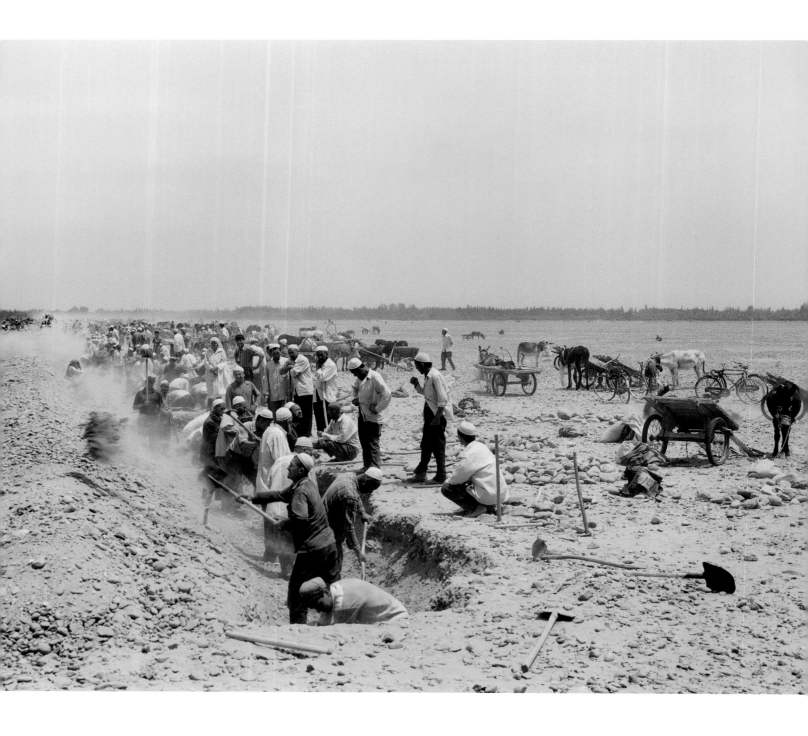

DIGGING AN IRRIGATION CANAL | XINJIANG | CHINA 2001

NEW FRONTIER

BLOOD OF A PERSECUTED PEOPLE
FORBIDDING AIR OF THE PENAL COLONY
OPPORTUNITIES FOR ALIEN MINDS WANTING EVERYTHING
A CAUSE ABANDONED BY INTERNATIONAL COMPLIANCE
RUMOURED STATE OF INSURRECTION
NATURE KIND TO THE DEAD

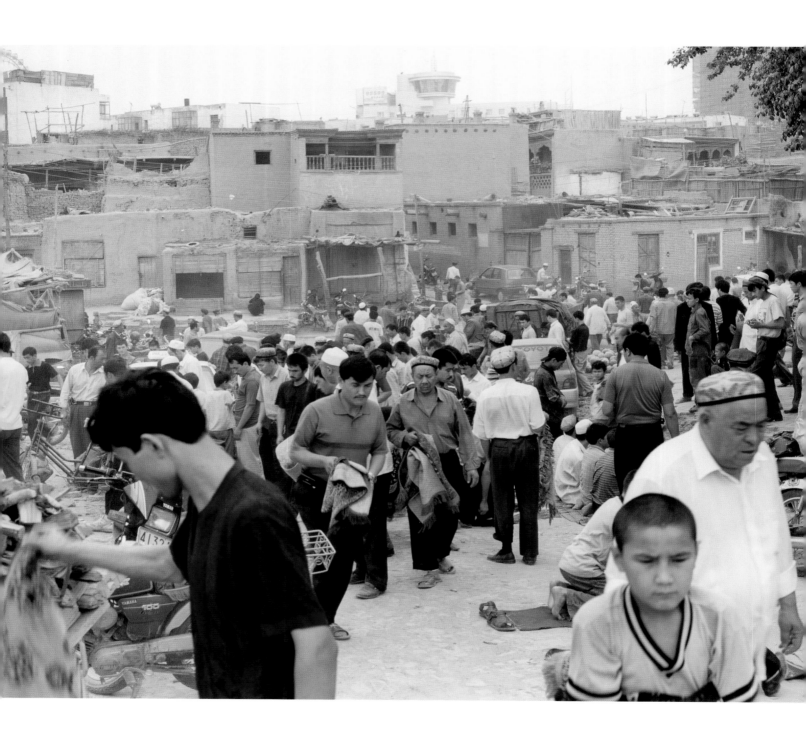

EVENING PRAYER [ABOVE] AND MUSLIM FUNERAL [OPPOSITE] | KASHGAR | XINJIANG | CHINA 2004 AND 2001

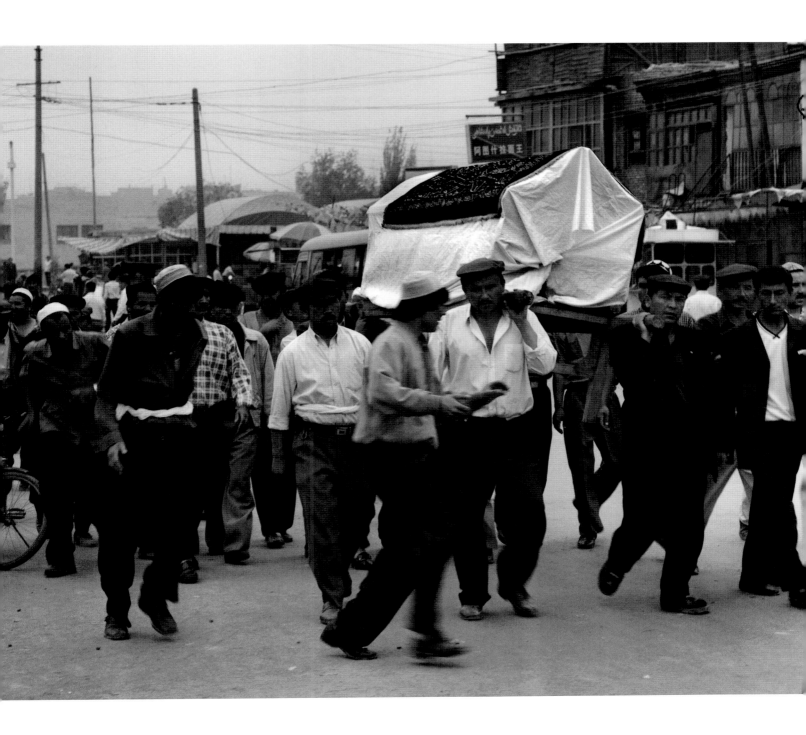

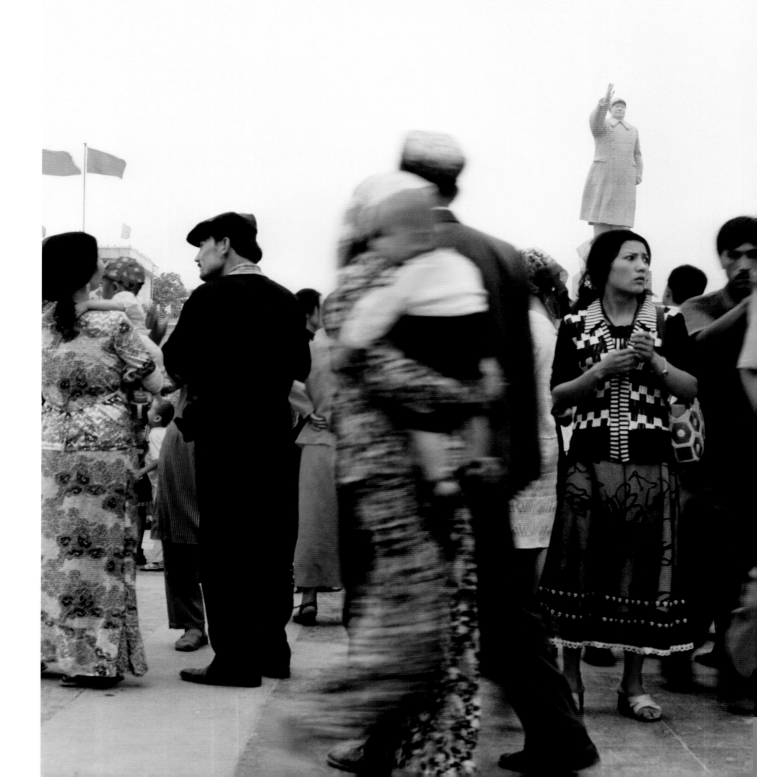

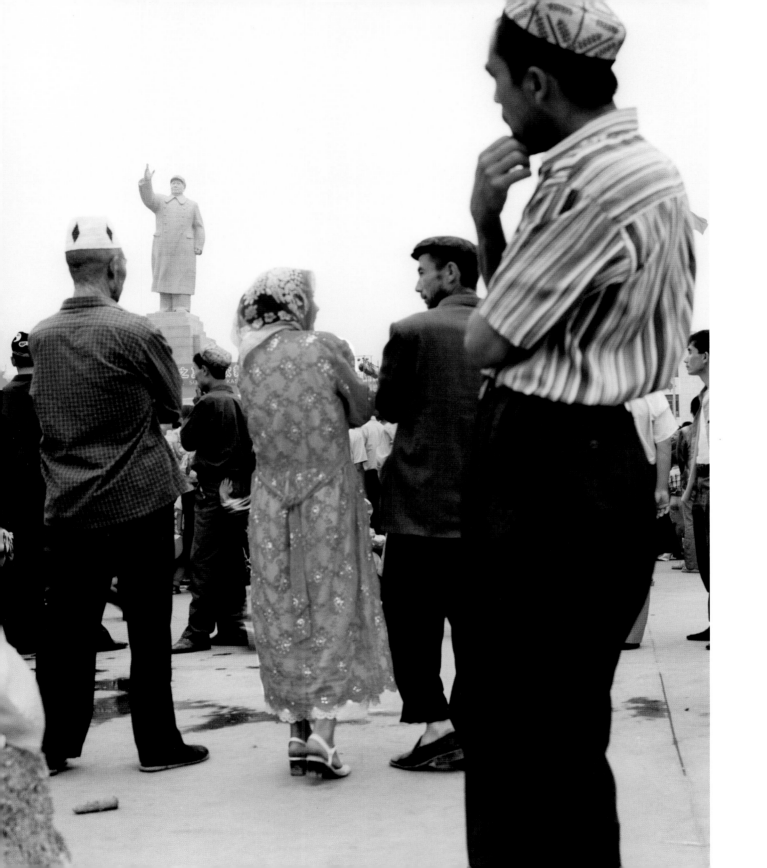

ROADS

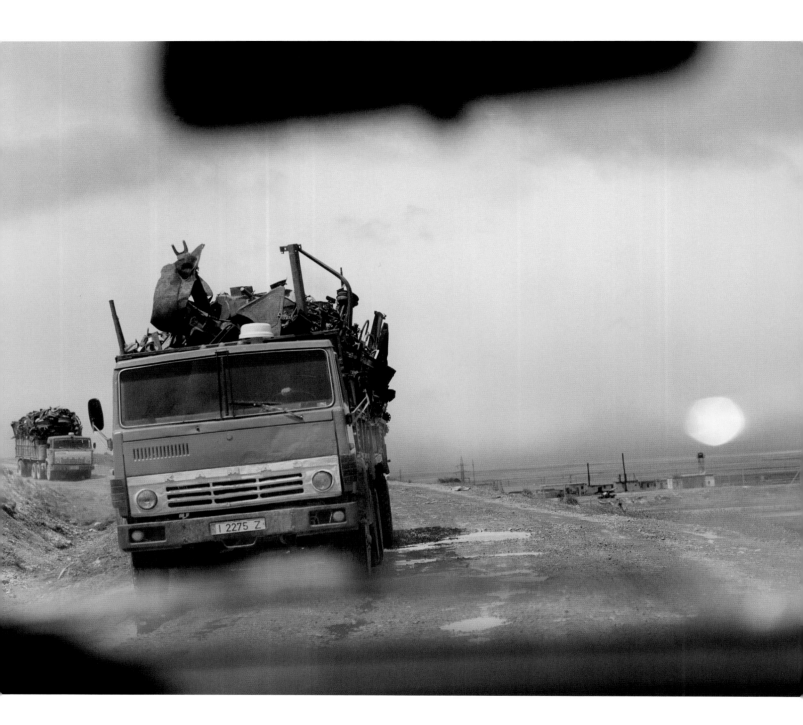

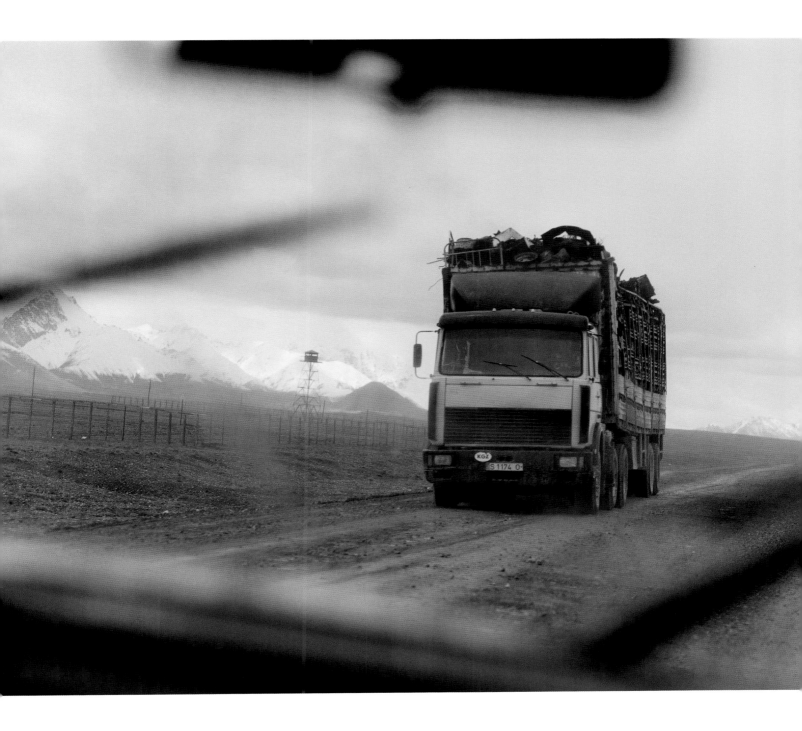

CENTRAL ASIAN SCRAP METAL EN ROUTE TO CHINA | TORUGART PASS | KYRGYZSTAN 2004

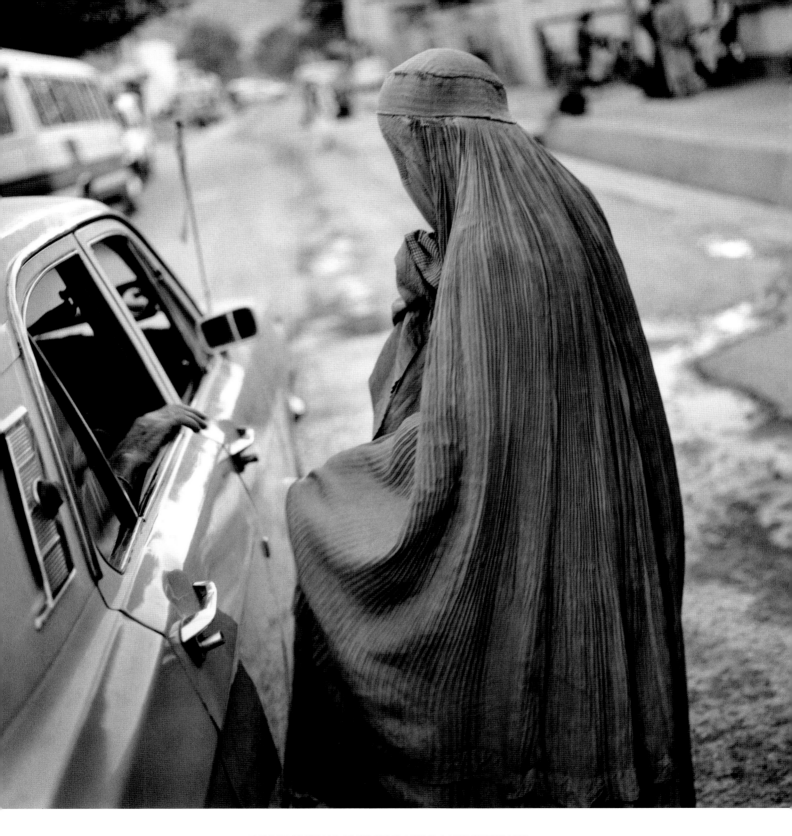

IN THE TIME OF MULLAH OMAR'S FATWA | KABUL | AFGHANISTAN 1998

R AND VIA PAMIR – XIYU OR THE WESTERN REGIONS – KUSHANA AND BALKH OR FERGHANA AND SAMARQAND TO MERV AND VIA PERSIA TO

E ACCOUNT FROM YUMENGUAN VIA LOULAN TO THE NORTH OF LOPNUR–KUCHA–AKSU–KASHGAR – REJOINING THE **SOUTHERN SILK ROAD**

NTRAL ROAD BEFORE KUCHA

R AND NORTHERN INDIA

NTRAL ROUTE TO THE NORTH OF THE TIAN SHAN – THE ILLI VALLEY OR LAKE ISSYK KUL – BRANCHING OFF INTO TWO FEEDER ROUTES:

BLACK SEA AND (2) OF THE **SOUTHERN EAST–WEST ROUTE** FROM SAMARQAND VIA PERSIA TO THE GULF AND THE WEST

D JAPAN

TO EASTERN EUROPE

GION

B TO OSH – CROSSING THE **SOUTHERN SILK ROAD** AT SARY TASH

LK ROAD BRANCHES TO GILGIT

NEW NORTHERN ROUTE OF THE WEILUE ACCOUNT – ACROSS THE YELLOW RIVER BASIN – TO SHANGHAI

BISHKEK – THE **SOUTHERN SILK ROAD** PASSES OF IRKESHTAM AND TORUGART TO CHINA

ROUTES

SECOND HALF OF THE FOURTH MILLENNIUM BCE THE **LAPIS LAZULI ROADS** FROM BADAKHSHAN TO MESOPOTAMIA

THIRD MILLENNIUM BCE THE **LAPIS LAZULI ROADS** FROM BADAKHSHAN TO THE INDUS VALLEY

SECOND MILLENNIUM BCE THE **JADE ROADS** FROM YARKAND AND KHOTAN TO CHINA AND THE ORIENT

FIRST MILLENNIUM BCE THE **FORERUNNER OF THE SILK ROADS** CONNECTING THE BORDERLANDS OF CENTRAL ASIA

SEVENTH CENTURY BCE THE **NORTHERN TRADE ROAD OF HERODOTUS** FROM THE GREEK BLACK SEA COLONIES TO THE ALTAI

220 BCE THE **IMPERIAL HIGHWAY NETWORK** FROM XIANYIANG TO THE REMOTEST PROVINCES OF THE QIN EMPIRE

SECOND CENTURY BCE—THIRD CENTURY CE THE **SOUTHERN SILK ROAD** FROM CHANGAN VIA DUNHUANG – CHARKHILIK – KHOTAN TO KASH(
 BYZANTIUM AND THE WESTERN SEA IN ROMAN SYRIA

SECOND CENTURY BCE—FOURTH CENTURY CE THE **NORTHERN SILK ROUTE OF THE HAN HISTORIES** OR **THE CENTRAL ROUTE OF THE WEIL**

SECOND CENTURY BCE—FIRST CENTURY CE THE **NEW ROUTE OF THE WEILUE ACCOUNT** FROM YUMENGUAN VIA TURFAN – REJOINING THE C

AFTER THE FIRST CENTURY CE THE **SOUTHERN SILK ROAD BRANCHES** FROM KHOTAN VIA LADAKH–HUNZA–KASHMIR TO GANDHARA, KANDAH

SECOND—THIRD CENTURIES THE **NEW NORTHERN ROUTE OF THE WEILUE ACCOUNT** FROM ANXI VIA HAMI – JIMSAR – PARALLEL TO THE (

 (1) THE **NORTHERN EAST–WEST ROUTE** FROM THE SYR-DARJA VIA THE NORTH OF THE ARAL SEA – ASTRAKHAN – THE SEA OF AZOW TO THE

FOURTH—TENTH CENTURIES THE **QINGHAI ROAD** FROM LANZHOU VIA XINING TO MIRAN – REJOINING THE **SOUTHERN SILK ROAD**

BEFORE THE FIFTH CENTURY THE **TIBETAN ROAD** FROM XINING VIA LHASA TO INDIA

SEVENTH—TENTH CENTURIES THE **NORTH-EASTERN SILK ROAD** FROM THE TARIM BASIN VIA KARAKHOTO – BEIJING – MANCHURIA TO KOREA A

THIRTEENTH AND FOURTEENTH CENTURIES **YAM (MONGOL POSTAL ROADS)** FROM KARAKORUM AND CAMBALUC OR BEIJING – ACROSS EURASIA

SEVENTEENTH CENTURY THE **KANDAHAR ROAD** FROM AGRA VIA LAHORE–KANDAHAR–FARAH–YAZD TO ISFAHAN

1870 THE **TREATY ROAD** FROM SRINAGAR VIA ZOJI LA–LADAKH–AKSAI CHIN–HAJI LANGAR TO SHAHIDULLAH IN XINJIANG OR NEW FRONTIER R

END OF 1911 THE **IMPERIAL HIGHWAY** FROM LUOYANG VIA CHANGAN OR XIAN–LANZHOU–SUZHOU TO XINJIANG

UNTIL 1923 THE **SMALL AND THE GREAT MONGOLIAN ROAD** FROM HOHHOT VIA OUTER MONGOLIA TO EASTERN TURKESTAN OR XINJIANG

UNTIL AFTER 1923 THE **WINDING ROAD** FROM HOHHOT VIA ALASHAN PLATEAU – KARAKHOTO TO BARKOL AND THE TARIM BASIN

UPGRADED AFTER 1930 THE **RUSSIAN MILITARY ROAD** OR THE **PAMIR HIGHWAY (PAMIRSKY TRAKT)** FROM DUSHANBE VIA CHOROG – MURGH

BUILT BETWEEN 1966 AND 1978 THE **KARAKORAM HIGHWAY** FROM KASHGAR VIA THE KHUNJERAB PASS AND PARALLEL TO THE **SOUTHERN S**

AFTER 1991 **DRUG ROADS** FROM AFGHANISTAN VIA (1) PENZIKENT OR (2) THE PAMIR HIGHWAY AND OSH TO MOSCOW AND EUROPE

AFTER 1991 **FIBRE OPTIC CABLES** FROM FRANKFURT VIA ISTANBUL–IRAN–KARAKUM – TO THE NORTH OF THE TIAN SHAN – PARALLEL TO THE

AFTER 1991 **SCRAP METAL ROADS** FROM CENTRAL ASIA VIA (1) DUSHANBE–HERAT–KANDAHAR AND KABUL TO PAKISTAN OR (2) VIA ALMA-ATA-

EN ROUTE TO FERGANA | UZBEKISTAN 2002

ANCIENT TRACK | KARAKORAM | PAKISTAN 2001

PIECES OF INFORMATION

IN A DITCH THE FIBRE OPTIC CABLE RUNNING PARALLEL TO THE SILK ROAD

TRAVELLING ALONG THE FIBRE OPTIC CABLE

RECALLING EARLIER TRAVELLERS ON THE SAME ROUTE

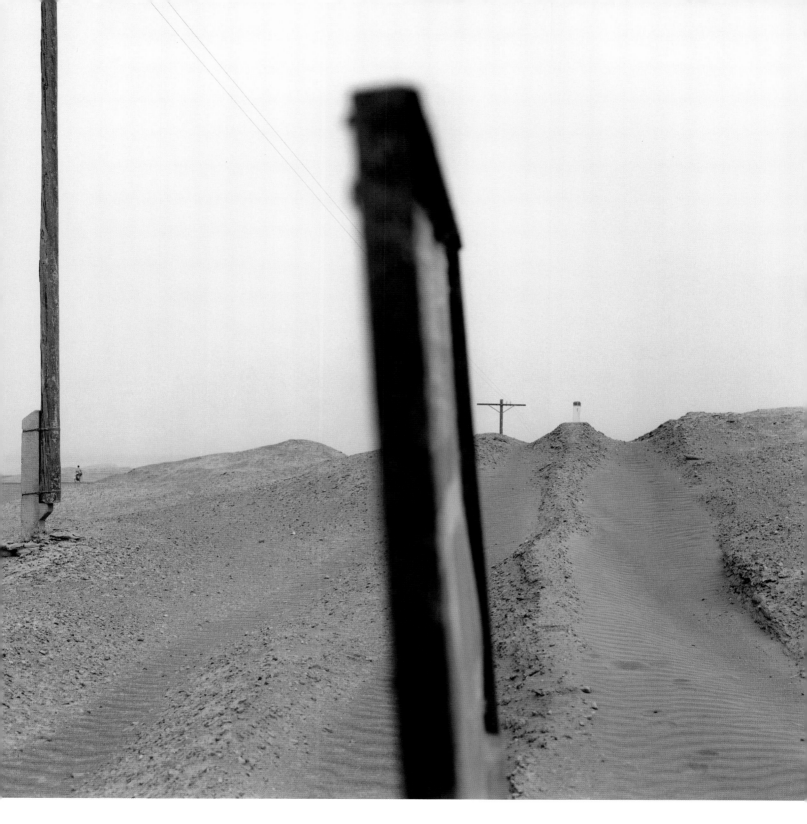

ROUTE OF THE FIBRE OPTIC CABLE | XINJIANG | CHINA 2001

CONNECTIVITY

PAX ROMANA

PAX SINICA

PAX MONGOLICA

PAX BRITANNICA

PAX AMERICANA

PAX DAVOS

PAX SINICA

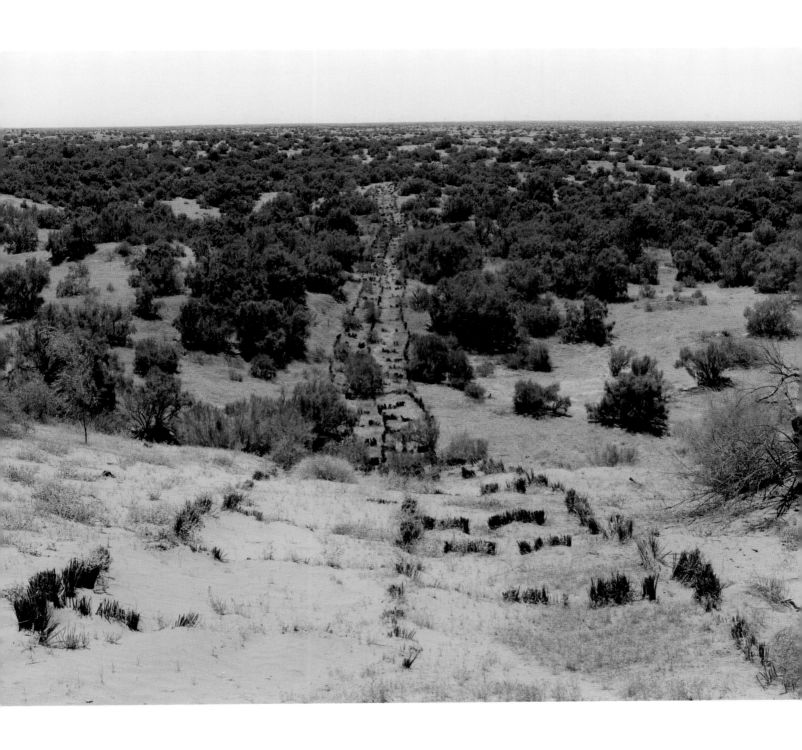

ROUTE OF THE FIBRE OPTIC CABLE | KARAKUM | TURKMENISTAN 2005

WE SEE WHAT WE KNOW

A ROAD ACROSS A DESERT LITTERED WITH COUNTLESS LANDMINES. A SOVIET BMD-2 ARMOURED TROOP CARRIER DESTROYED AT SOME TIME DURING TWENTY YEARS OF WAR. SHELTER FOR FOUR HUNGRY CHILDREN. EIGHT HOURS SPENT FILLING POTHOLES. EARNING FIFTEEN THOUSAND AFGHANI – THE EQUIVALENT OF TEN CENTS OR TWO LOAVES OF NAN – FROM DRIVERS AND PASSENGERS OF AN UNKNOWN NUMBER OF CONTAINER TRUCKS TRANSPORTING UNKNOWN QUANTITIES OF CONSUMER GOODS MADE IN JAPAN FROM THE PERSIAN GULF THROUGH IRAN AFTER PAKISTAN'S CLAMP-DOWN ON SMUGGLING RESULTS IN UNKNOWN MILLIONS OF DOLLARS IN TRANSIT FEES AND DUTIES, FUELLING WAR OPERATIONS

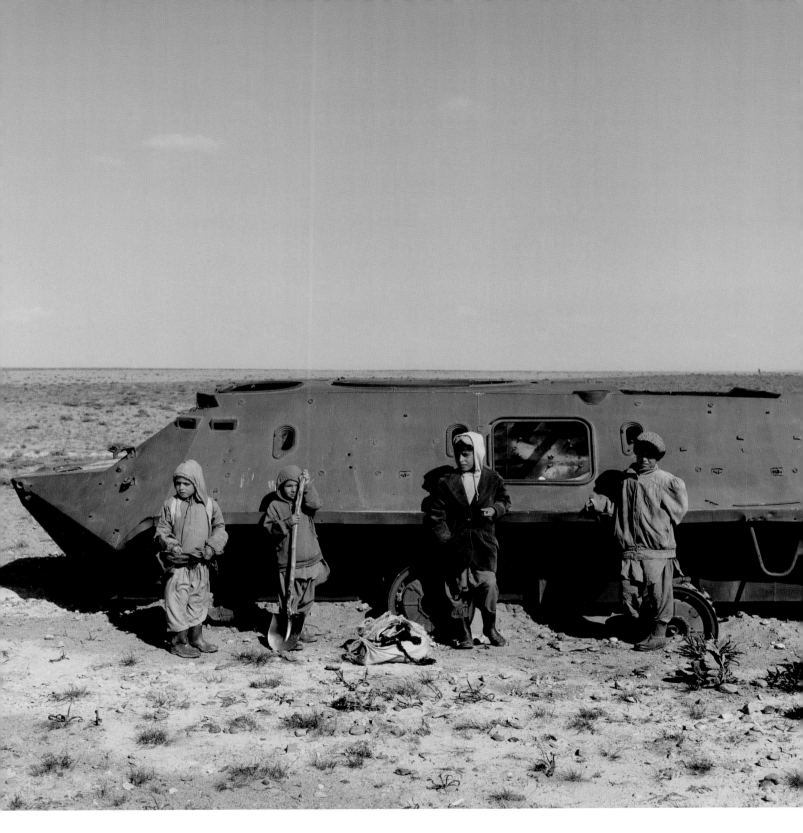

SMUGGLERS' ROAD TO IRAN | AFGHANISTAN 2001 [ABOVE AND FOLLOWING PAGES]

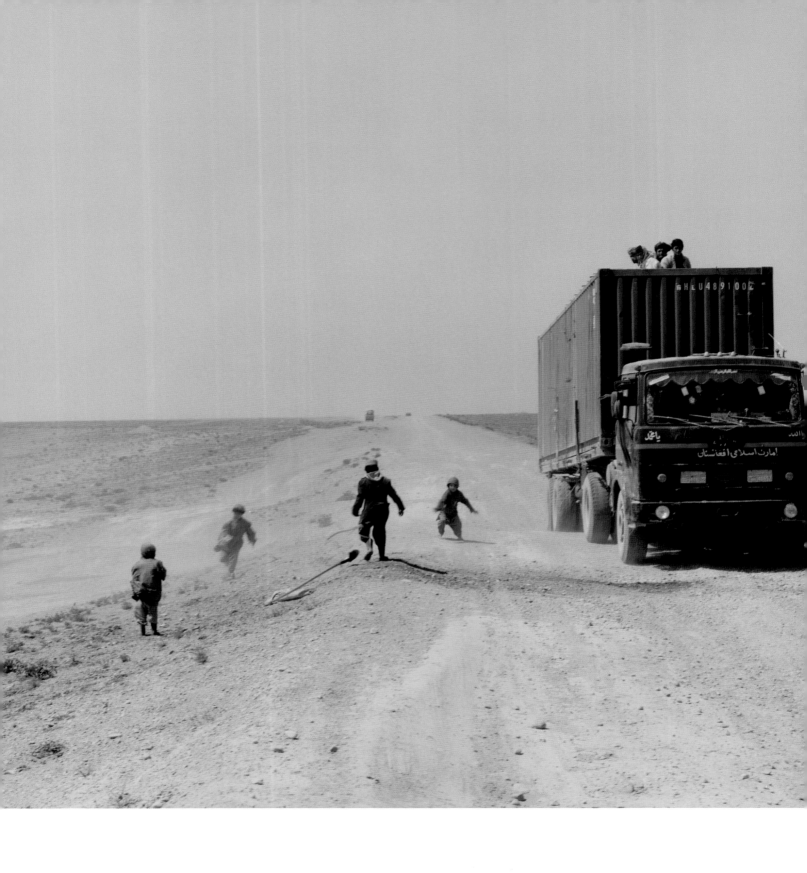

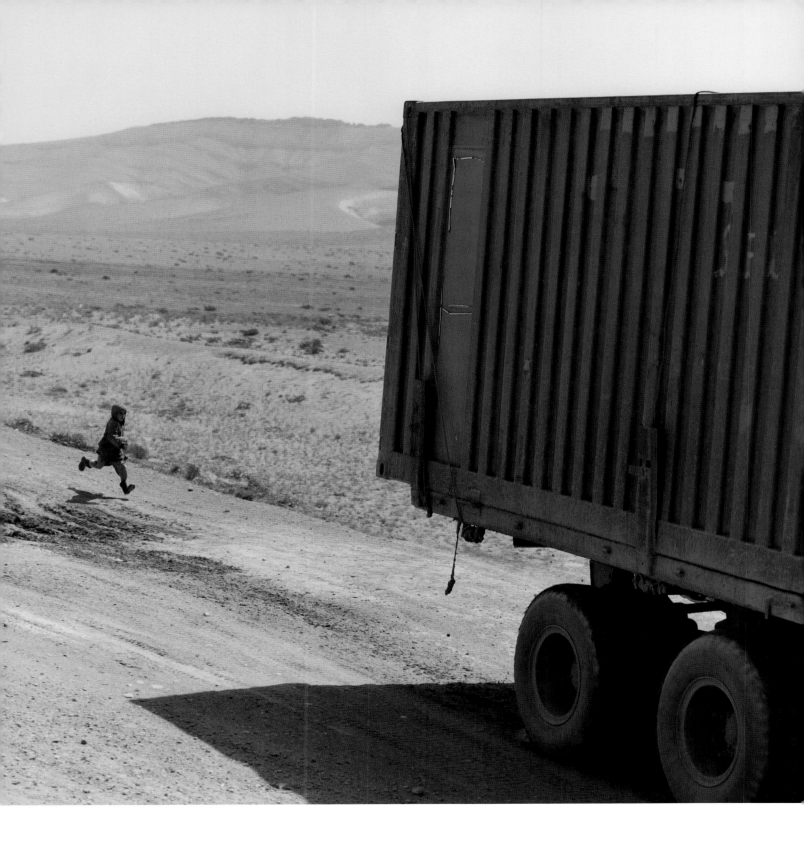

CERTAIN MOMENTS OF SURFACE CALM

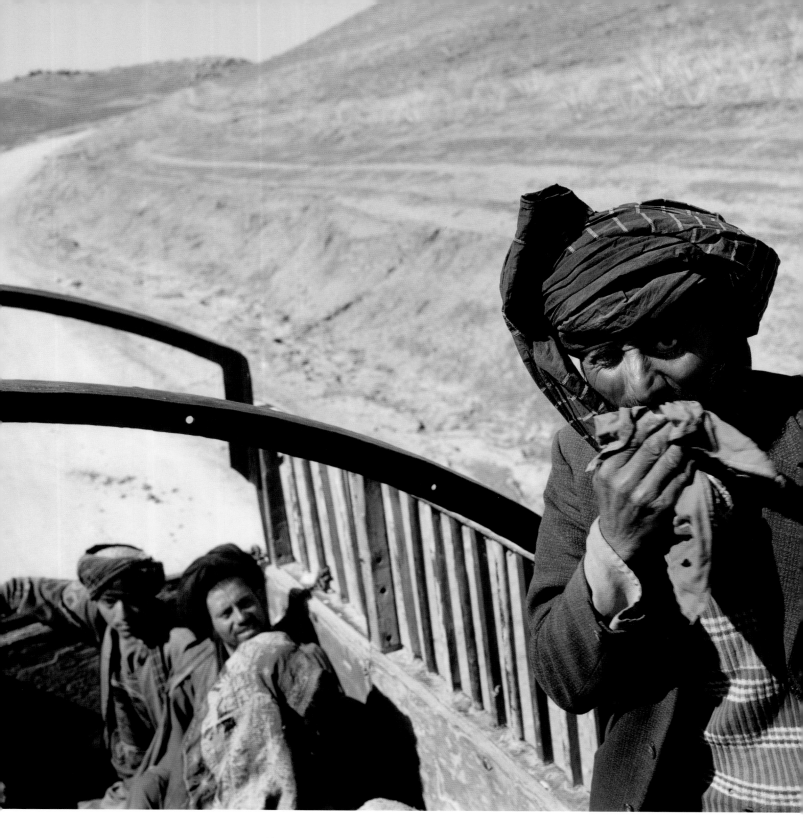

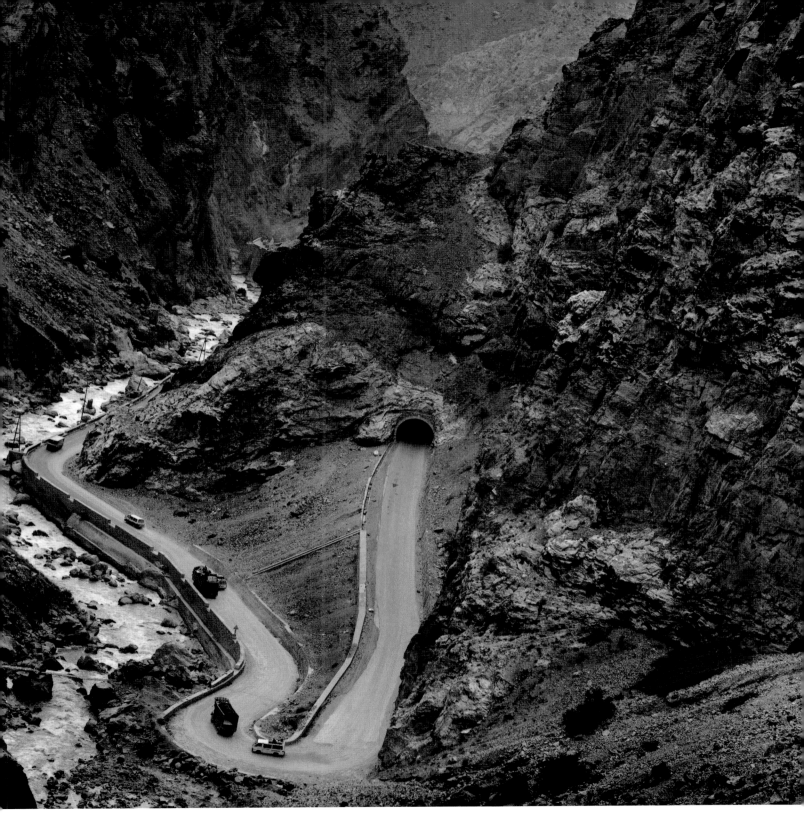

HIGHWAY TO KABUL | SORUBI GORGE | AFGHANISTAN 1998

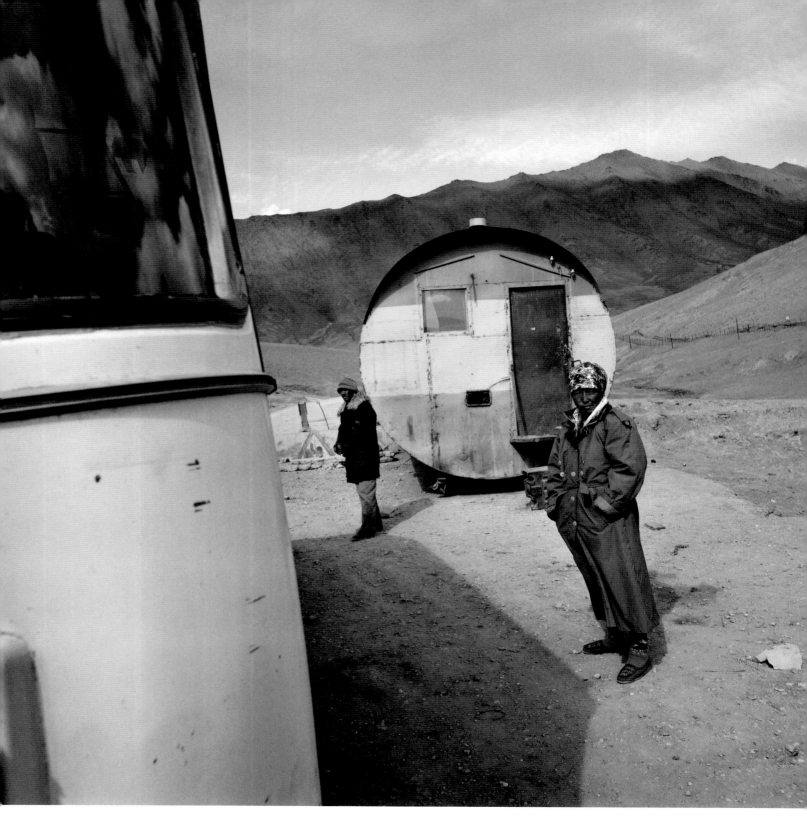

TAJIK–KYRGYZ BORDER | KYZYL-ART PASS | KYRGYZSTAN 2004

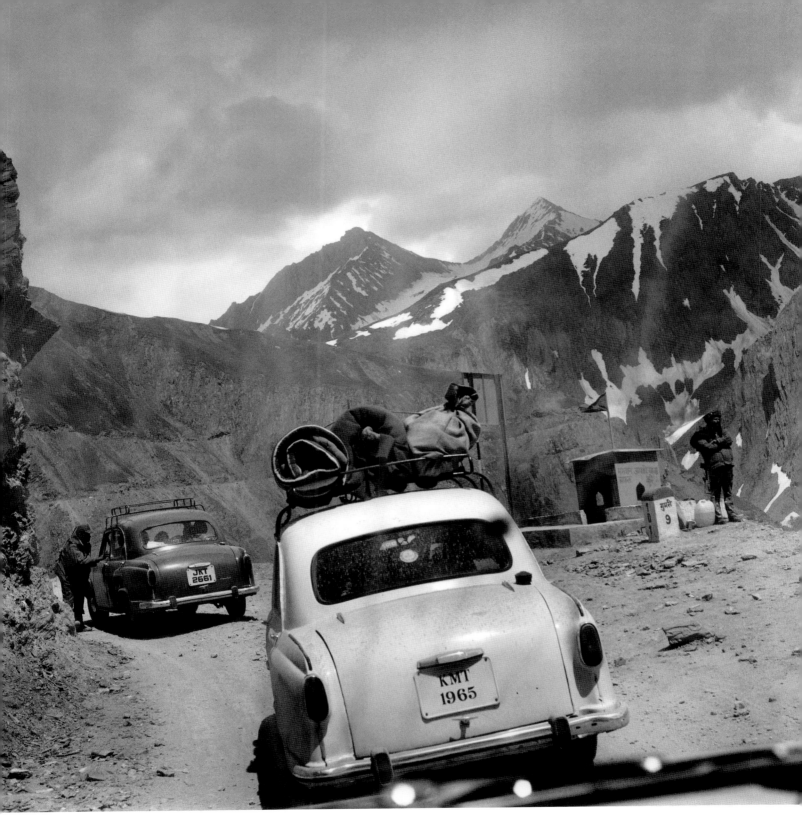

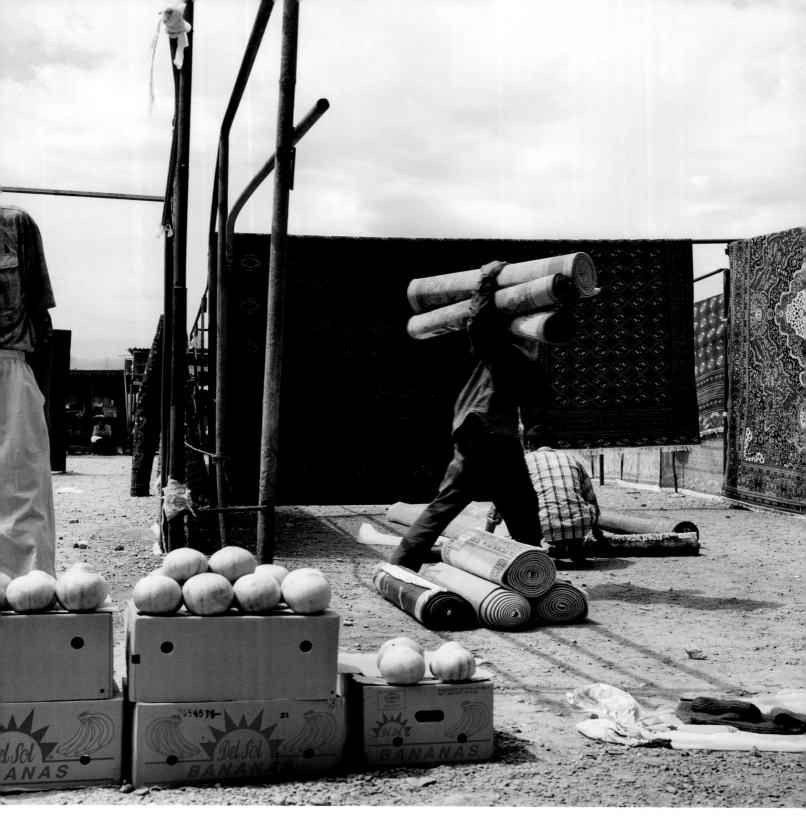

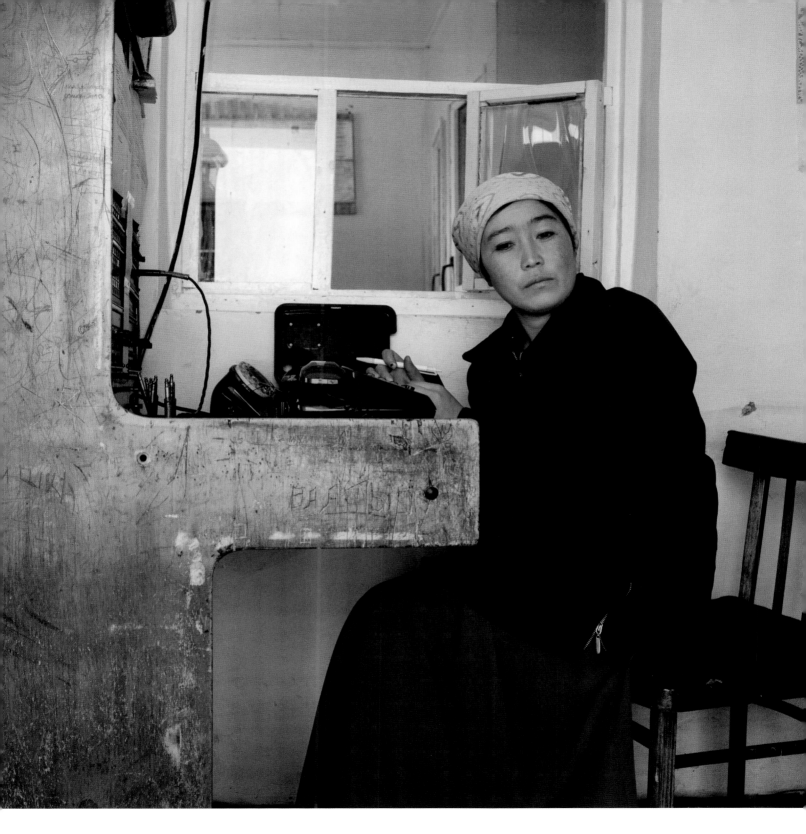

THE TELEPHONE OPERATOR | ALAI CORRIDOR | KYRGYZSTAN 2004

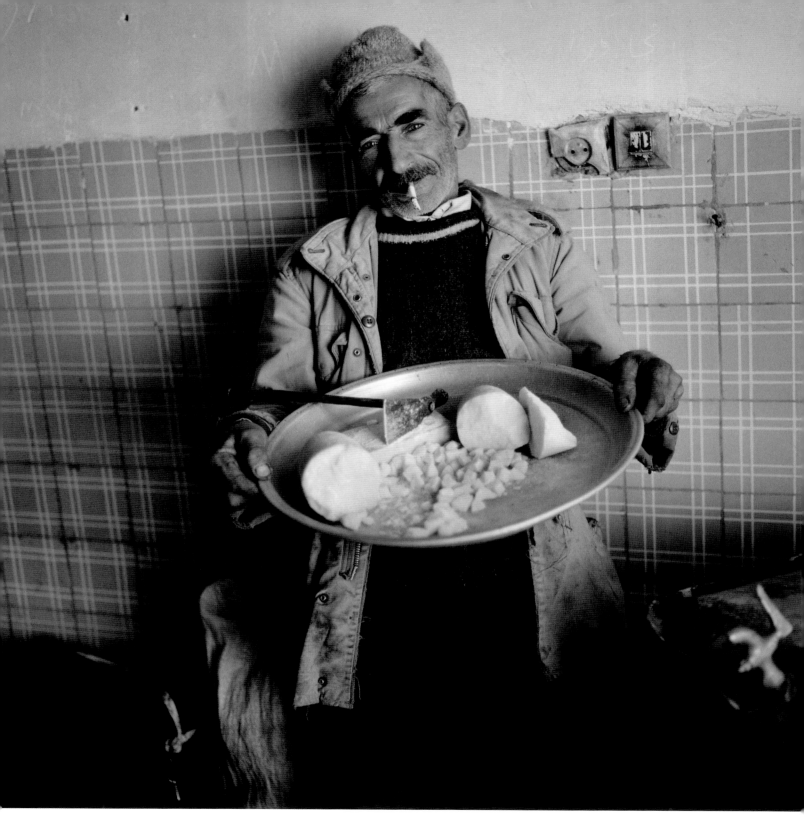

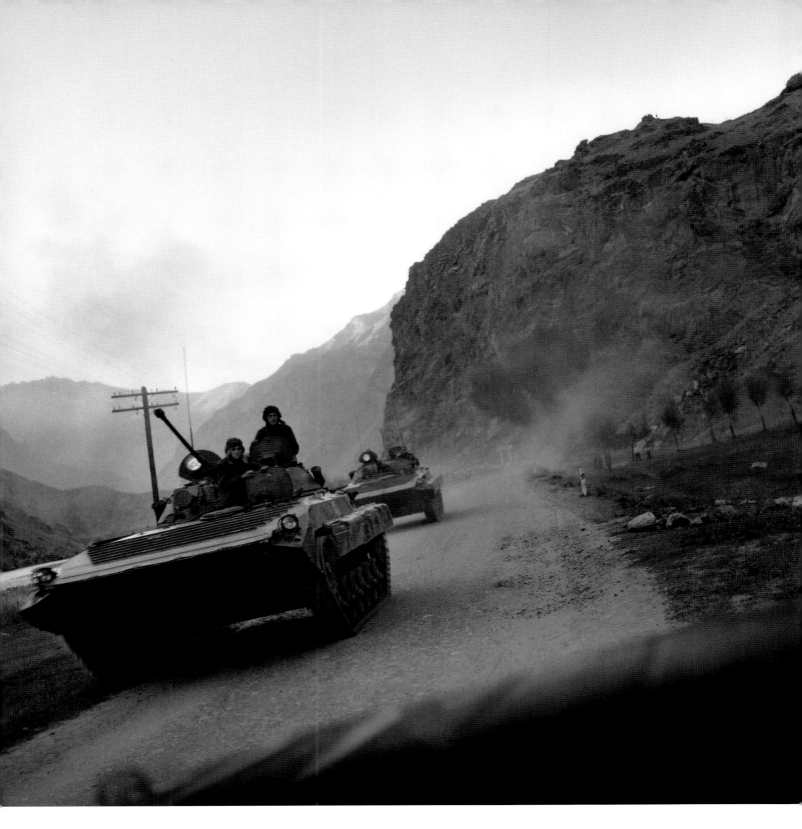

RUSSIAN CIS BORDER TROOPS | BADAKHSHAN | TAJIKISTAN 1996

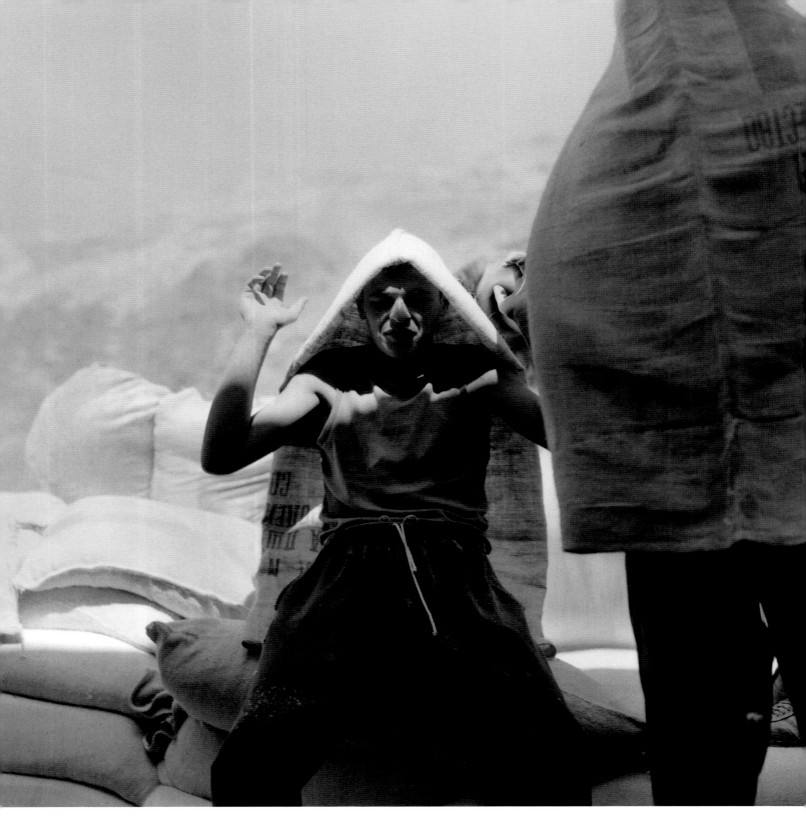

HUMANITARIAN AID | BADAKHSHAN | TAJIKISTAN 1996

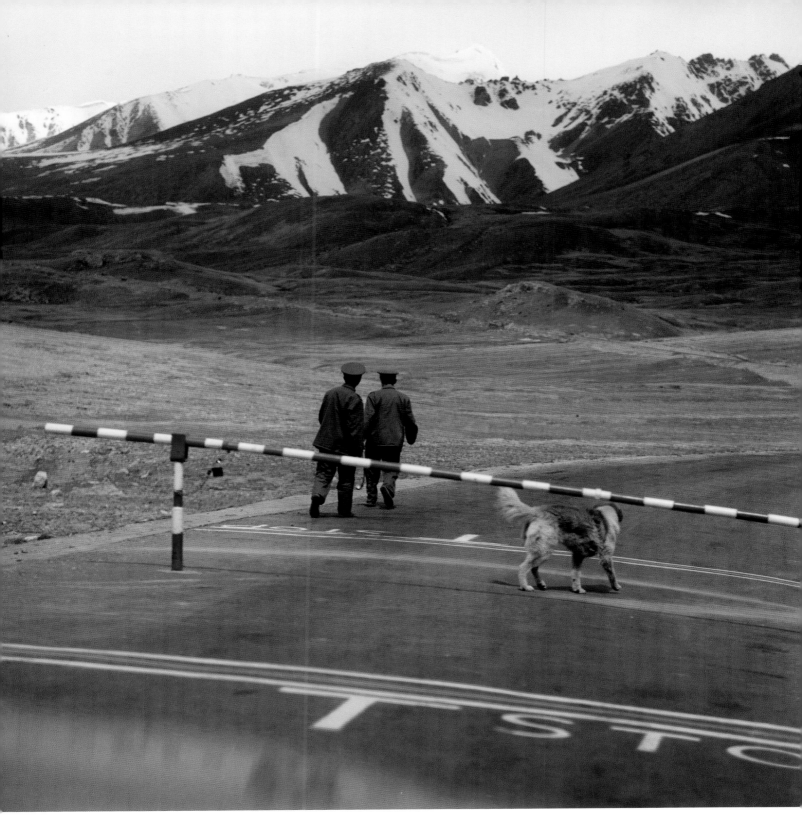

PLA BORDER GUARDS | KHUNJERAB PASS | KARAKORAM HIGHWAY | XINJIANG | CHINA 2001

ON AN ORDINARY DAY

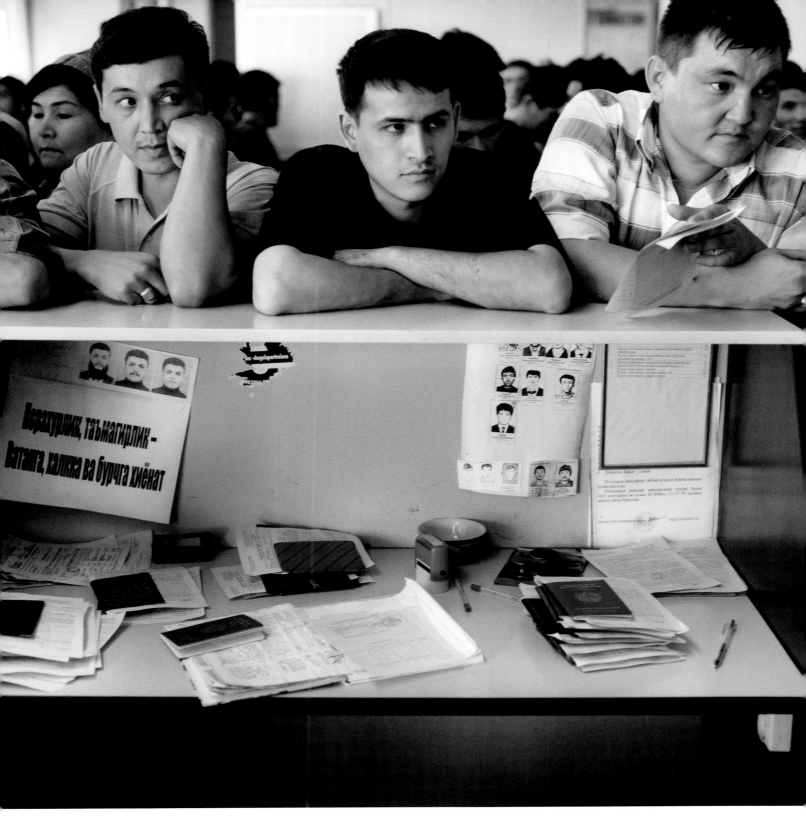

IMMIGRATION DESK | UZBEK–KAZAKH BORDER | TASHKENT | UZBEKISTAN 2002

SITES

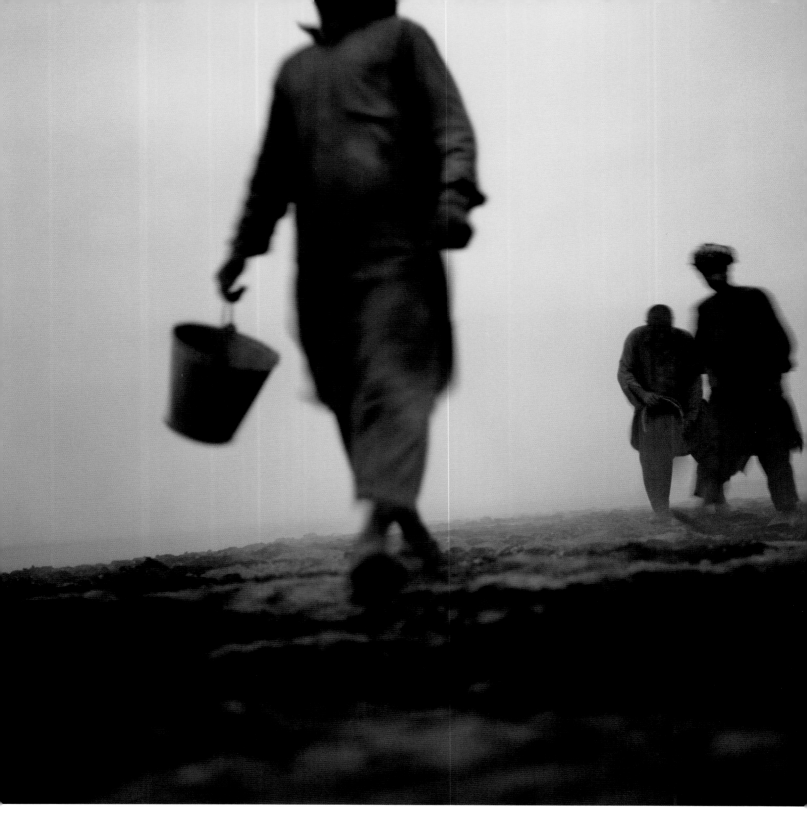

WORKING A KILN AT DAWN | BALKH | AFGHANISTAN 2002

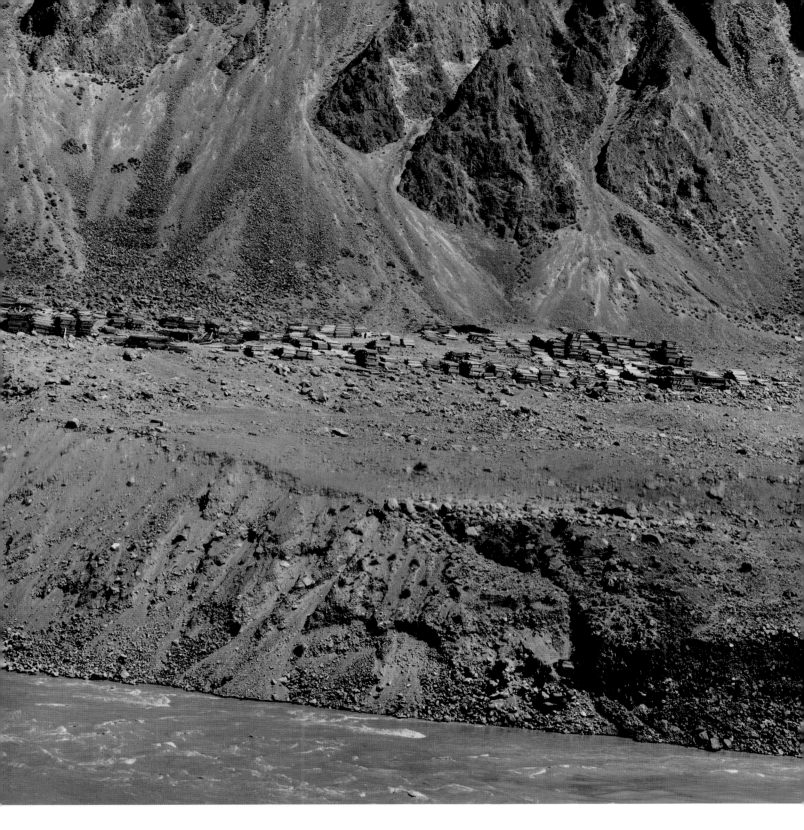

HEAT | UPPER INDUS VALLEY | PAKISTAN 2001

CITIES

BEGINNINGS IN FABLE AND FACT

PULSE FLUTTERING

FAMILIAR PERIODS OF DARKNESS

RIVERS CHANGING COURSE

VESTIGES SHIFTING AROUND MAPS LIKE FLIES ON TABLES

LAST PERSON DEPARTING

DESCENT INTO DESERT GRAVE

HUMPS IN THE PLAINS

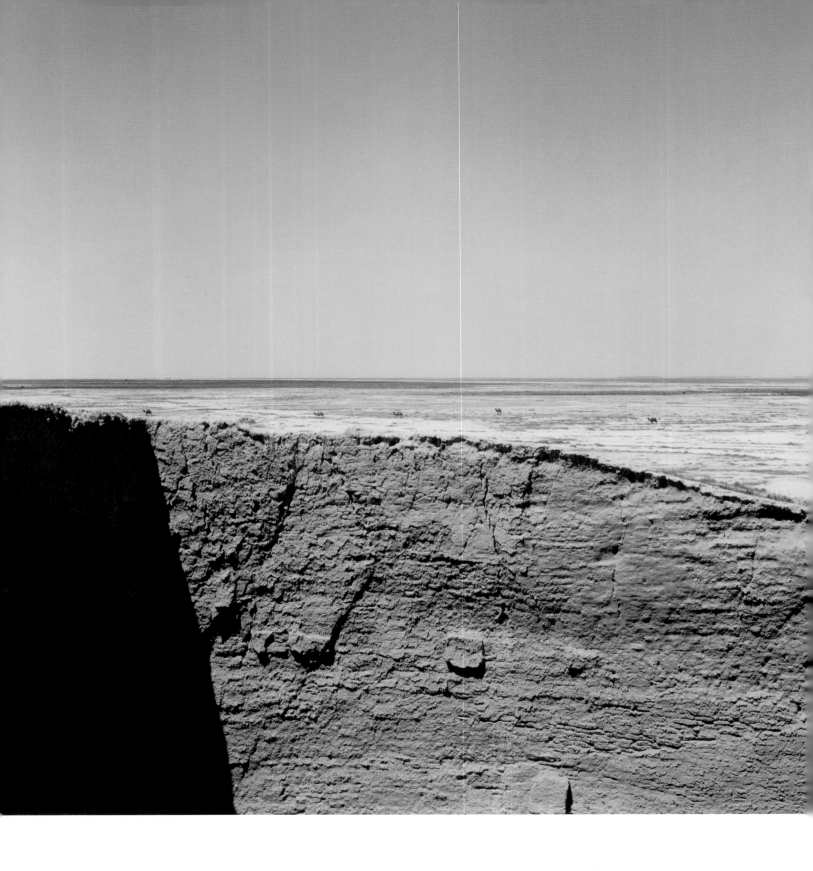

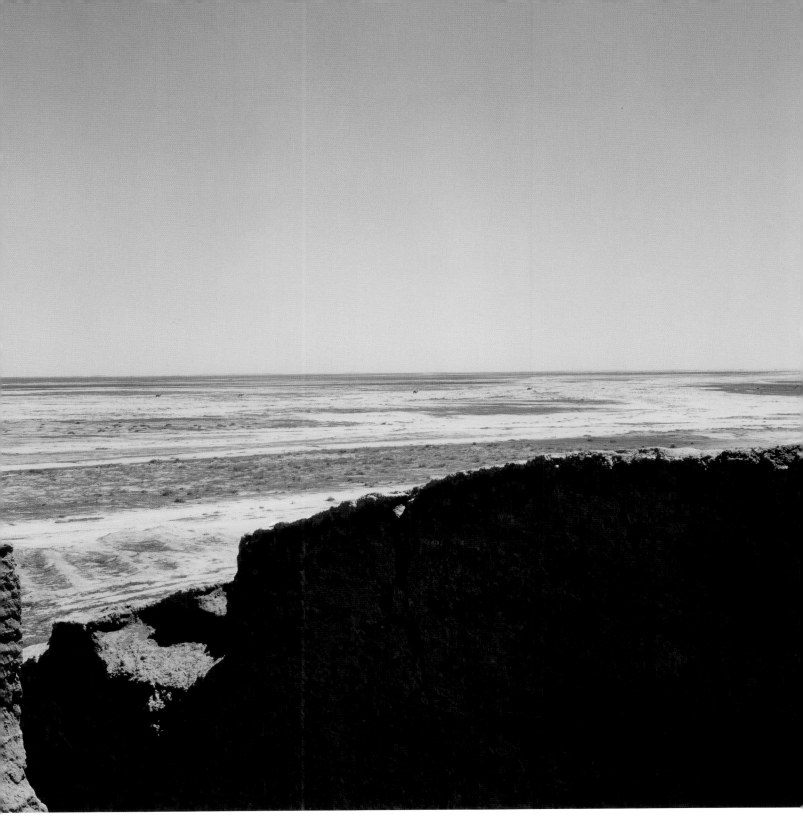

RUINS OF ARCHAIC DEHISTAN | MISIRIAN PLATEAU | TURKMENISTAN 2005

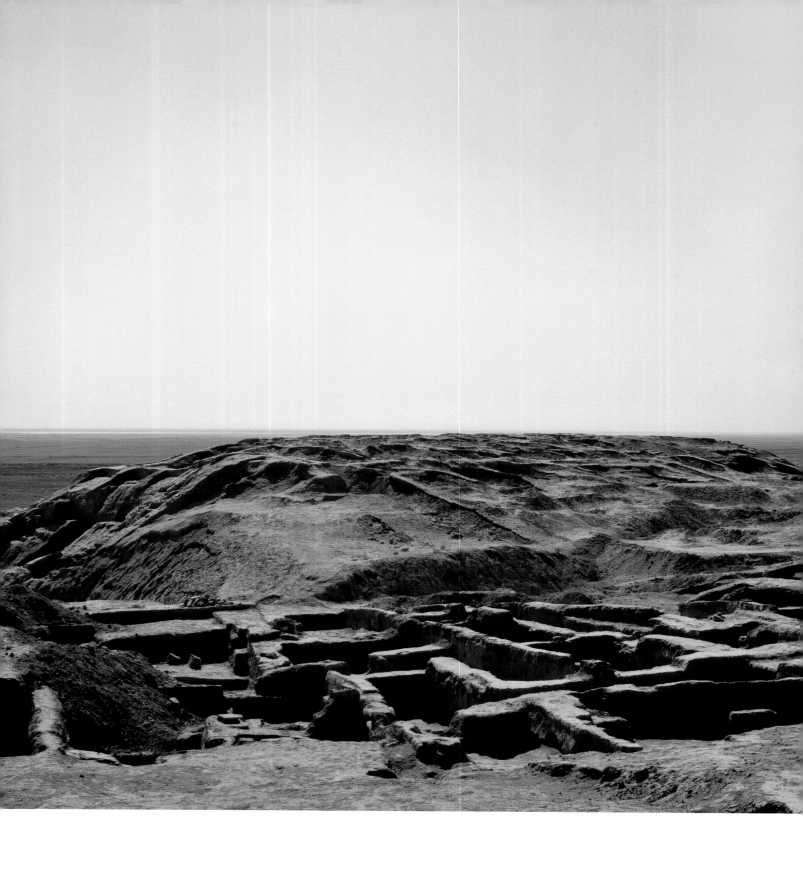

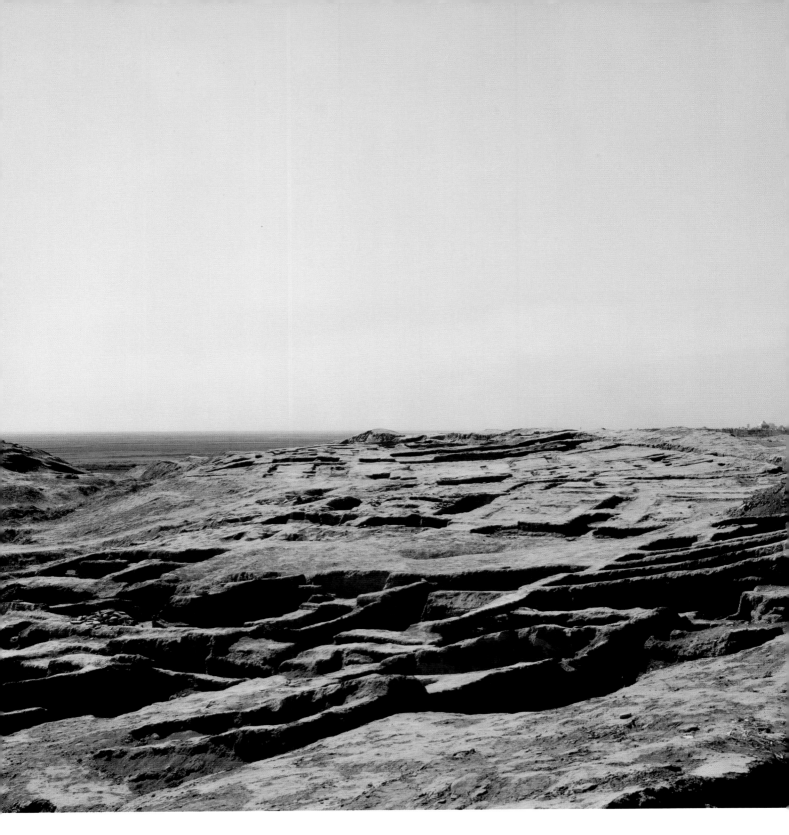

GRAECO-BACTRIAN RUINS OF KAMPYR TEPE | SUKHANDARYA | UZBEKISTAN 2002

TABLE
OF NOTEWORTHY ENTRIES TO RESTORE
A DEFECTIVE SENSE OF HISTORY

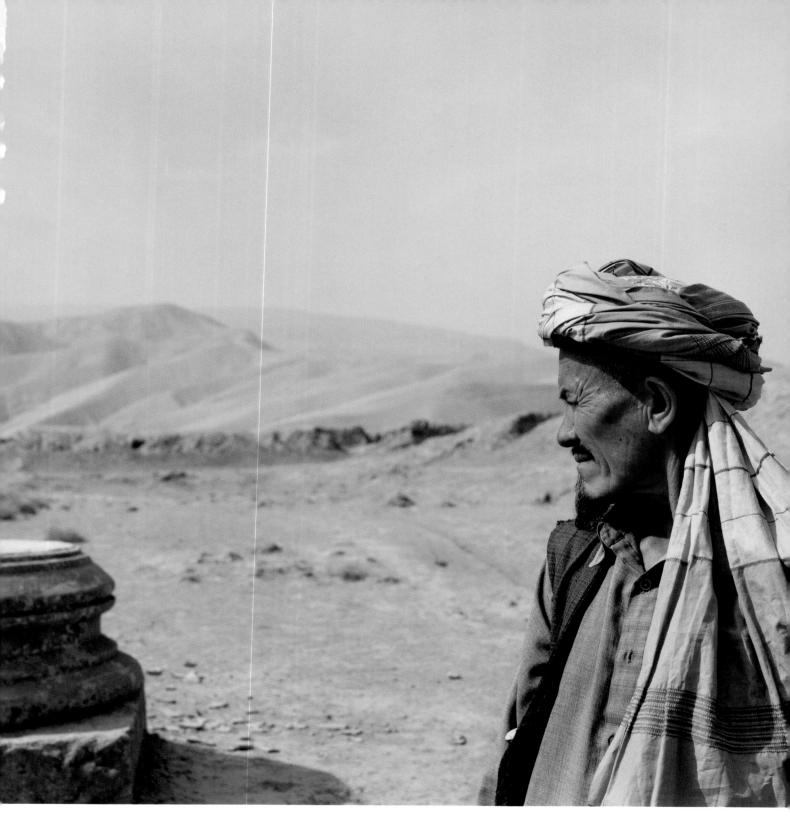

RUINS OF THE ACROPOLIS OF KUSHAN RULER KANISHKA I | SURKH KOTAL | AFGHANISTAN 2002

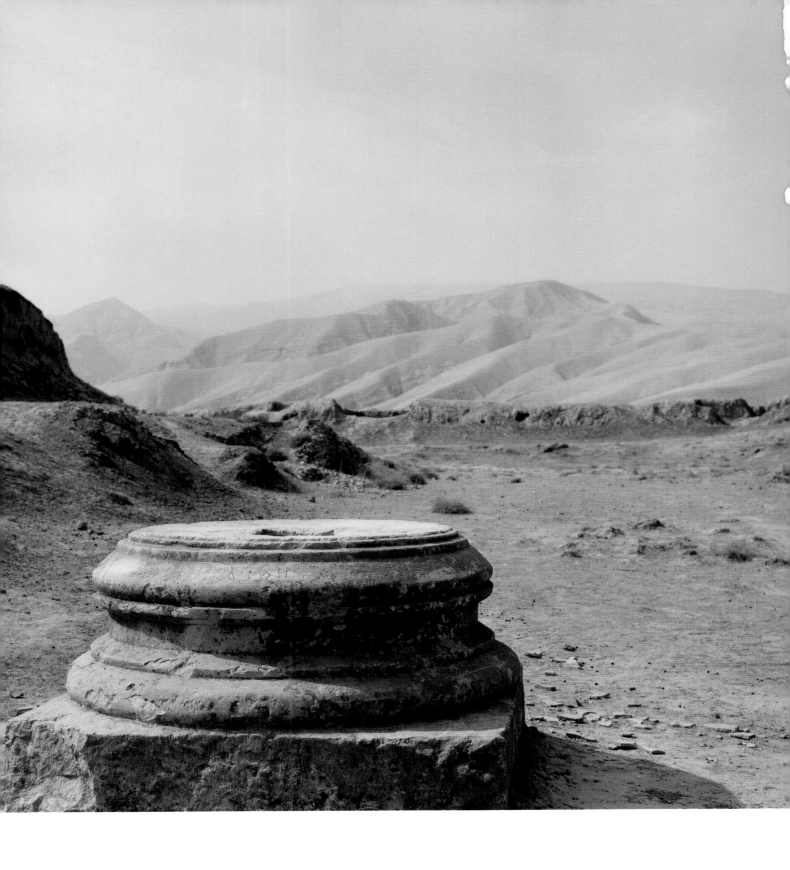

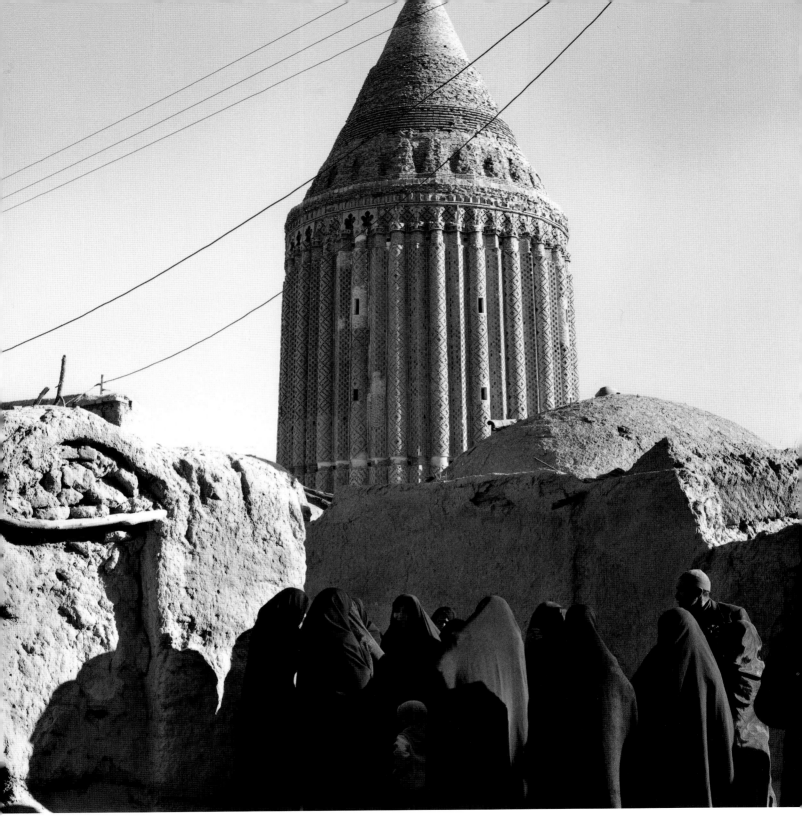

ZOROASTRIAN BURIAL TOWER | KASHMAR | IRAN 1995

TERRACES LEADING TO THE ACROPOLIS OF KUSHAN RULER KANISHKA I | SURKH KOTAL | AFGHANISTAN 2002

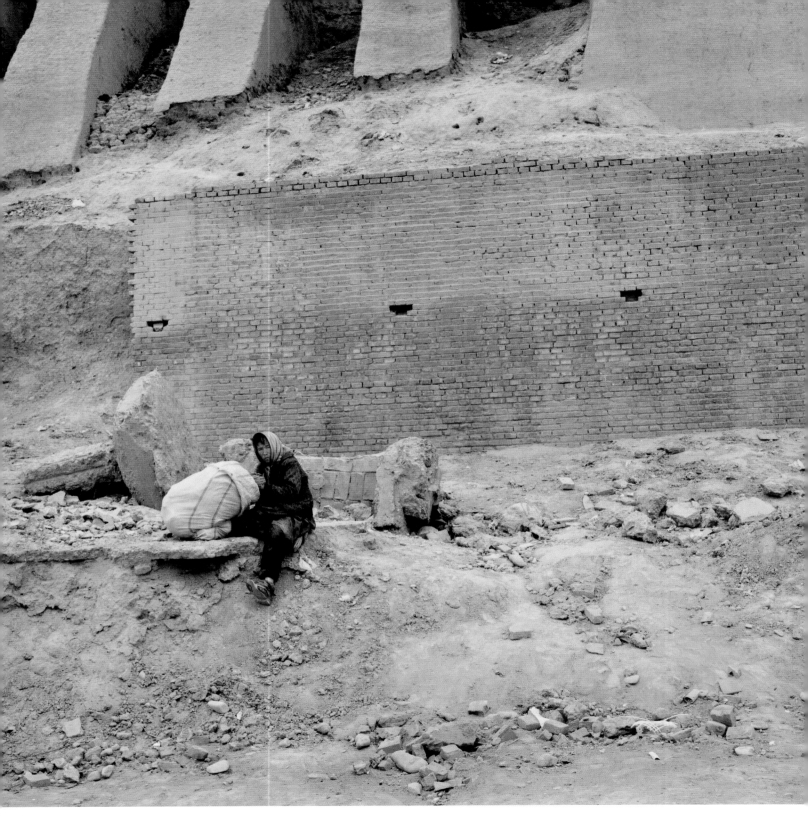

THE EXPELLED | KASHGAR | XINJIANG | CHINA 2004

POSSIBILITIES OF HISTORY

ALTAR OF FIRE TURNED INTO ARTILLERY BASE

CITY WALLS TURNED INTO PARKING LOTS

LIKE IN A BAZAAR THE PRESENT IS RICH WITH WHISPERS AND RUMOURS

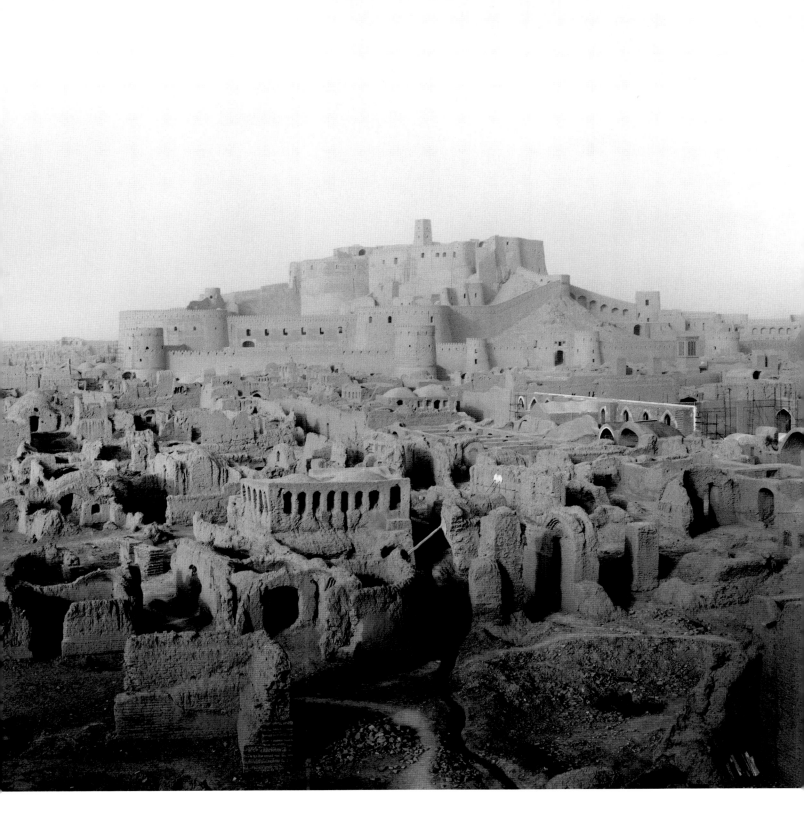

SASANID AND SELJUK RUINS OF BAM | IRAN 1995

DOWNTOWN KASHGAR | XINJIANG | CHINA 2004

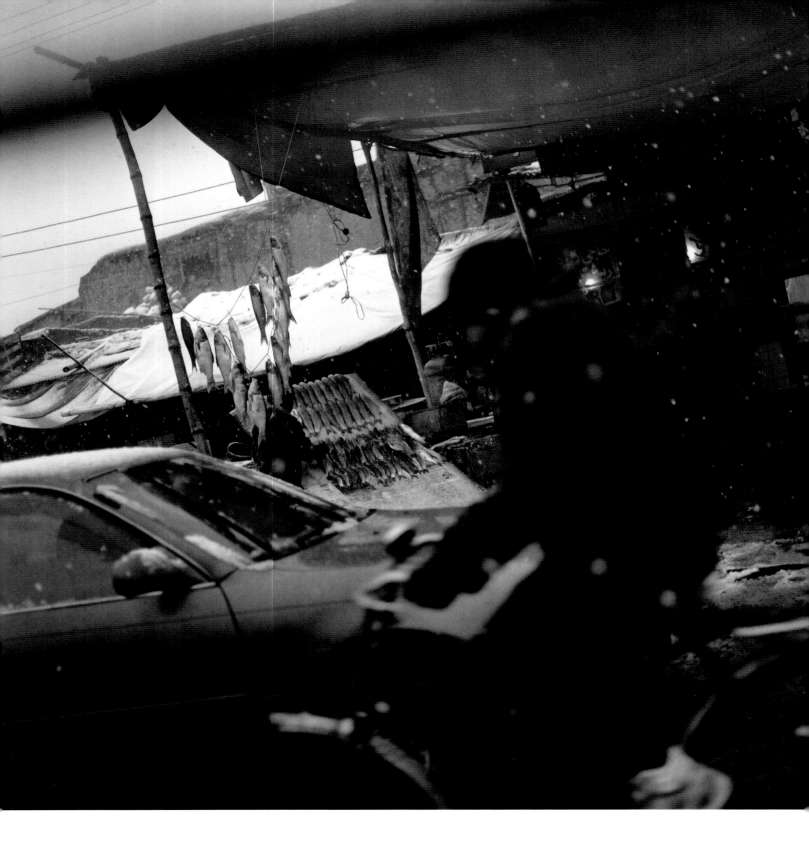

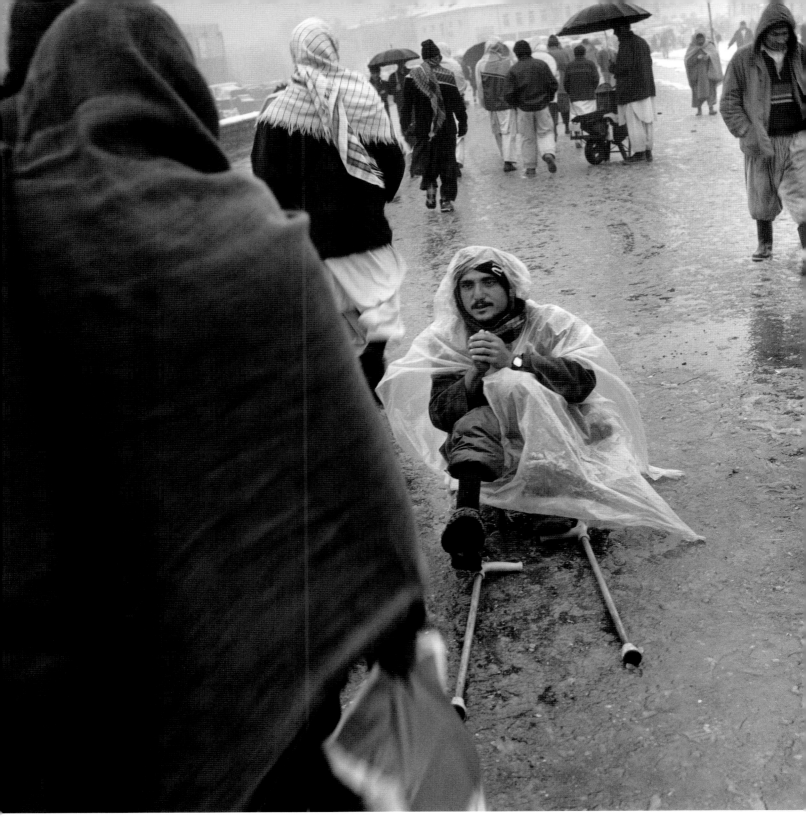

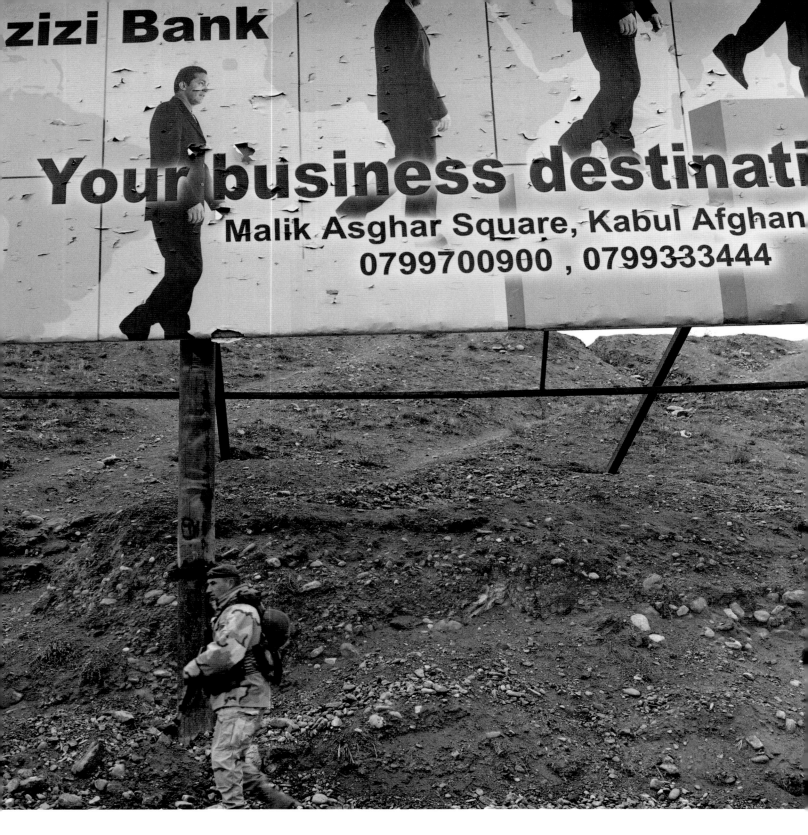

Your business destinati...

zizi Bank
Malik Asghar Square, Kabul Afghan...
0799700900 , 0799333444

OBVIOUS EFFORTS AT A TIME OF WAR | KABUL | AFGHANISTAN 2006

ON AN ORDINARY DAY

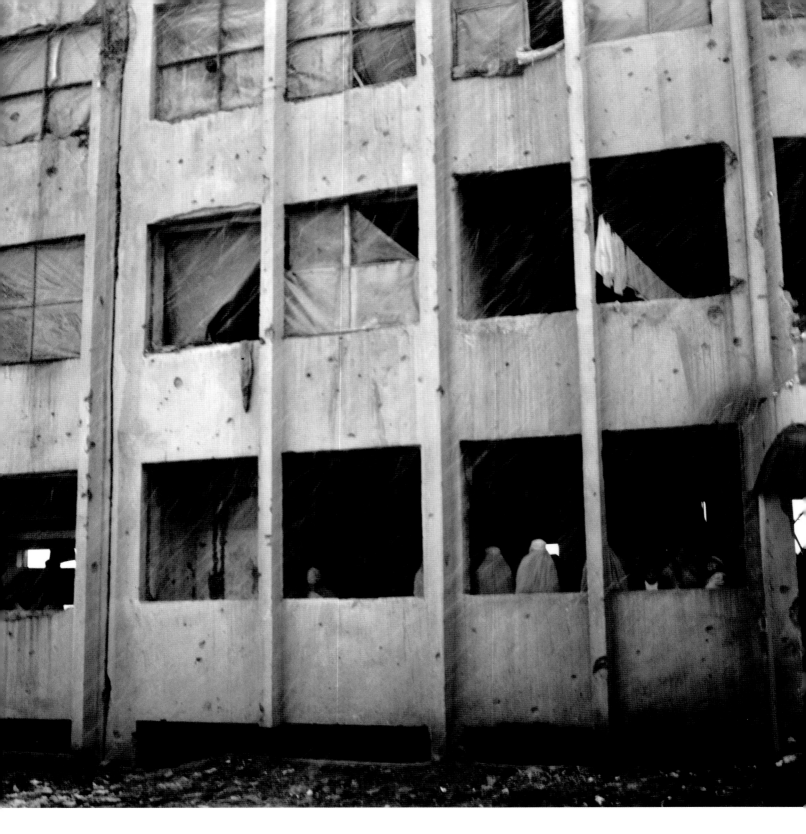

SHELTER FOR RETURNEES FROM PAKISTAN | KABUL | AFGHANISTAN 2006

HOW THE RHUBARB CAME TO AFGHANISTAN IS NOT CLEAR

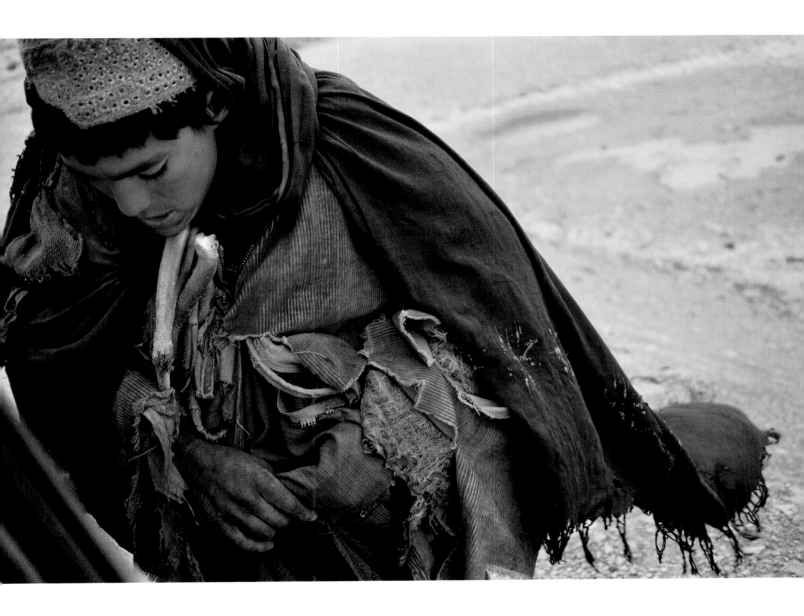

162

GATES AND BARRIERS

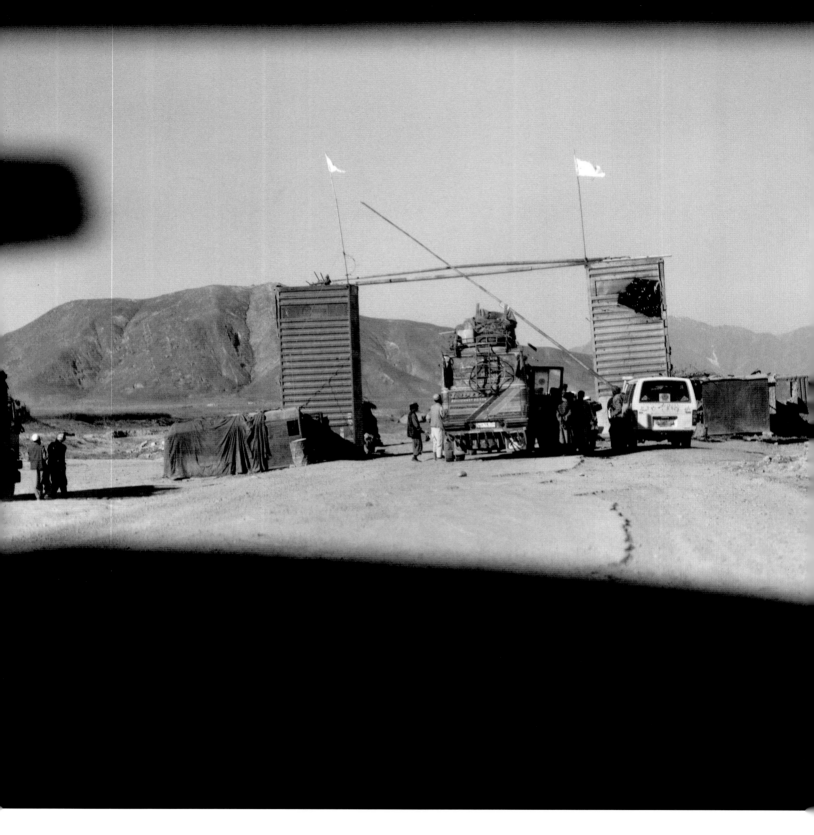

TALIBAN CHECKPOINT EN ROUTE TO GHAZNI | AFGHANISTAN 1998

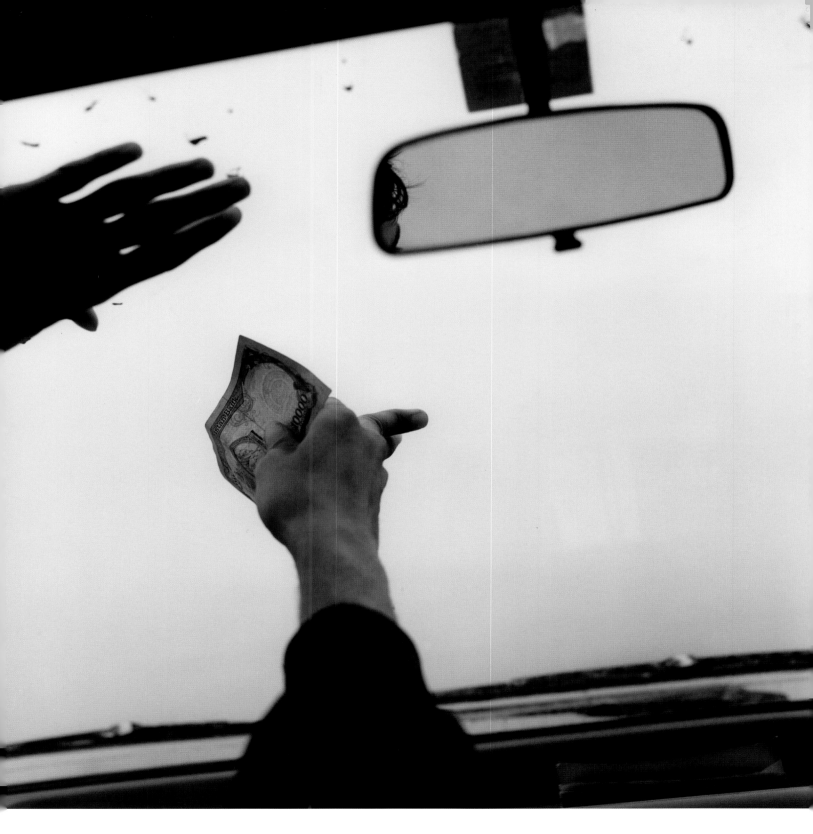

SANDSTORM NEAR LASHKARGAH | AFGHANISTAN 2001

STONE TOWER

ROADSIDE TRADING STATION ON THE SILK ROADS MIDWAY BETWEEN SYRIA AND CHINA

ROUTE OF EARLIEST ENCOUNTERS BETWEEN EASTERN AND WESTERN ASIA

LITHINOS PYRGOS

TURRIS LAPIDEA

BURJ AL-HIJARA

TASH QURGHAN

FOR [MARINOS OF TYRE] SAYS THAT AS ONE ASCENDS THE GORGE THE STONE TOWER COMES NEXT

PTOLEMY (ABOUT 150 CE)

THE BASE OF THOSE WHO TRADE INTO SERES AT THE IMAOS RANGE

AUREL STEIN (JULY–AUGUST 1915)

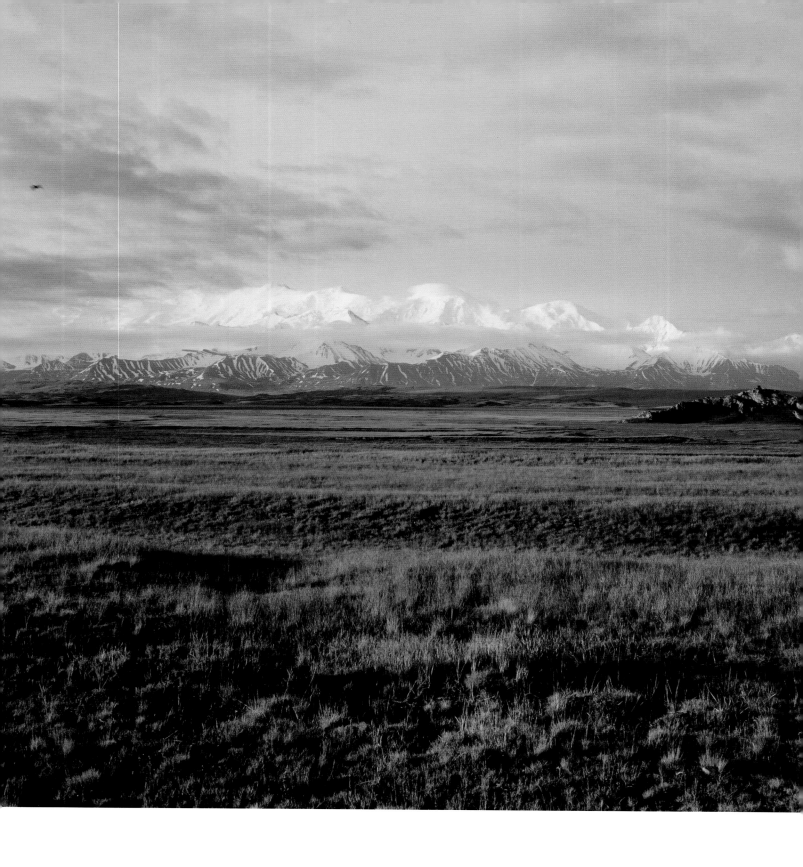

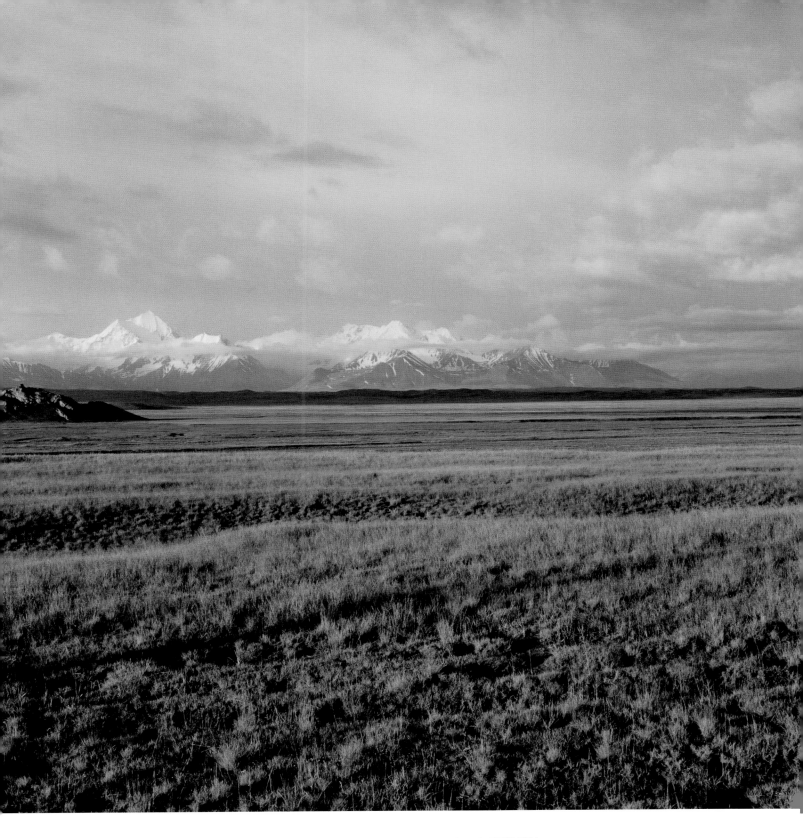

PAMIR MOUNTAINS IN TAJIKISTAN | ALAI CORRIDOR | KYRGYZSTAN 2004

SOME STONES FROM THE STONE TOWER

REMOVED FROM OLD GRAVES

SOME STONES FROM THE STONE TOWER

HEAPED ONTO NEW GRAVES

OLD GRAVES | ALAI CORRIDOR | KYRGYZSTAN 2004

NEXUS

CORRIDORS OF GEOGRAPHY

CULTURES IN CONTACT

SILK ROAD PHENOMENON

GLOBAL HEARTLAND OF DIFFUSION AND CONVERGENCE

VECTORS OF SPATIAL DISSEMINATION

INTERLOCKING HISTORIES

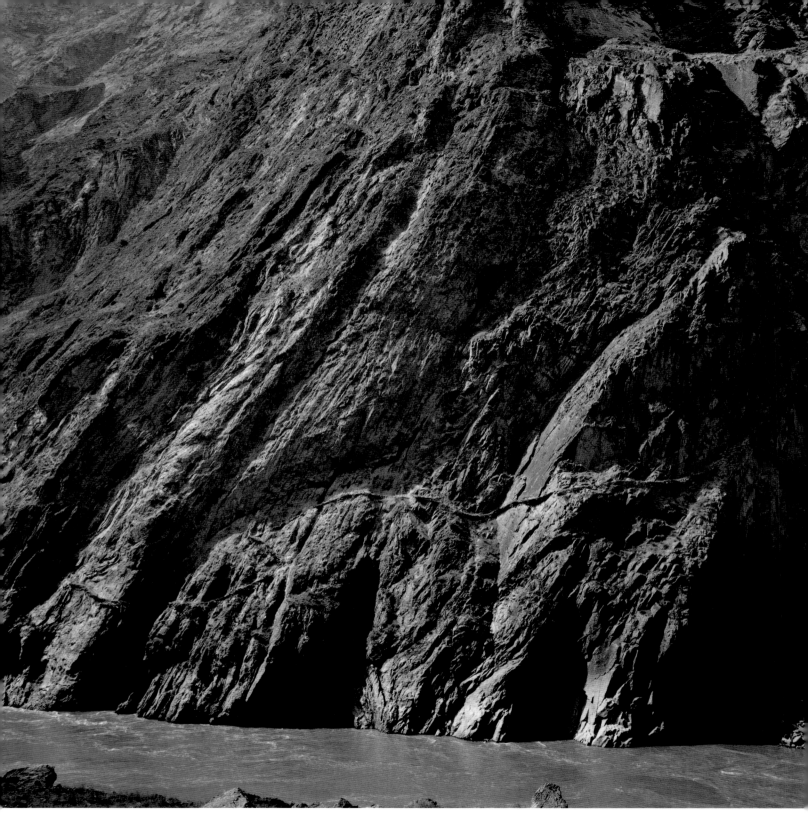

ANCIENT AFGHAN TRACK | WAKHAN CORRIDOR | TAJIKISTAN 1996

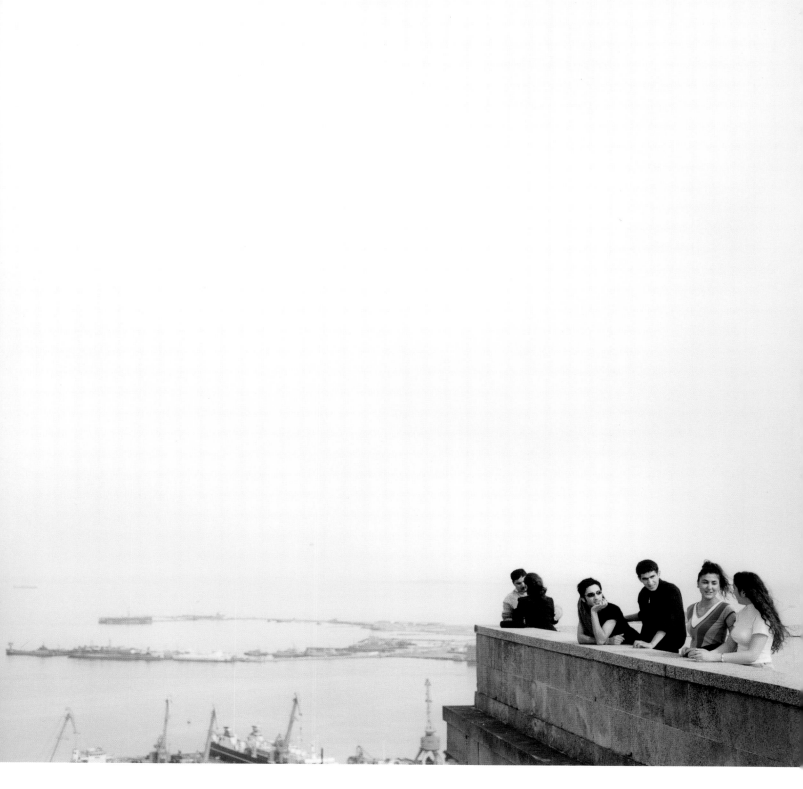

VIEW ACROSS THE CASPIAN SEA | BAKU | AZERBAIJAN 2005

DSUNGAR DARBAZASI DZUNGARSKIYE VORODA DSUNGARIAN GATE

NATURAL THOROUGHFARE BETWEEN TIAN SHAN AND ALTAI. CONNECTING THE CHINESE DSUNGAR BASIN AND THE KAZAKH STEPPE. WARM WINDS FROM THE EASTERN APPROACHES OF THE GATE MELTING GROUND SNOWS IN WINTER. GATE USED BY CAUCASOID PEOPLES VENTURING INTO THE TARIM BASIN DURING BRONZE AND IRON AGES. MEETING OF ANDRONOVO AND AFANASEVO CULTURES INITIATING GLOBALIZATION. FOUR THOUSAND YEARS LATER: SALINIZATION OF LAKE EBINOR ON THE CHINESE SIDE OF THE GATE. ON THE KAZAKH SIDE EROSION OF THE BANK OF LAKE ALAKOL EXPOSING MONGOLIAN BURIAL MOUNDS. VILLAGERS AND ENGINE DRIVERS CO-OPERATING IN FREIGHT TRAIN ROBBERIES. CHILDREN IN A DYING VILLAGE KILLING FROGS WITH STONES

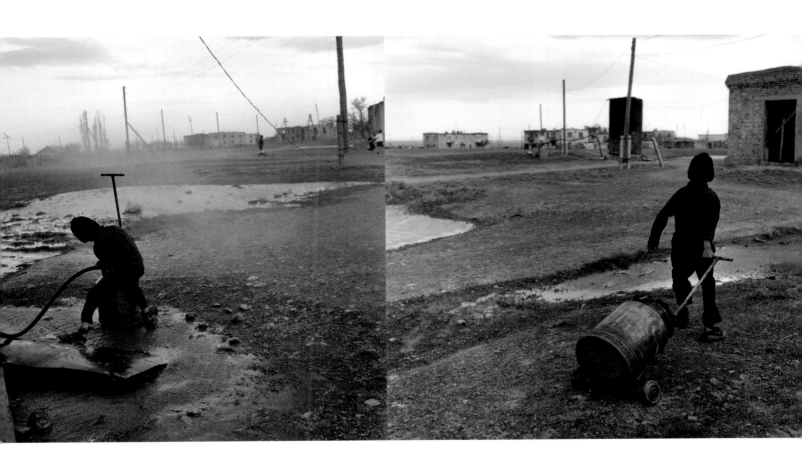

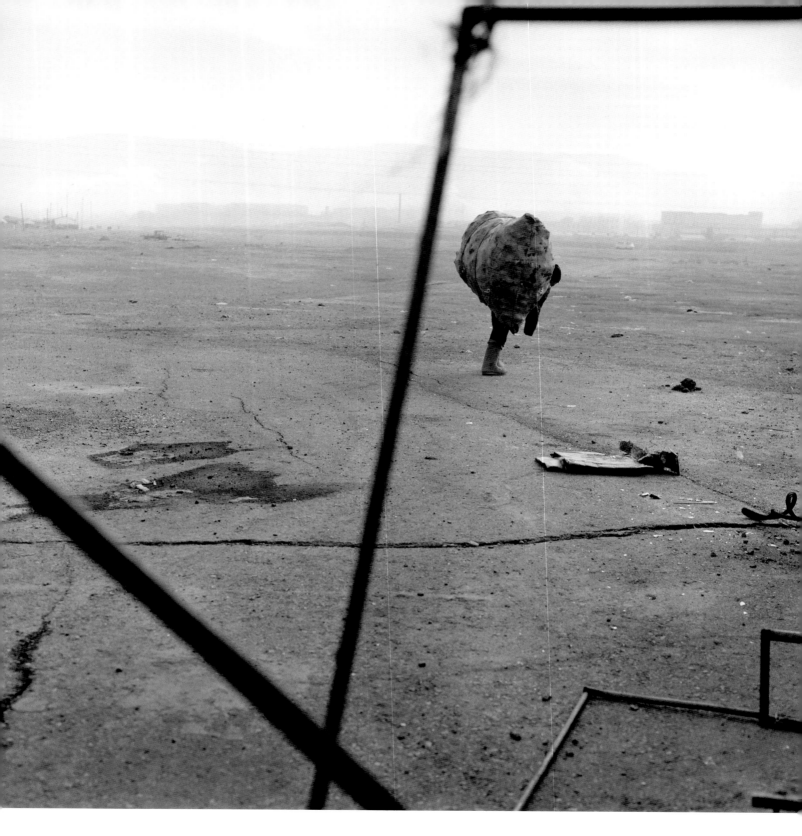

THE GARBAGE COLLECTOR | ULAANBAATAR | MONGOLIA 2000

ON AN ORDINARY DAY

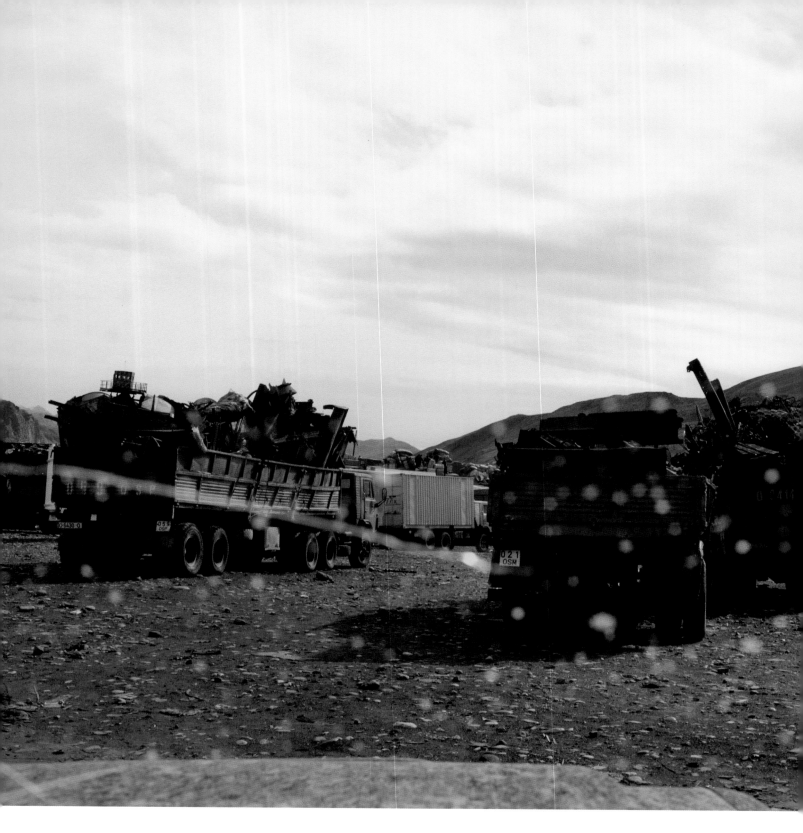

CENTRAL ASIAN SCRAP METAL AT THE GATEWAY TO CHINA | IRKESHTAM | KYRGYZSTAN 2004

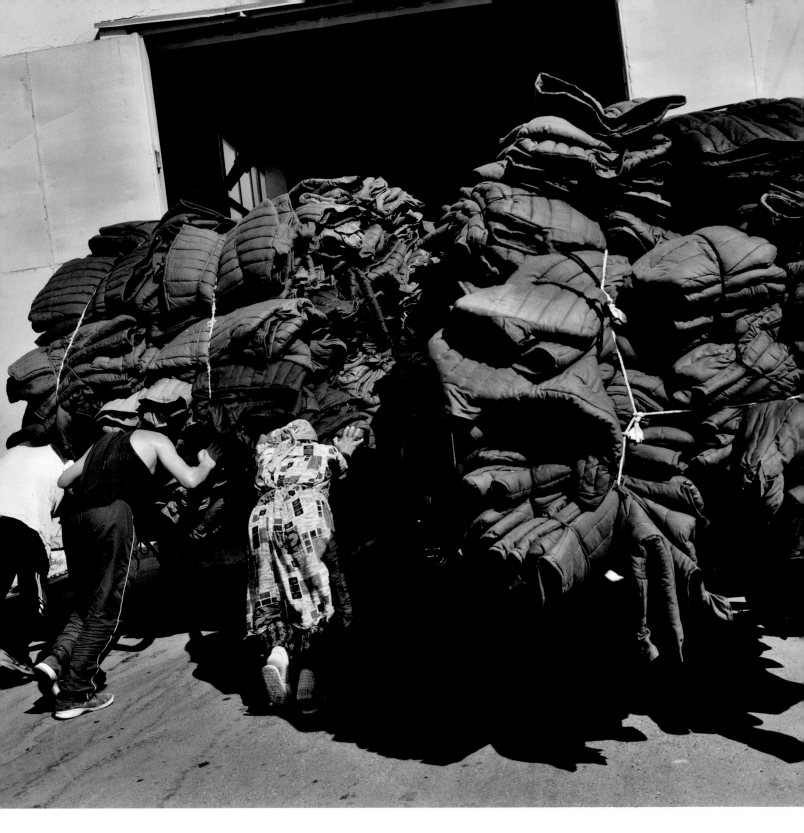

186

IRON GATE

GRAECO–BACTRIAN FRONTIER WALL

CROSSROADS BETWEEN TARTARY AND PERSIA CROSSROADS BETWEEN INDIA AND TRANSOXIANA

QAHLUGHA JELEZNIYE VOROTA TEMIR DARVOZA

ALEXANDER THE GREAT

KING OF MACEDONIA DURING THE SIEGE OF THE FORTRESS OF THE SOGDIAN RULER SISIMITHRES

328 BCE

XUAN ZANG

CHINESE PILGRIM TRAVELLING TO THE SOURCES OF BUDDHIST TEACHINGS IN INDIA

630–631 CE

CHANG CHUN

CHINESE TAOIST MONK TRAVELLING AT THE SUMMONS OF GENGHIS KHAN TO THE CAMP OF THE CONQUEROR IN THE HINDU KUSH

FEBRUARY 1222

RUY GONZALEZ DE CLAVIJO

AMBASSADOR TO THE COURT OF TIMUR IN SAMARQAND DISPATCHED BY KING HENRY III OF CASTILE AND LEON

AUGUST 1404

SOVIET RED ARMY

INVADING AFGHANISTAN

DECEMBER 1979

SOVIET RED ARMY

RETREATING FROM AFGHANISTAN

FEBRUARY 1989

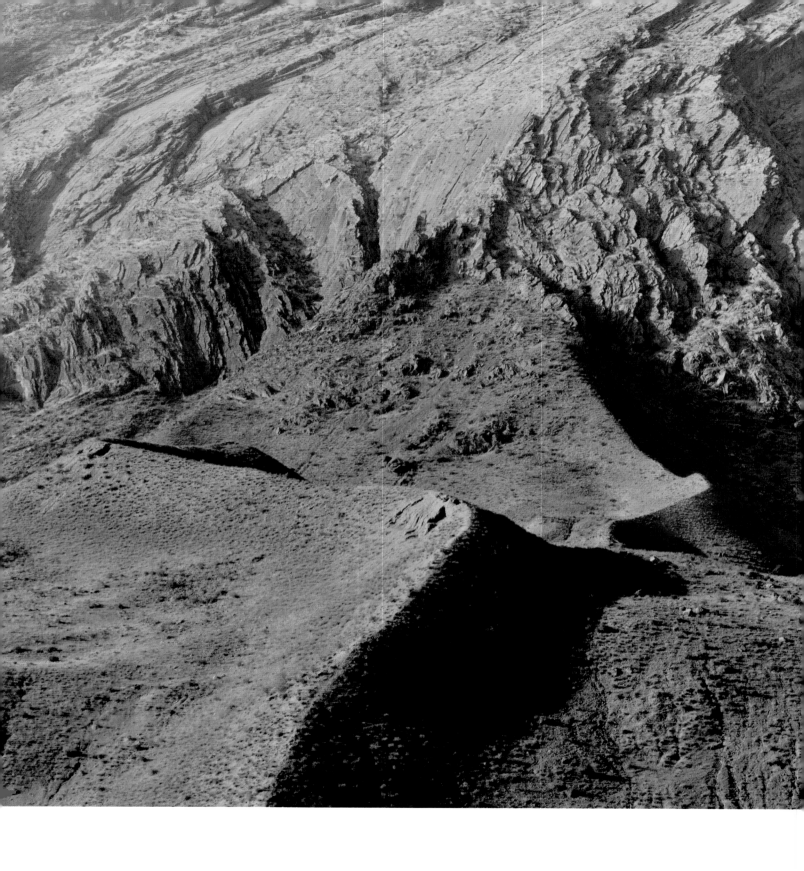

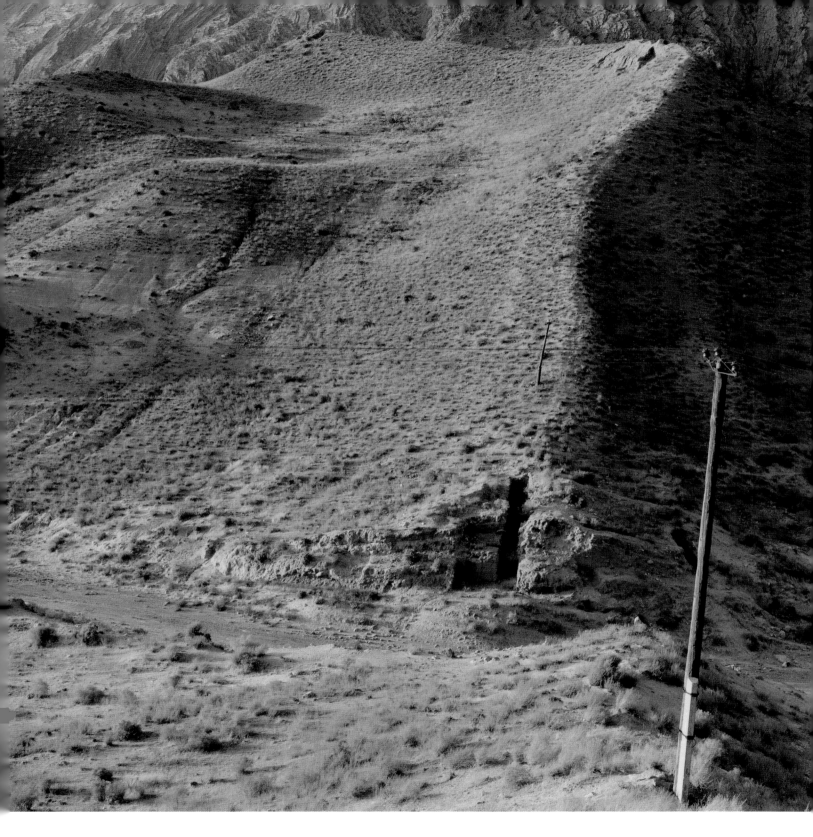

GRAECO-BACTRIAN BORDER WALL | IRON GATE | UZBEKISTAN 2002

190

ADMINISTRATIVE DEMARCATIONS

ARBITRARY CONFINES

BARRIERS

BOUNDARIES OF THE CULTIVATED AREAS

COLONIAL FRONTIERS

CONTENTIOUS BORDERS

EASTERN VASTNESS

EXTERNAL BOUNDARIES

FORTIFIED LINES

GEOGRAPHICAL INCURSIONS

HOMELAND BORDERS

IMAGINARY BORDERS OF THE SEVEN CLIMES

IRRATIONAL LANDSCAPES

LATITUDINAL BORDERS

LINE OF CONTROL

LONGITUDINAL BORDERS

MARGINS OF THE KNOWN WORLD

NATIONAL FRONTIERS

NATURAL LIMITS

NEW FRONTIER

SETTLEMENT FRONTIERS

SURROUNDING SEA

WESTERN REGIONS

WILDERNESS

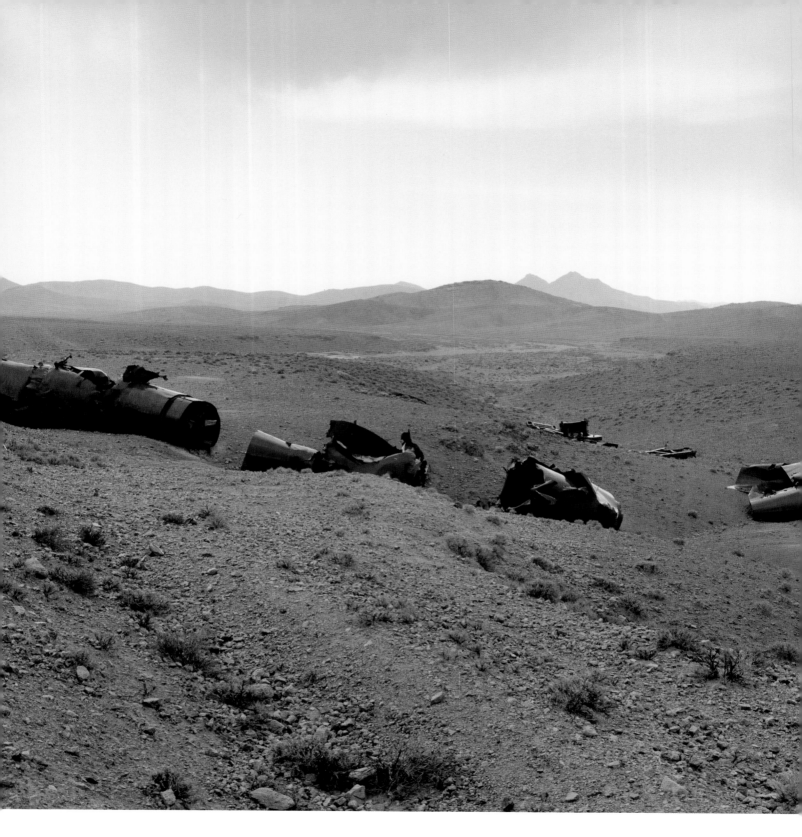

REMAINS OF AMBUSHED RED ARMY FUEL CONVOY | FARAH | AFGHANISTAN 2001

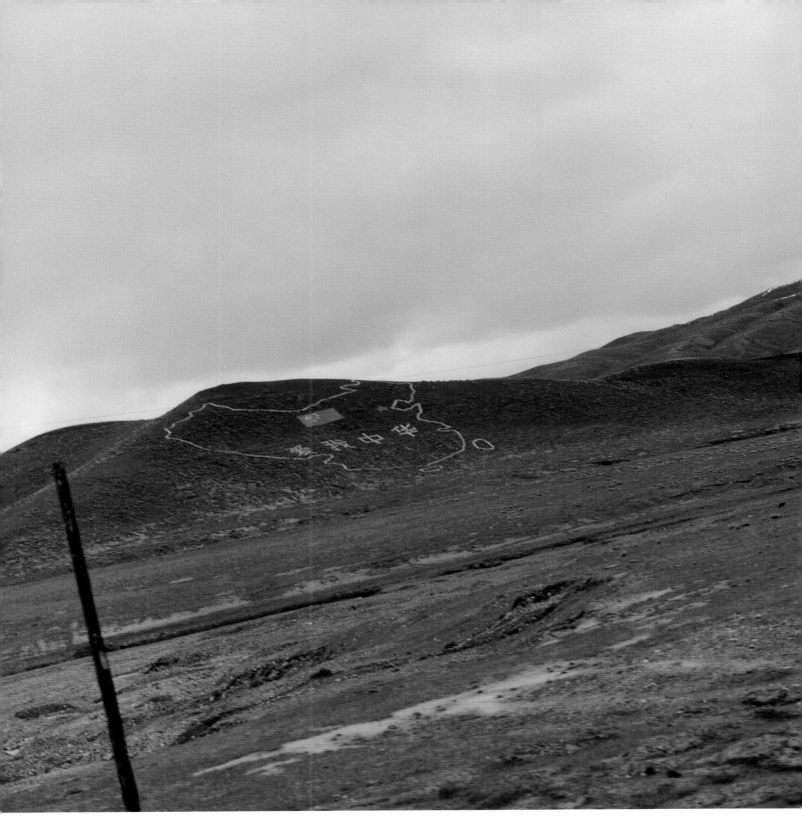

MAP OF THE PEOPLE'S REPUBLIC | KYRGYZ BORDERLAND | XINJIANG | CHINA 2004

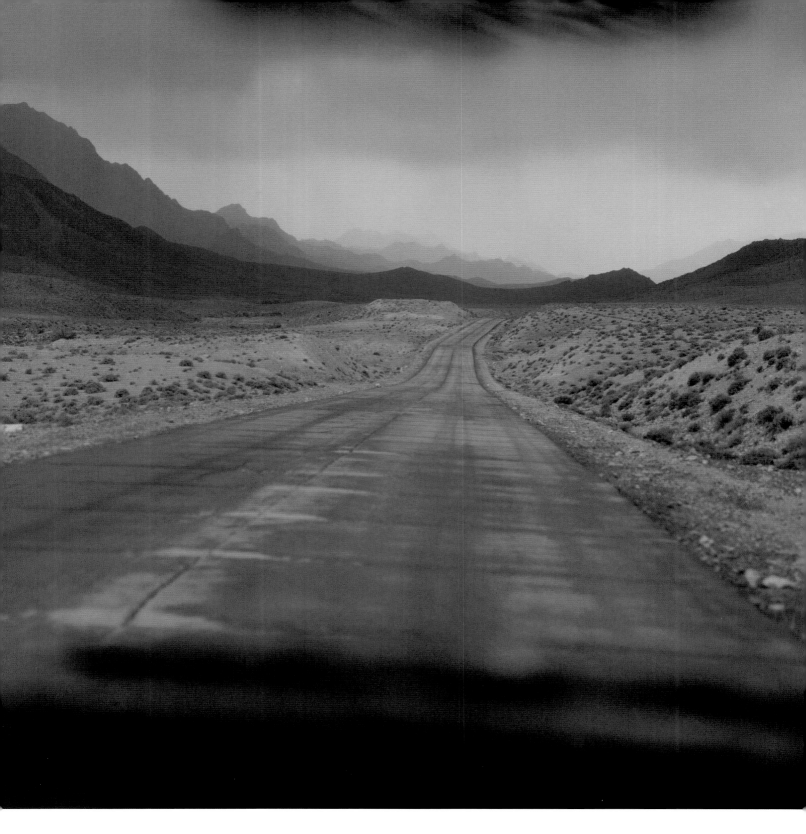

JOURNEY ALONG A COLD WAR ROAD

A ROAD PRESENTED BY THE SOVIET POLITBURO TO THE KING OF AFGHANISTAN

TO SERVE PEACEFUL ECONOMIC DEVELOPMENT

TO COUNTERBALANCE AMERICAN ENCIRCLEMENT IN THE SOUTH

BUILT 250 YEARS AFTER THE TSAR'S FIRST DREAMS ABOUT THE INDIAN OCEAN

BUILT 20 YEARS BEFORE THE SOVIET INVASION OF AFGHANISTAN

BRIDGES AND CONCRETE BUILT TO CARRY THE WEIGHT OF T-55 AND T-59 BATTLE TANKS

WIDE GAPS NOW BETWEEN EACH OF THE CONCRETE SLABS

A MAN WRAPPED IN SHEEPSKIN SELLING RHUBARB

A MAN CROUCHING UNDER A WHEELBARROW DURING A RAINSTORM

A LINE OF MIG-23S LYING ON THE WET RED LATERITE AT THE DESERTED SHINDAND AIRFIELD

196

THINGS TO SEE AND NOT TO SEE

WEDNESDAY

THE MAP SHOWING A THIRD-CLASS ROAD FROM HERAT INTO THE HUNGER POCKET OF BADGHIS
THE CLAY RIDGE OF SABZAK PASS FROZEN
TRAVERSING THIS BOUNDARY BETWEEN IRANIAN AND TURKIC LANGUAGES
LEAVING FOOTPRINTS ON THE GROUND

SATURDAY

BEFORE THE PASS ENCOUNTER WITH TALIBAN GOVERNOR RETURNING FROM HERAT
EN ROUTE TO HERAT DROUGHT REFUGEES ESCAPING FAMINE IN BADGHIS
CROSSING THIS WATERSHED BETWEEN THE INNER ASIAN WORLD AND THE INDIAN OCEAN WORLD
PERSPECTIVES OF A PASSER-BY

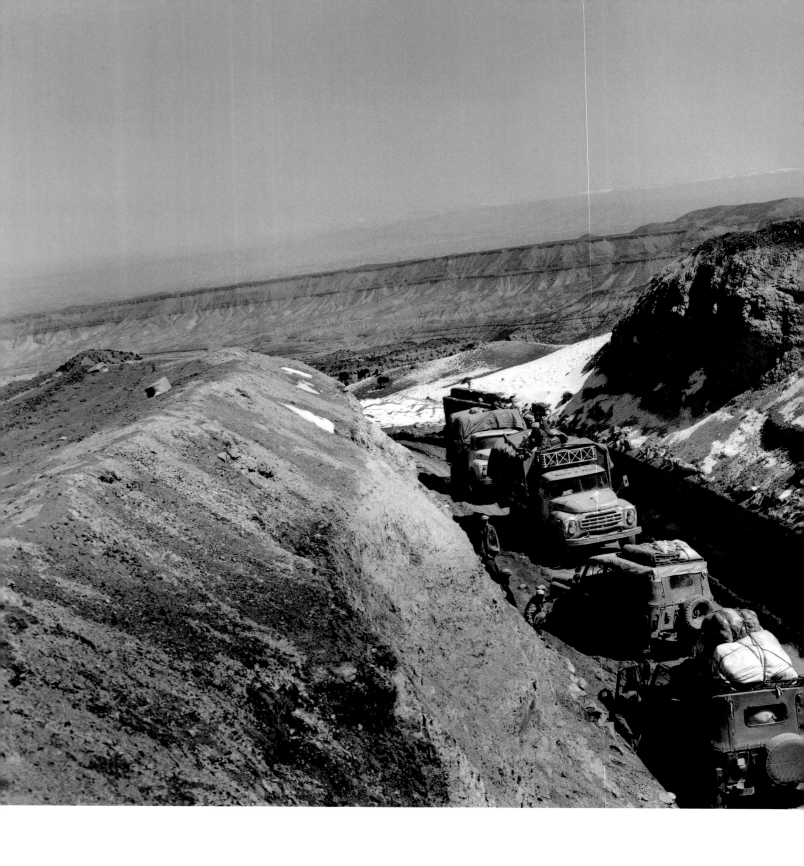

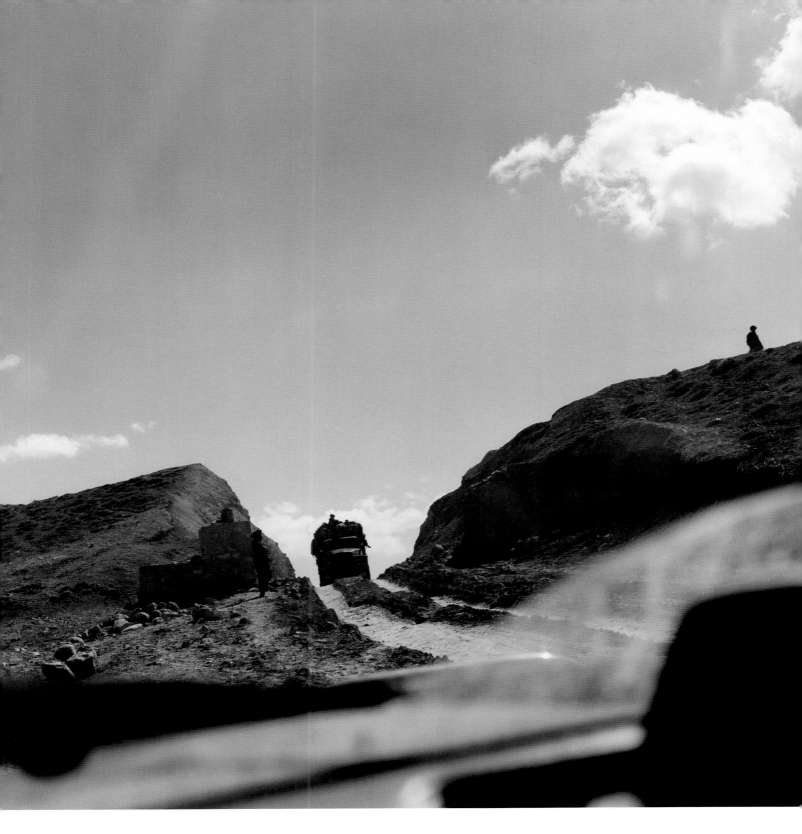

TWO CROSSINGS OF THE SABZAK PASS | AFGHANISTAN 2001

200

-ROM HERE BEGINS
HAPPY VALLEY WHERE
WORLD ENDS AND
PARADISE BEGINS

53 RCC 32TF

202

WAR – AS FAR AS WE KNOW

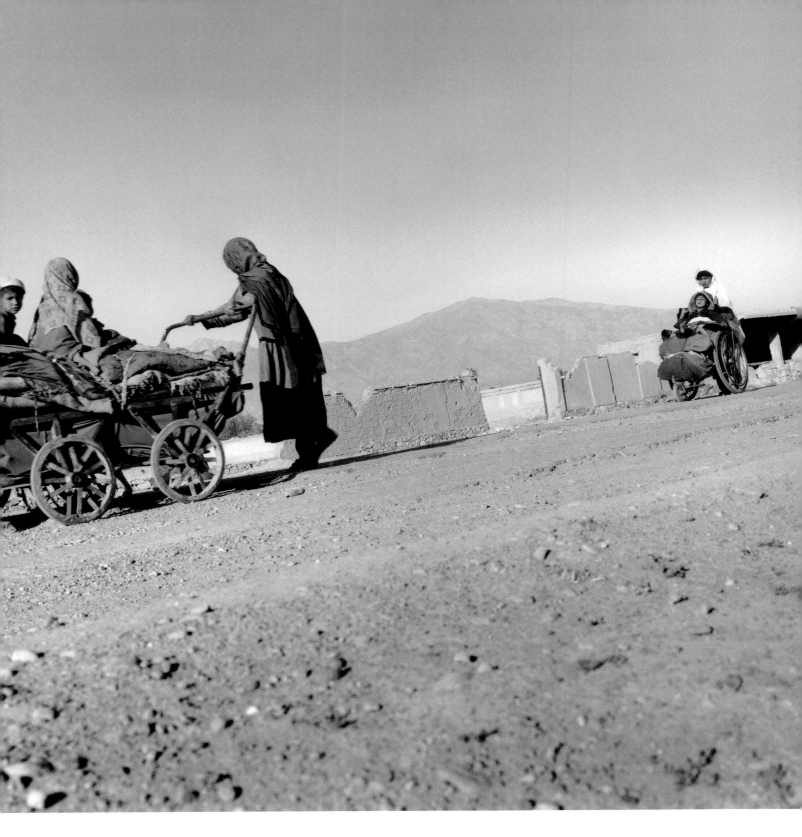

INTERNALLY DISPLACED PEOPLE | KABUL | AFGHANISTAN 1998

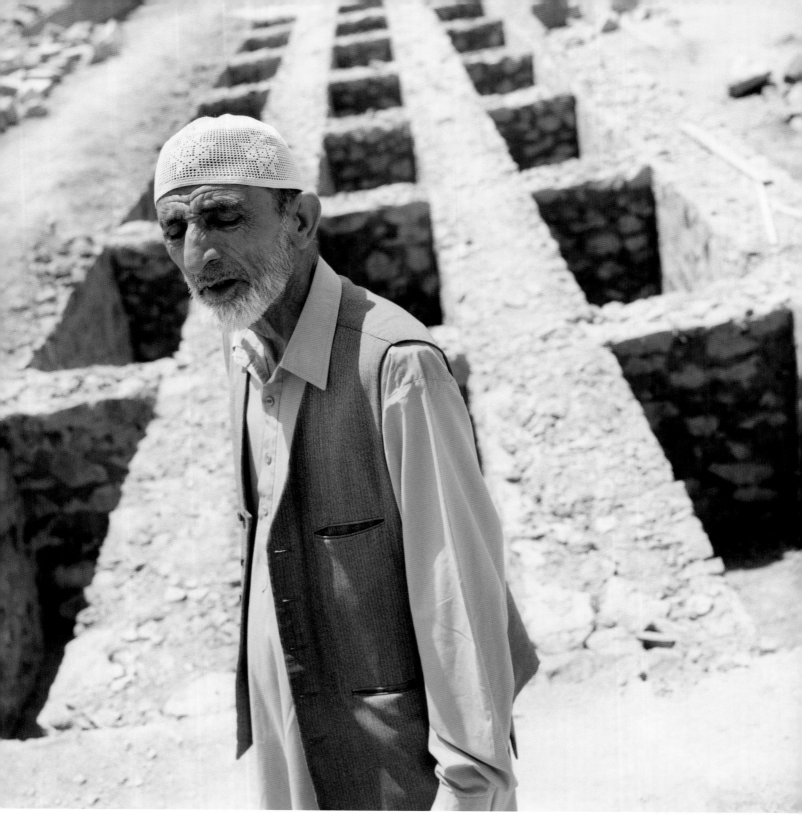

THE GRAVE DIGGER | SRINAGAR | KASHMIR | INDIA 2000

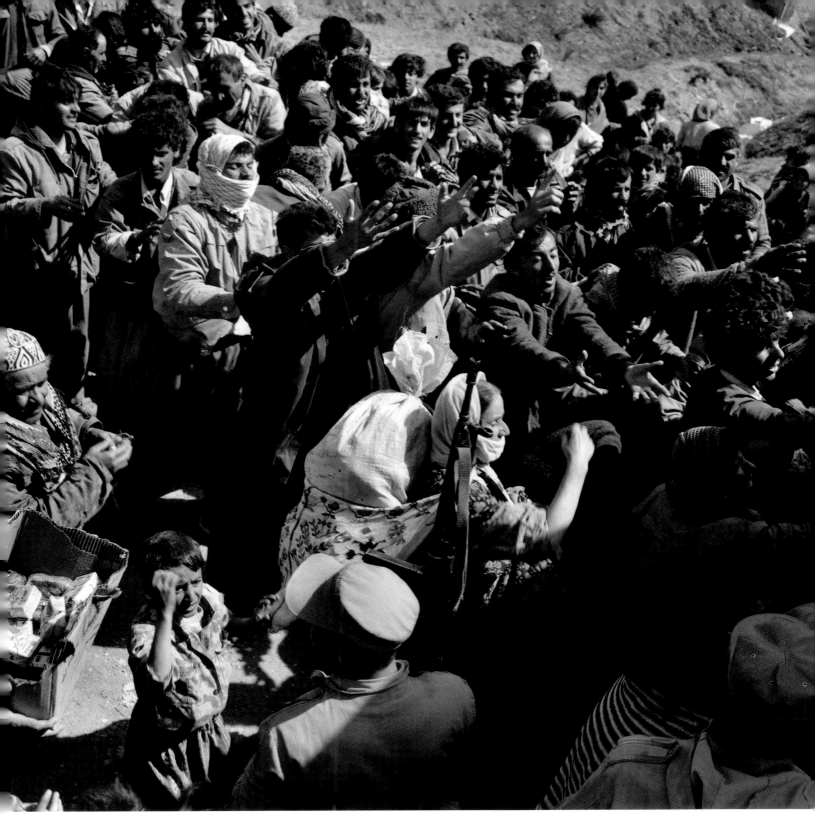

KURDISH REFUGEES | IRAQI BORDER | IRAN 1991

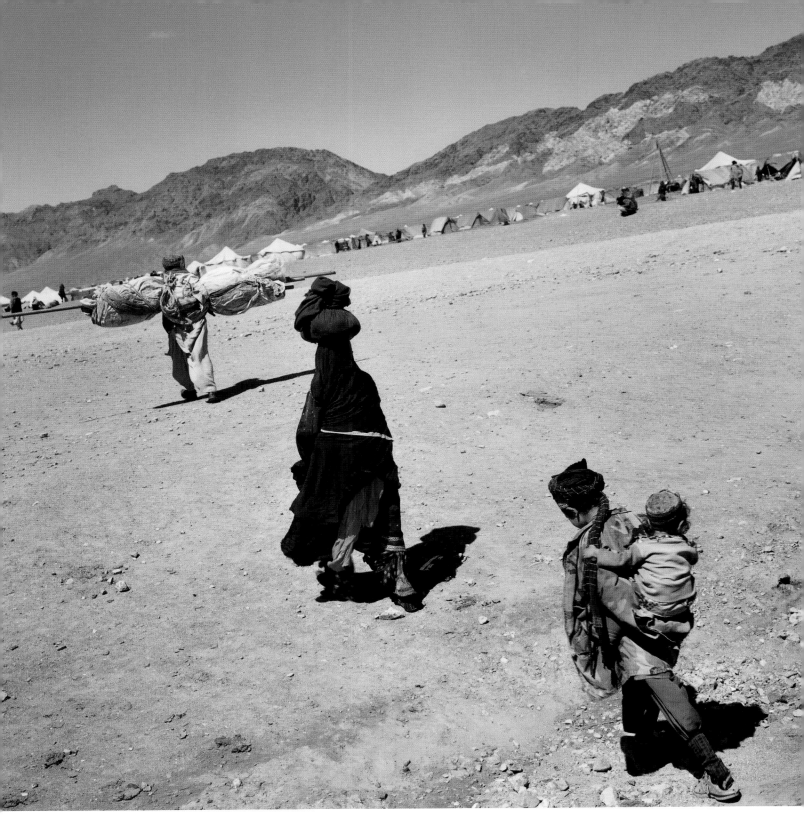

PEOPLE DISPLACED BY THE DROUGHT | HERAT | AFGHANISTAN 2001

210

PLUNDERED COINS ROOM · NATIONAL MUSEUM OF AFGHANISTAN · KABUL JUNE 1998

NEWSPAPERS REPORTING TERRORIST ATTACKS ON U.S. EMBASSIES IN AFRICA · WALL STREET AUGUST 1998

THINGS I SAW THREE YEARS BEFORE TWO POINTS BECAME ONE

COLOSSUS OF BAMIYAN · CARVED SEVENTH CENTURY · DESTROYED 8–9 MARCH 2001

WTC NYC · ERECTED 1966–1977 · DESTROYED 11 SEPTEMBER 2001

VOID IN THE CLIFF

IMAGE IN THE HEAD

MESSAGE OF LIFE AND OPPORTUNITY REACHING THE FARTHEST PEOPLES

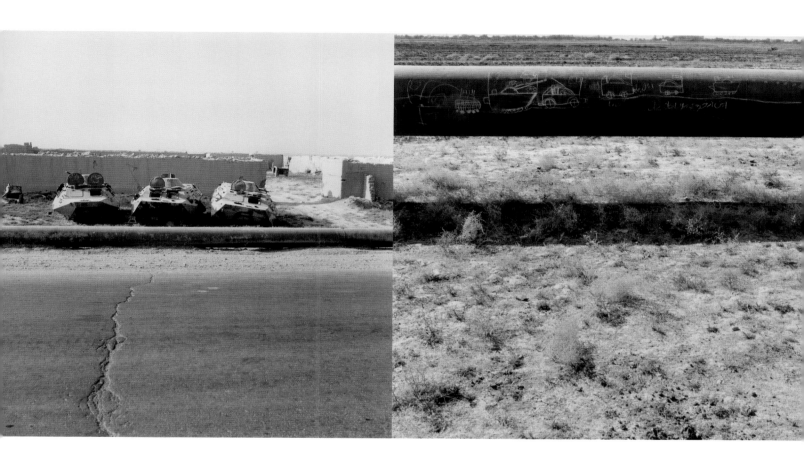

IMPERIAL ENTERPRISE

KAZAN

CHKALOV ORENBURG

FORT SEMEY SEMIPALATINSK SEMEY

AKMOLA AKMOLINSK TSELINOGRAD ASTANA

CARICYN VOLGOGRAD STALINGRAD VOLGOGRAD

TYURATAM LENINSK BAIKONUR

KZYL-ORDA PEROVSK KZYL-ORDA

FORT ALEKSANDROVSKII FORT SHEVCHENKO

FORT VIERNY ALMA-ATA ALMATY

PISHPEK FRUNZE BISHKEK

KARAKOL PRZHEVALSK KARAKOL

BINKATH ASH-SHASH SEIKEND TASHKENT

KHUJAND LENINABAD KHUJAND

NOVY MARGELAN SKOBELEV FERGHANA

KRASNOVODSK TURKMENBASHI

BACHARATA BOCHAR BUCCARA BOKHARA BUCHARA

AMUYA CHARDZHOU TURKMENABAD

SHUMAN DUSHANBE STALINABAD DUSHANBE

TIRMIDA AL-TIRMIDH TERMED TERMEZ

KABUL

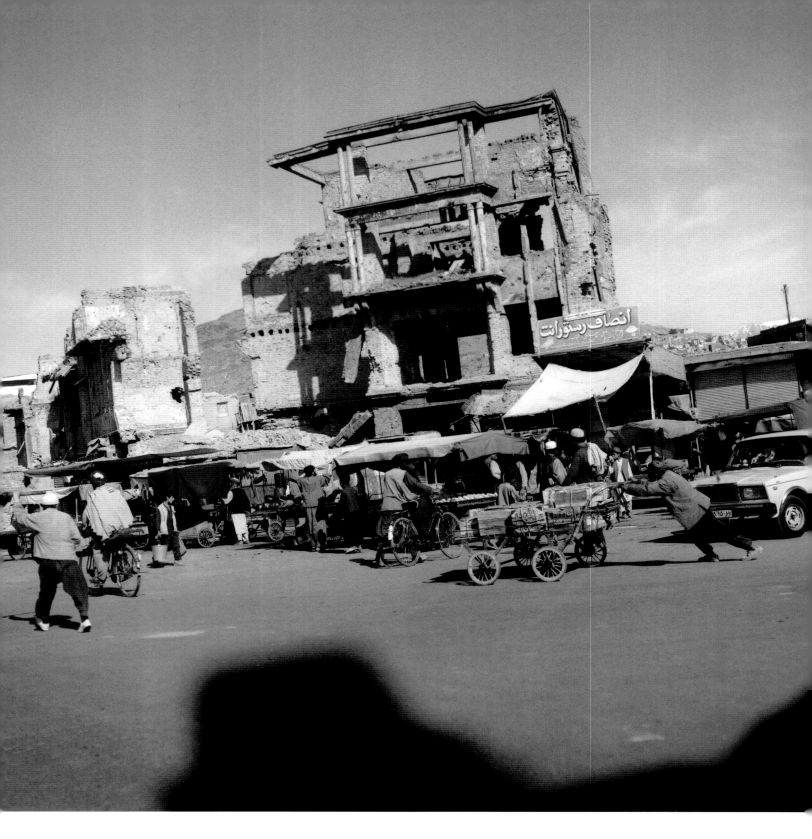

ARRIVAL IN KABUL | AFGHANISTAN 1998

WAR – AS FAR AS WE KNOW

3500—3000 BCE · Mesopotamia · Sack of the ancient arms production centre of Hamoukar by expansionist Uruk, evidence of the first known organized war

c. 1350 BCE · Mesopotamia · Assyria turns from farming and trade to militarism and its rulers proclaim that war is a natural condition

Twelfth century BCE · Kingdom of Colchis · On a possible mercantile venture Jason and the Mycenaean Greek Argonauts make a foray up the Phasis river

Tenth century BCE · Western Zhou Dynasty · Emperor Mu visits the Kunlun Mountains in the Far West

Late eighth century BCE · Cimmerian tribes forge an alliance with Scythian tribes against the Assyrians

c. 700 BCE · Scythia · Consolidation of the first nomadic empire in the central Eurasian steppes

614—612 BCE · Mesopotamia · Having united the Iranian-speaking tribes into a kingdom, Cyaxares captures Ashur and Babylon in alliance with Nebuchadnezzar's father Nabopolassar, thus ending the Assyrian Empire

689 BCE · Mesopotamia · Babylon is destroyed by the Assyrians

597 BCE · Palestine · Nebuchadnezzar takes Jerusalem and deports Jews to Mesopotamia

550 BCE · Media · The Medes become subjects of Achaemenid Persia

539 BCE · Mesopotamia · Persian Emperor Cyrus defeats the Babylonian army and enters Babylon

c. 516—512 BCE · Achaemenid Persia · Darius I's expedition against the Scythians fails

End of sixth century BCE · Achaemenid Persia · The Ionian revolts constitute the first major conflict between Greece and Persia

490 BCE · Greece · The watershed Battle of Marathon marks the culmination of the first attempt by Achaemenid Persia under Darius I to subjugate Athens

480 BCE · Greece · A second invasion led by Xerxes I is defeated by the Greeks at Salamis, Plataea and Thermopylae

334 BCE · Achaemenid Persia · Alexander the Great's Macedonian army crosses into Asia

330 BCE · Media · After Alexander's occupation, Media's southern part is given to a Macedonian commander and is eventually passed to the Seleucids

330—329 BCE · Achaemenid Persia · Alexander enters Babylon and occupies the Persian satrapies of Areia, Drangiana and Arachosia

329—327 BCE · Bactria, Sogdiana and Margiana · Conquest by Alexander the Great is followed by war against the Sogdian insurgency

327—325 BCE · Indus Valley · Alexander defeats Poros and commits atrocities against the civilian population of the Malli

325—324 BCE · Persian satrapy of Gedrosia · Alexander undertakes a punitive expedition in the Zagros Mountains against the Cossaeans

324 BCE · Persian Gulf · Alexander prepares for the conquest of the Persian Gulf and Arabian peninsula. Death of Alexander

Before 324 BCE · Warring States · A border wall is raised by the state of Qin against incursions by the Hu, i.e. the Xiongnu, or the Huns

306 BCE · Gansu · A barbarization policy pursued by the state of Zhao during the Warring States period allows military penetration of the Xiongnu lands in Gansu

c. 304 BCE · Seleucid Bactria · Seleucus I is forced to abandon the eastern part of Alexander's empire to Chandra Gupta I of the Indian Maurya Empire

Third century BCE · Eastern Central Asia · The Xiongnu emerge as a great political power

c. 290—280 BCE · Seleucid Bactria · Nomadic tribes carry out incursions into Margiana and Areia

c. 290—280 BCE · Seleucid Bactria · Incursions are repelled, Alexandria-in-Areia is rebuilt by Antiochus I

c. 230 BCE · Seleucid Bactria · Breakaway satraps create the Graeco-Bactrian kingdom

221 BCE · Warring States · Unification under the First Emperor Qin Shi Huangdi and the foundation of the Qin Dynasty mark the beginning of Imperial China

214 BCE · State of Qin · The Xiongnu are expelled from the Ordos and construction of the Great Wall begins

209 BCE · Nomadic Empire of the Xiongnu · Unification takes place under Modun and the Ordos Desert in the state of Qin is reoccupied

206 BCE · Graeco-Bactrian Kingdom · Following campaigns by Antiochus III the Seleucid supremacy becomes accepted

c. 206 BCE · Nomadic Empire of the Xiongnu · The Donghu are defeated in the northeast and Modun campaigns in the west against the Yuezhi tribes

200 BCE · Nomadic Empire of the Xiongnu · Attack by slow-moving Han infantry under Emperor Gaodi against fast-moving nomadic cavalry fails

198 BCE · Western Han Dynasty · A peace alliance with the Xiongnu through treaties includes the marriage of Han princesses to Modun

196 BCE · Asia Minor · A 'cold war' begins between Rome and the Seleucid Empire who try to settle spheres of influence by making alliances with Greek minor powers

188 BCE · Asia Minor · The Roman-Syrian or Antiochian War ends with the Treaty of Apamea. Asia Minor falls to the Romans, Rome gaining hegemony over Greece and becoming the single major power in the Mediterranean world

After 180 BCE · Western Han Dynasty · Xiongnu-imposed border markets are established in Xi Yu, or the Western Regions as the Chinese call parts of Central Asia

177 BCE · Yuezhi Empire · After total defeat by the Xiongnu, the Yuezhi split into the Lesser and Great Yuezhi with the latter settling in the Ili Valley

After 175 BCE · State of Loulan · The Xiongnu conquer Loulan after incursions into the Tarim Basin in the Western Regions

After 162 BCE · Wusun State · The Wusun move from the Tian Shan into the Ili Valley, pushing the Yuezhi farther west to Sogdiana

After 162 BCE · Parthian Persia · The Yuezhi expand towards the Oxus forcing the Scythians into Parthian territory

About 152 BCE · Southern Media · Conquest by Persian armies of Mithridates I

145—130 BCE · Seleucid Bactria · Invasion by Tokhari, Asiani and other Yuezhi tribes virtually obliterates the Greek presence in Bactria

144 BCE · Seleucid Satrapy of Babylonia · The Parthians capture Babylon

138—125 BCE · Xi Yu · Western Han General Zhang Qian's first Central Asia mission to the Yuezhi tribes seeks a military alliance against the Xiongnu

129—119 BCE · Western Han Dynasty and Nomadic Empire of the Xiongnu · War leads to the establishment of the Han prefecture in Jiuquan in the Gansu Corridor

c. 126 BCE · Yuezhi Empire · Bactria is occupied by the Chinese and divided into five provinces, including Guishuang or Kushan

124 BCE · Parthian Persia · Mithridates II contains the Scythians in Seistan and sends envoys to Rome and to the Han emperor Wudi

116 BCE · Kushan Empire, formerly the Yuezhi · Campaigns against the Han in the Tarim Basin in the Western Regions

115 BCE · Xi Yu · Zhang Qian undertakes his second mission to Central Asian lands beyond the Tian Shan

60 or 59 BCE · Xi Yu · The office of Protector General is established with hegemony over the Western Regions

53 BCE · Parthian Persia · Following incursions by Crassus's legions and the Battle of Carrhae, Roman prisoners of war are sent to the eastern frontier service, from where they allegedly defect to
 the Xiongnu ruler Zizi

36 BCE · Nomadic Empire of the Xiongnu · A punitive venture is undertaken by the Han against the Xiongnu, and Roman prisoners of war who have escaped from Parthia are allegedly captured

26 BCE—36 CE · Roman Judaea · Pontius Pilatus acts as prefect of the province and judges at the trial of Jesus, ordering his crucifixion

First century CE · Kushan Empire · The Kushan control the trade routes linking Persia, Transcaspia, Kabul, Sogdiana, the Tarim Basin, Kashmir and the Indus Valley

73 · Da Qin or the Imperium Romanum · Han envoy Gan Ying sets out for Roman Syria and beyond, and gets at least as far as the head of the Persian Gulf

84 · Kushan Empire · Han general Ban Chao appeals to the Yuezhi to prevent the Sogdians from supporting rebellions by the King of Kashgar

106—116 · Petra, Armenia and the Persian city of Ctesiphon are conquered by Roman Emperor Trajan

165 · Parthian Persia · Roman siege of Seleucia ends with conflagration of the city and the massacre of 300,000 of its inhabitants

166 · Eastern Han Dynasty · An envoy, possibly dispatched by Roman Emperor Marcus Aurelius, reaches the Seres or the Silk People, not necessarily to be identified with the Chinese

208—224 · Parthian Persia · The Sasanid conquest of Margiana and Bactria brings the Kushan Empire to an end

224 · Parthian Persia · The great assembly held at Balkh acknowledges the authority of Artaxerxes thus ending the Parthian Empire and introducing Sasanid reign over Persia

296 · Sasanid Persia · Galerius' infantry is totally overthrown in the third engagement in the plains of Mesopotamia

Fourth century · Sasanid Persia · Bactria and Sogdiana come under Sasanid control. Sasanids carry out incursions into Gandhara

After 402 · Northern Wei Dynasty · The Ruanruan or Avars carry out incursions from the steppes into the Tarim Basin as far as Khotan

400 · Sasanid Persia · Turkic people invade Tajik borderland of Persia

Mid-fifth century · Sasanid Persia · The Hephthalites or White Huns migrate from the Altai and expel the Sasanids from Bactria

Sixth century · Gandhara · The Hephthalite Empire destroys the Kingdom of Gandhara and invades Persia

507 · Arabia · Forces of the Christian state of Ethiopia attack the Yemenite trading post of Mecca

525 · Egypt is conquered by Cyrus's son Cambyses

527 · Principality of Hira · Byzantine emperor Justinian encourages the Principality of Ghassan to make war against Hira followed by proxy war against Persia

532 · Byzantium · Emperor Justinian secures an 'Eternal Peace' with Persia at the cost of a heavy tribute

555 · Central Eurasia · A federation of Turkic tribes defeats the Avars, establishing predominance of Turkic language families

563—568 · Sasanid Persia · In alliance with the Western Turks expanding from the steppes the Sasanids destroy the Hephthalite Empire

After 565 · Southern and Eastern Afghanistan are recognized as independent components of the Kushano-Hephthalite Kingdom

570 · Arabia · Birth of Muhammed, the prophet of Islam

611—614 · Byzantium · The Persians invade Byzantine territory and capture Jerusalem

633 · Byzantium and Sasanid Persia · The first Arab invasions take place using Bedouin tactics of surprise and mobility

642 · Sasanid Persia · The Arab army's commander Suwayd reaches the hinterland of the Caspian Sea along the Khorasan road and makes contact with the Gurgan ruler controlling the frontier
 area and meeting place between the settled Iranian people and the nomadic Turkic speakers in the Northeast

650 · Sasanid Persia · The first phase of the Arab conquest of Mawarannahr, later called Transoxiana, begins with sporadic raids across the Oxus into Sogdia

651—652 · Sasanid Persia · The Arab conquest of Merv and invasion of Seistan continues Abd Allah's pursuit of Yazdgard III

658—659 · The Western Turks collapse after Tang campaigns against the Turks, the Uighurs and under Tang regency in the Western Regions

661 · The Tang Dynasty controls the administration of Kashmir and Eastern Persia

661 · The Tang Dynasty campaigns against the Tibetans in the Western Regions

661 (January) · Umayyad Caliphate · Ali, cousin and son-in-law of Muhammed, is murdered by a fellow Muslim in the new Iraqi capital of Kufa

679 · Western Regions · The Tang campaign against the Western Turks

680 (October) · Umayyad Caliphate · Second inter-Arab civil war begins with a Shi'ite insurrection in Iraq led by the Prophet's grandson and Ali's son Husayn and leads to the massacre of Kerbala

681 · Mawarannahr · Salm ibn Ziyad is appointed governor in Khorasan, the first Arab to winter across the Oxus and probably in Samarqand

691—692 · Umayyad Caliphate · Some Quranic verses among the inscriptions of the Dome of the Rock built on Jerusalem's Temple Mount by Abd al-Malik directly challenge Christian doctrine

692 · Xi Yu · The Tang form an alliance with the Western Turks and recapture the Tarim Basin from the Tibetans

700 · Xi Yu · A federation of Tibetan groups venture into Tang territory

705—715 · Mawarannahr · The second phase of the Arab conquest begins beyond the Oxus being the governorate of Qutayba ibn Muslim, with systematic attempts at conquest of Tokharistan,
 Sogdia and Khwarezm

714 · Xi Yu · The Turks are defeated by the Tang at Lake Issyk Kul in the Tian Shan

715 · Tibetan Kingdom · Arab armies carry out incursions into the Ferghana Valley and become allies of the Tibetans

716—737 · Mawarannahr · During the third phase of the Arab conquest of Transoxiana the governor of Khorasan launches major military campaigns in Sogdia and establishes garrisons in Buchara and Samarqand, yet suffering setbacks at the hands of resurgent Turks and their allies among local princes

719 · Sogdian Principalities · Tang armies carry out incursions in Central Asia

737 · Mawarannahr · At the beginning of the fourth phase of the Arab conquest, an accommodation with local princes acknowledges Umayyad overlordship but allows them to retain power and status

737—740 · The Tibetan Kingdom is invaded by Tang armies

742—744 · Uighur Kingdom · Unification of the Uighur tribes. The Empire of the Kok-Turks is destroyed in Mongolia

747 (9 June) · Eastern Iran · Abu Muslim unfurls revolt in Khorasan and subsequently crosses the Euphrates to defeat Umayyad forces

747 · Kingdom of Little Balur · Tang armies carry out incursions across the Pamir Mountains into the Tibetan-controlled valley to the north of Gilgit

747 · Umayyad Caliphate · Arab armies pursue campaigns from eastern Iran into the Hindu Kush

748 · Tang Dynasty · Tang armies carry out incursions into the Ferghana Valley

750 · Abbasid Caliphate · Victories in Iraq and Syria result in a revolution in Islamic history due to the destruction of the Arab Kingdom of the Umayyads and the establishment of a new Iranian empire under the guise of Persianized Islam

750 · Abbasid Caliphate · Arab campaigns take place in Mawarannahr, i.e. ancient Sogdiana

751 · Abbasid Caliphate and Tang Dynasty · The Arab conquest of Central Asia ends at the Battle of Talas and stops China's westward advance

755 · Western Regions · The Tibetans occupy Tang-held territory

791 · The Tibetan Kingdom occupies Gansu, part of the Tang Empire

840 · Uighur Kingdom · After their defeat against the Kyrgyz the Uighurs carry out raids in the Western Regions

865 · Turfan and other parts of the Western Regions · Following the Uighur occupation, mini-states are established

867 · Eastern Iran · Tahirids followed by the dynasty of the Saffarides

875 · Eastern Iran · Saffarides followed by the dynasty of the Samanids

875 · Samanid Persia · The Samanids establish a regency in Mawarannahr

878 · Abbasid Caliphate · The twelfth and last Imam Muhammed al-Mahdi goes into hiding in a cave under the Askariya shrine in Samarra

900 · Samanid Dynasty of Persia · Ismail I overthrows the Saffarids of Khorasan and the Zaydites of Tabaristan

943 · Abbasid Caliphate · Buyid Shi'ites from the northern Caspian highlands invade Iraq and take Baghdad

998 · Afghanistan under Khorasani Persian-Arab rule · Conquest by the Ghaznavids of southern Afghanistan

999 · Ghaznavid Afghanistan · Defeat of the Samanids and occupation of Khorasan

999 · Karakhanid Dynasty · The Karakhanids establish a regency in Mawarannahr after the disintegration of the Samanids

Tenth and eleventh centuries · Western Turkestan · As part of Oghuz Turks migration from Eastern Turkestan, Turkmen tribes settle in Transcaspia

1001· Ghaznavid Afghanistan · Mahmud carries out a campaign against the Hindus in Peshawar and in the Punjab

1036 · Tangut tribes or Jurchens · The Tangut annex Uighur territory in the Chinese parts of the Western Regions

1055 · Abbasid Caliphate under domination of Shi'ite Buyid Emirs · The Seljuks capture Baghdad

1071 (26 August) · Seljuk Dynasty · At the Battle of Manzikert between the Byzantine Empire and Alp Arslan's forces, Byzantine Emperor Romanus IV Diogenes is captured and released eight days later in exchange for a treaty

After 1072 · Seljuk Dynasty · Sunni Muslim Seljuks establish suzerainty over the Karakhanids and the Emirate of Merv

1079 · Syria and Palestine · Seljuks wrestle the lands from local dynasties and declining Fatimids, thus creating a new order in the Middle East

1095—1099 · Seljuk Dynasty · After the first invasion of Christian crusaders called upon by Pope Urban II, Latin feudal principalities are established on the coast between Syria and Palestine

1122—1125 · Tangut tribes or Jurchens · The Tangut destroy the Liao Dynasty or Khitan

After 1125 · Liao Dynasty · The Liao migrate westwards and establish the Karakhitai Dynasty in Central Asia

After 1141 · Seljuk Dynasty · Defeat in the jihad declared by Sultan Sanjar against the immigrant Karakhitai encourages the European crusades

1126—1193 · The Turkic State of Khwarezm conquers the rest of Seljuk Persia

1147—1149 · Seljuk Empire · The failed Second Crusade of the French and South German armies leads to the capture of the free city of Damascus by Nur ad-Din

1148 · Ghaznavid Afghanistan · Conquest by the Ghurids of Ghor

1157 · Seljuk Dynasty · Revolts by Turkic tribes after Sanjar's death accelerate the decline of Seljuk power and the break-up of the empire

1187—1192 · Latin Principalities · The recapture of Jerusalem by Saladin leads Pope Gregory VIII to call for Third Crusade, led by Philippe II of France, Richard I of England and Frederick I, Holy Roman Emperor, with Richard capturing Cyprus from the Byzantines

1202 · Byzantium · The Fourth Crusade initiated by Pope Innocent III leads to the sack and plundering of Constantinople, possibly the final breaking point of the Great Schism between the Eastern Orthodox and the Western or Roman Catholic Churches

1205 · Seljuk Dynasty · Conquest of Persian heartland by the Khwarezm Shas

1206 · Mongol Empire · All Mongol tribes reaffirm their loyalty to Prince Temujin, called Genghis Khan

1218 · Empire of the Khwarezm Shas · Genghis Khan's punitive expedition in pursuit of Khwarezm ruler Muhammad II Ala ad-Din leads to Mongolian lightning war

1219—1221 · Mongol Empire · Genghis Khan's Khwarezm and Caucasus campaigns result in the fall of Bukhara and Samarqand

1220—1223 · Kipchak Empire · Genghis Khan's generals Jebe and Subetei carry out a great western raid to the Volga and the Sea of Azov

1221—1222 · Afghanistan · Genghis Khan's campaign extends to the Hindu Kush

1226—1227 · Xixia Empire · Genghis Khan wages a campaign against the Western Xia in central China

1228—1229 · Latin Principalities · Through diplomacy, Emperor Frederick II achieves delivery to the Crusaders of Jerusalem, Nazareth and Bethlehem for a decade without warfare

1236—1242 · Georgia, Armenia, Russian Principalities, Hungary and Poland · Batu Khan and Subetei invade. Subsequently a Pax Mongolica prevails in Eurasia

1243 · Latin Principalities · Papal interest in Ayyubid Egypt leads the Sultan to summon a Khwarezmian force to storm Jerusalem and drive the Crusaders into battle in Gaza

1247 · Holy Roman Empire · Genghis Khan's nephew Guyuk demands subservience from Pope Innocent IV and European monarchs

1250 · Ayyubid Sultanate · During the Seventh Crusade the rulers of Egypt suffer a final crisis and are replaced by the Mamluks, a dynasty originating from enfranchised military slaves who were descendants of non-Muslims from the Caucasus and the northern Black Sea region

After 1255 · Il Khanate · Hulagu Khan expands Mongol control over Persia

After 1255 · Il Khanate · Hulagu Khan campaigns against the Chagatai Khanate in Mawarannahr and in the Russian steppes

1258 (20 February) · Il Khanate · With the help of Armenians, Chinese artillery experts, Georgians, Persians and Turks, Hulagu's Mongol army lays siege to and eventually sacks Baghdad, ending the Abbasid Caliphate

1323 · Mamluk Sultanate · A final peace settlement is agreed between the Mamluks and the Il Khanate, with the latter being split into small states ruled by local dynasties

1326 · Byzantium · After incessant border warfare, the Ottoman Turks take Bursa and make it the capital of their rapidly growing state

1354 · Byzantium · Ottoman forces cross the Dardanelles into Europe

1360 · Chagatai Khanate · Tughluk invades Mawarannahr

1360 · Chagatai Khanate · Tamerlane, or Timur, forges an alliance with Emir Husayn of Balkh against the Mongols

1372 · Timurid Empire · Timur's campaign in Khwarezm

1381 · Timurid Empire · Timur's expedition against Khorasan

1382 · Timurid Empire · Timur's campaign against Mazandaran in northern Persia

1383 · Muscovite Russia · Tartars capture Moscow, re-imposing tribute on Russia

1384—1386 · Timurid Empire · Timur's campaign against Kandahar and Seistan

1386 · Timurid Empire · Beginning of Timur's three-year campaign in Persia

1387 · Kipchak Khanate or the Golden Horde · Tokhtamish's incursions into Mawarannahr

1388 · Timurid Empire · Timur's campaign in Khwarezm

1389—1390 · Timurid Empire · Timur's campaigns against Moghulistan, the eastern part of the former Chagatai Khanate

1390—1391 · Timurid Empire · Timur's campaigns in the Volga and Don basins against Tokhtamish's Golden Horde

1392 · Timurid Empire · Beginning of Timur's five-year campaign against the Golden Horde

1398—1399 · Timurid Empire · Timur's India campaign

1400—1401 · Timurid Empire · Launch of Timur's seven-year campaign to Iraq, Syria and Anatolia

1402 · Timurid Empire · Defeat of the Ottomans at Ankara and capture of Sultan Beyazid I

1405 · Timurid Empire · Launch of the campaign against the Ming Dynasty. Death of Timur

1422 · Byzantium · A first, unsuccessful siege of Constantinople is carried out by Ottoman forces

1423—1424 · Ming Dynasty · Offensives in the Mongolian steppe

Before 1451 · Kingdom of Hungary and Timurid Empire · Murad II wins victories against the Hungarians and the forces of Timur's son Shah-Rukh

1453 (29 May) · Byzantium · After a seven-week siege, Constantinople is captured by Ottoman Sultan Mehmed II and the last Emperor Constantine XI dies in battle

After 1456 · Kazakh Khanate divides into three hordes or Zhuhs

1468 · Dsungar incursions lead to the disintegration of the federation of Uzbek tribes

1480 · Muscovite Russia · The Mongolian Golden Horde carries out unsuccessful campaigns

1480 · Muscovite Russia · Ivan the Great wages a counter-offensive against the Tartar Khanates, the successors of the Mongolian Golden Horde, throwing off the Tartar yoke and ending all tribute and dependence

1485—1490 · Mamluk and Ottoman Sultanate · After inconclusive wars between the two powers, the adoption of new firearms such as handguns and cannons tips the military advantage towards the Ottomans

1494—1495 · Uzbek Shaybanid Dynasty · Re-conquest of Mawarannahr and establishment of the khanates of Bukhara and Khiva

1494—1503 · Principality of Ferghana · Babur's campaigns in Mawarannahr

1503—1504 · Babur Empire · Babur conquers the Kingdom of Kabul

1507—1508 · Babur Empire · Babur conquers southern Afghanistan

1510—1511 · Babur Empire and Safavid Persia · Babur's campaigns against the Uzbeks of Mawarannahr

1514 (23 August) · Ottoman Sultanate and Safavid Persia · Ottomans win victory due to their use of artillery in the Battle of Chaldiran, igniting a long period of Turkish-Iranian hostilities

1514 (7 September) · Ottoman Sultanate and Safavid Persia · The Ottoman occupation of the Iranian capital of Tabriz is followed by withdrawal back to Anatolia and a subsequent war of propaganda between the Sunni and Shia faiths, of which Sultan and Shah are respectively champions

1519 · Babur Empire · Babur's first India campaign

1529 (12 October) · Austria · After shattering the Hungarian army, the last unsuccessful assault begins under Suleyman during the first Ottoman siege of Vienna

1552 · Muscovite Russia · Ivan IV annexes the Turk Khanate of Kazan

1556 · Muscovite Russia · Annexation of the last Tartar enclave of Astrakhan to the north of the Caspian Sea

1557—1598 · Uzbek Shaybanid Dynasty · Expansion to Badakhshan i.e. northeastern Afghanistan and Khorasan

1571 · Muscovite Russia · Crimean Tartars burn Moscow

1598 · Safavid Persia · English brothers Anthony and Robert Shirley assist Shah Abbas in building a new infantry and artillery after the Ottoman model to halt Uzbek incursions from Central Asia

1611—1612 · Ming Dynasty · Tartar tribes carry out incursions into the Western Regions

1616 · Mughal India · The British East India Company operates out of Surat

1678—1679 · Dsungar Empire · Occupation of the Tarim Basin in the Western Regions of Ming China

1683 (12 September) · Austria · At the Battle of Vienna, Polish-Austrian-German forces break the Ottoman Empire army's advance towards Central Europe, marking the beginning of political hegemony of the Habsburg Dynasty

1690—1697 · Qing Dynasty · Campaigns against the Dsungar Empire

1696 · Dsungar Empire · Offensive against the Qing to the south of Lake Baikal

1696 · Qing Dynasty · Counter-offensive against the Dsungar Empire

1706 · Afghanistan · Mirwais Khan Hotak leads an uprising by Pashtuns and Safavid Persians are expelled

1715 · Tsarist Russia · Peter the Great dispatches the first military expedition into the Kazakh Steppes

1717 · Tsarist Russia · The first military expedition to Khiva fails

1717 · Tibet · Occupation of Lhasa by the Dsungars

1720 · Tibet · Second attempt by the Qing to conquer Lhasa. The Dsungars retreat from Tibet

1721—1722 · Safavid Persia · Invasion by Hotaki Afghans and capture of Isfahan

1722—1723 · Hotaki-ruled Persia · Russia occupies Derbent and Baku in the Caucasus and subsequently invades Persia

1723—1725 · Kalmyk Khanate carries out raids into the Kazakh Steppes

1729 · Safavid Persia · Nadir Shah expels the Hotaki Afghan invaders

1731 · Tsarist Russia establishes a protectorate agreement with the Kazakh Small Horde

1732 and 1740 · Tsarist Russia establishes protectorate agreements with the Kazakh Middle Horde

1738—1739 · Afsharid Persia · Nadir Shah invades Afghanistan, captures Kandahar and invades India

1740—1747 · Afsharid Persia · Nadir Shah invades Mawarannahr, now called Western Turkestan, and establishes hegemony

1747 · Emirate of Afghanistan · The tribal Loya Jirga or grand council elect Ahmad Shah, a member of Nadir Shah's Afghan contingent, as king. The Durrani Dynasty is established, the origin of modern Afghanistan

1755—1760 · Dsungar Empire · Annihilation of the Dsungar people and conquest of the Ili Valley by the Qing

1758—1759 · Qing Dynasty · Conquest of the Tarim Basin in the Western Regions now called eastern Turkestan

1768 · Qing Dynasty · Former Western Regions are renamed Xinjiang or 'New Frontier'

1783 (until 1870) · Tsarist Russia · Kazakhs lose 1 million people in anti-Russian revolts, famine and migration

1785 · Caucasia · An imperial Russian Province is formed and an insurgency led by Sheik Mansur begins

1785 · Afsharid Dynasty of Persia · Obliteration of the Astrakhanid Dynasty, successors of the Shaybanid Dynasty, in western Turkestan

After 1785 · Three Central Asian Khanates · The Khanate of Bukhara achieves dominance over Khiva and Khokand

1792 · Ottoman Empire · A new Russian war against the Turks leads to the annexation of the Ottoman provinces of Bessarabia and ends the centuries-long Muslim domination of the Black Sea

1798 (June 28) · Ottoman Egypt run by Mamluk military households · The arrival of Napoleon Bonaparte's expeditionary force marks the first direct contact between an imperial Western power and an ancien régime of Africa

1804 · Tsarist Russia · Following Russia's annexation of Georgia in 1801, Persia goes to war with Russia

1807—1808 · Qajar Persia · The first of two French and British military missions arrive to train the Iranian army

1813 · Tsarist Russia · Alexander I orders the conquest of the Caucasus and Trans-Caucasia

1813 (12 October) · Caucasia · The Treaty of Gulistan secures Russian control of all Persian dominions in the Caucasus and exclusive control of the Caspian Sea

1809—1819 · British India · The Sikhs sign a Treaty of Amity and Concord with the British, and conquer Kashmir

1818 · Caucasia · The Caucasian War by Tsarist Russia against ethnic groups, including the Chechens, begins

1821—1829 · Greece · The War of Independence is fought against the Ottoman Empire

1822—1824 · Tsarist Russia · The Kazakh Middle and Small Hordes are abolished and their territory incorporated into Russia

1825—1857 · Khokand Khojas rule · The Khojas declare jihad against the Kaffirs ('unbelievers'), i.e. the Qing invaders in Xinjiang

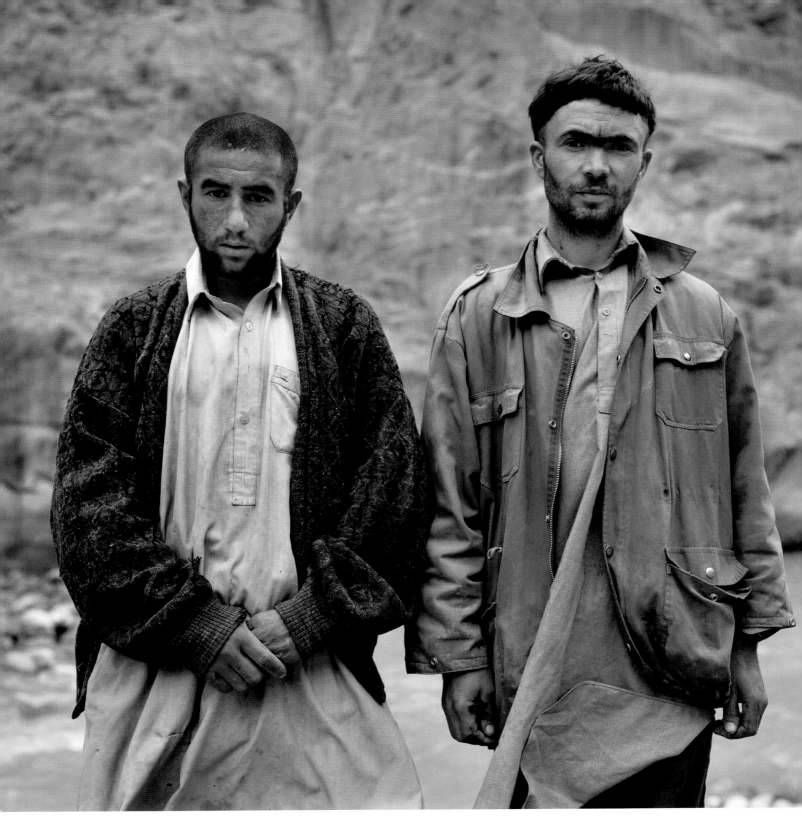

ROAD WORKERS | KARAKORAM HIGHWAY | PAKISTAN 2001

1827 · Qing Dynasty · Re-capture of the secessionist western part of Xinjiang

1830 · Ottoman Empire · Reforming Sultan Mahmud II seeks Western aid in modernizing the armed forces

1834 · Tsarist Russia · Construction of forts begins on the eastern shore of the Caspian Sea, encroaching into Turkmen areas

1834 · Tsarist Russia · Murid guerilla war begins in the Caucasus

1835 · Ottoman Empire · Arrival of the Prussian military mission

1838 · Ottoman Empire · Arrival of the British naval mission

1839 · Yemen · British forces occupy Aden, useful as a coaling station on the maritime route to India

1839—1840 · Tsarist Russia · General Perovsky undertakes an unsuccessful winter expedition to Khiva at the orders of Nicholas I

1839—1842 · Kingdom of Afghanistan · The first Anglo-Afghan war leads to the capture of Kabul and subsequently to the destruction of the British expeditionary force

1842 · Khanate of Bukhara · In the Great Game in Central Asia, British envoys Stoddart and Conolly are executed as spies

1846 · British India · The British sign a peace treaty with the Sikhs and Kashmir is sold to the Dogra ruler Gulab Singh

1853 · Tsarist Russia · General Perovsky advances to the Syr Darya and captures Kyzyl-Orda

1854 · Tsarist Russia · Fort Verniy is founded, later to become Alma Ata, now Almaty

1854—1855 · The Crimean War is fought between Tsarist Russia and the British with their allies

1857—1859 · British India · The Indian Mutiny turns into India's First War of Independence

1859 · Caucasia · Imam Shamil surrenders and the Murid guerilla war in the Caucasus ends, with Chechnya being incorporated into Tsarist Russia

1860 · Tsarist Russia and Qing Dynasty · A Sino-Russian treaty establishes the borders of Xinjiang

1861—1865 · Confederate States and the Northern States of America · The Civil War increases demand for cotton from Central Asia

1862 · Huijan ('Land of the Muslims'), i.e. Xinjiang, secedes from the Qing Empire

1864 · Kingdom of Kashgaria · The Dongan rebellion leads to secession from Qing Empire

1864 · Tsarist Russia · 'Pacification' of Caucasus accomplished

After 1864 · Tsarist Russia · The annexation of Chimkent leads to the Russian domination of Western Turkestan and subsequent colonization of the steppes

1865 · Qing Dynasty · The Dongan rebellion abates and strategic and economic projects begin in Xinjiang

1865 · Western Turkestan · Tsarist Russia and the Khokand Khanate race to capture Tashkent

1865 · Tsarist Russia · General von Kaufmann is installed as governor-general in Western Turkestan

1868 · The Khanate of Bukhara is reduced to Russian vassalage and partially annexed

1868 · Khanate of Bukhara · Russians capture Samarqand

1869 · Tsarist Russia · The port of Krasnovodsk, now Turkmenbashi, is founded on the eastern shore of the Caspian Sea

1870 · Tsarist Russia · Turkmen revolts begin against Russian expansionism in Central Asia

1871 · Tsarist Russia · Occupation of the Ili Valley

1873 · The Khanate of Khiva is annexed by Tsarist Russia

1874 · Tsarist Russia · A Transcaspian government is established in Krasnovodsk

1875—1876 · The Khanate of Khokand becomes the Russian protectorate of Ferghana after jihad against the invaders

1875—1877 · Qing Dynasty · Hong Kong Shanghai bank finances campaigns in and annexation of Xinjiang

1876 · Qing Dynasty · Muslim uprisings in Xinjiang abate

1876 · Jammu and Kashmir · Dogra power extends into Gilgit and other principalities of Dardistan

1878—1880 · Kingdom of Afghanistan · Second Anglo-Afghan War

1880 · Ottoman Empire · Germany, Britain's main imperial rival, begins to display interest in the Middle East

1881 · Qing Dynasty · Ili Valley region is ceded to Russia

1881 · Tsarist Russia · Capture of Ashkhabad and massacre of 15,000 Turkmens at Geok-Tepe

1881 · Tsarist Russia and Qajar Persia sign a truce establishing borders after a Russian massacre of Turkmens at Geok Tepe

1884 · Tsarist Russia · Merv capitulates and the Persian border town of Sarakhs is captured by Russia

1884 · Qing Dynasty · Xinjiang becomes a province of the Manchu Empire with a viceroy installed in Yining, and is subsequently colonized

1885 · Tsarist Russia and Kingdom of Afghanistan · Russia conquers Transcaspia, the southwestern part of Western Turkestan bordering Persia

1885 · Tsarist Russia · Revolt in the Ferghana towns of Andizhan, Margellan and Osh against Russian colonization is brutally crushed

1885 · Tsarist Russia at war with the Kingdom of Afghanistan · A skirmish takes place at the Oasis of Panjdeh south of Merv

1885 · Qing Dynasty · A Dongan rebellion leads to massacres and popular uprisings, with Russia threatening intervention

1887 · Kingdom of Afghanistan · Demarcation of Afghan-Russian borders

1888 · Qing Dynasty · Eastern Turkestan is formally annexed under the name Xinjiang

1888 · British India · The British advance from Kashmir into the principality of Chitral seeking allegiance

1888 · Tsarist Russia · Lord Curzon travels from Baku across the Caspian Sea to Krasnovodsk and along the Transcaspian railway to Samarqand

1889 · Principality of Hunza · In the course of the Great Game, British army officer Younghusband and Russian captain Gromchevsky meet

1889 · Jammu and Kashmir · The Gilgit agency is re-established by the British Government of India to control Russian incursions across the Pamir Mountains

1890 · Qing Dynasty · The British and the Russians open consulates in Kashgar, Xinjiang, hotbed of Uighur secessionist efforts

1890—1892 · Tsarist Russia · Mass immigration of Russian and Ukrainian settlers into the Kazakh Steppes

1891 · Principalities of Hunza and Nagar · The British carry out incursions with Gurkhas and Kashmiri imperial service troops and capture Baltit and Nilt

1893 · Kingdom of Afghanistan · Establishment of the Durand line 'settles' British India's western border problem

1893 · Tsarist Russia · Construction of a fort at Termez on the Amu Darya, the ancient Oxus, to guard the Afghan border

1895 · Kingdom of Afghanistan · The British-Russian demarcation of Afghan-Russian borders establishes the Wakhan corridor in the Pamir Mountains

1898 (17 May) · Tsarist Russia · Calls for jihad in Andizhan, and an uprising led by Sufi Khan Tura is brutally crushed

1900 · Qing Dynasty · The Boxer Rebellion leads to the siege of the Beijing embassies and their subsequent relief by multinational forces who plunder the city

1904 · Qing Dynasty · Younghusband leads a British incursion into Tibet, entering Lhasa

1907 · British India and Tsarist Russia · The Anglo-Russian Convention ends the Great Game and incursions into the borderlands of Afghanistan

1907 · Qajar Persia · Due to concerns about German threat from the north, Persia is divided into Russian and British spheres of influence

1908 · Tsarist Russia · 665,000 Russian colonizers immigrate from the Urals into the Kazakh Steppes

1911 · Tsarist Russia · 200,000 people from European regions of Russia, or 4 per cent of the total population, migrate to the irrigated parts of Turkestan

1911 · Eastern Turkestan · Following the fall of the Qing Dynasty, more than 2000 years of imperial rule in China ends and warlord rule begins in Xinjiang

1914 · Tsarist Russia · By World War I railroad imperialism in Central Asia extends to 4300 km with extensions to the Afghan and Persian borders

1914 (28 June) · Austria-Hungary · Archduke Franz Ferdinand is assassinated by a Bosnian Serb, setting off a chain-reaction of war declarations leading to World War I

1914 (August) · Ottoman Empire · The secret Ottoman-German Alliance is signed, threatening Russia's Caucasian territories and Britain's communications with India

1914 (29 October) · Ottoman Empire · After joining the Central Powers, and bombarding the Russian Black Sea ports of Odessa, Sevastopol and Theodosia, the Sultan issues a fatwa calling for jihad against the Allied Powers

1914 (5 November) · Ottoman Empire · After recognizing Kuwait as an independent state under its protection, Britain declares war on the Ottoman Empire

1914 (December) · Ottoman Empire · Enver Pasha's Caucasian campaign against Russia fails

1915 · Tsarist Russia · The protectorate of Outer Mongolia is established

1915 · Ottoman Empire · The Armenian population in Anatolia is subject to repression, now recognized as genocide

1915 · Ottoman Empire · France, Great Britain and Italy secretly begin to plot the partition of the Ottoman Empire

1916 · Persia · A German mission dispatched across Persia fails to persuade the Emir of Afghanistan to join the war on the side of the Central Powers

1916 · Tsarist Russia · The nomadic population of Turkestan rises against forced labour conscription for the Russian army during World War I

1916 · Tsarist Russia · Anti-Russian and anti-colonialist rebellions by Muslim Jadid groups take place in Uzbek cities

1916 · Tsarist Russia · A major anti-Russian revolt by Kazakh-Kyrgyz tribes results in several hundred thousand migrants to China

1916 · Ottoman Empire · A Russian campaign in northeastern Turkey culminates in the capture of Erzurum and Trabzon

1916—1917 · Ottoman Empire · The British occupy Baghdad and Gaza

1917 · Tsarist Russia · Islamic revival in Central Asia and nostalgia for Pan-Turkism, spurred on by the Russian presence and encouraged by ideas of democracy and modern education, leads to the creation of the Jadids or Young Bukharians movement

1917 (October) · Tsarist Russia · The Bolshevik Revolution takes place

1917 · Bolshevik Russia · A Jadids conference in Turkestan leads to division with some supporting the Bolsheviks and others hostile to anything Russian

1917 · Bolshevik Russia · A Soviet is established in Tashkent made up of ethnic Russians belonging to rival Bolshevik factions and without Jadids

1917 · Bolshevik Russia · The Emir of Bukhara ignores the Tashkent Soviet's appeal for help persuading the Whites to join a struggle against the Jadids and the Reds

1917 · Bolshevik Russia · The Bolsheviks and the Emir of Bukhara sign a peace treaty. The Jadids are betrayed for a second time

1918 · Russian Turkestan · Khokand declares autonomy and the Tashkent Soviet crushes the revolt

1918 · Russian Turkestan · An autonomous Turkestan Republic is declared with a mandate limited to Tashkent

1918 · Russian Turkestan · The Turkmen leader Junaid Khan leads the army of the Khanate of Khiva, courted by the Reds and the Whites

1918 · Russian Turkestan · The Tashkent Soviet undermines British imperialism by playing a pan-Islamic card and welcoming Indian revolutionary agitators

1918 · Kingdom of Afghanistan · Negotiations with the Tashkent Soviet are intended to undermine British rule and the Bolsheviks using Afghans for their purposes

1918 · Russian Turkestan · The Bolsheviks crush the White armies and attack Khiva

1918 · Russian Turkestan · Large numbers of the 40,000 German or Austrian prisoners of war are recruited to the Red Army

1918 (February) · Russian Turkestan · Khokand is captured by the Bolsheviks

1918 (3 March) · Bolshevik Russia · The Treaty of Brest-Litovsk concludes World War I hostilities between the Central Powers and Russia and stipulates the cession by Russia of Batumi and Kars to the Ottoman Empire

1918 (March) · Russian Turkestan · A treaty is signed between the Emir of Bukhara and Tashkent Soviet and subsequently the first phase of Basmachi revolts in Ferghana force the Russians to conclude a truce with the Jadids

1918 (April) · Russian Turkestan · The Basmachi rebellion and of civil war begins

1918 (24 May) · Ottoman Empire · The German-mediated Treaty of Batum ends the war between the Democratic Republic of Armenia and the Ottoman Empire. Georgia declares
its independence

1918 (28 May) · Ottoman Empire · The Treaty of Poti signed by Germany and the Democratic Republic of Georgia to prevent Georgia's occupation by the Turks and to secure Berlin's position in German-
Turkish rivalry for Caucasian influence and resources

1918 (7 July) · Kashgaria · British spies Bailey, Blacker and Etherton arrive from Kashmir with a mission to proceed to Tashkent

1918 (12 July) · Russian Turkestan · Ashkhabad revolt against Bolshevik tyranny

1918 (14 July) · Russian Turkestan · Transcaspian government is established, also called the Ashkhabad Committee

1918 (24 July) · Russian Turkestan · Tashkent Soviet forces drive Transcaspian forces back to Merv Oasis

1918 (24 July) · Russian Turkestan · British War office instructs the commander-in-chief in India by telegram to afford maximum support to anti-German elements in Turkestan

1918 (25 July) · Transcaucasia · Coup d'état puts Baku and its oil wells into Bolshevik hands. British troops from Persia carry out incursion

1918 (12 August) · Russian Turkestan · In alliance with the Ashkhabad Committee, the British East Persia cordon force defeats the Bolsheviks

1918 (14 August) · Russian Turkestan · British spies Bailey and Blacker arrive in Tashkent

1918 (19 August) · Russian Turkestan · Britain and the Ashkhabad Committee sign an agreement to counter Bolshevism and stop a Turco-German invasion

1918 (28 August) · Russian Turkestan · The Bolsheviks attack the Ashkhabad Committee and the British East Persia cordon force

1918 (14 September) · Transcaucasia · British troops retreat after the breakthrough of the Turkish Army of Islam through the final defences of Baku

1918 (19 September) · Russian Turkestan · 26 Bolshevik commissars who escaped from Baku are executed near Krasnovodsk in Turkestan

1918 (30 October) · Ottoman Empire · Armistice of Mudros/Lemnos is signed by the Ottoman Empire and the Entente powers. All Ottoman activities in the World War I theatre are terminated

1919 (14 April) · Russian Turkestan · The withdrawal of British troops from the Transcaspian railway war marks the last stage of the Great Game

1919 · Russian Turkestan · The Bolsheviks capture Khiva

1919 · Kingdom of Afghanistan · The Third Anglo-Afghan war ends in Afghanistan's independence from British-India

1919 · Kingdom of Afghanistan · The Soviet Union is the first nation to recognize the new Afghan state and Afghanistan is the first neighbouring country to recognize Lenin's Bolshevik regime

1919 · Qajar Persia · An Anglo-Persian agreement centres around drilling rights for the Anglo-Persian Oil Company but is never ratified

1920 · Qajar Persia · Bailey arrives in Meshed as a member of the Bolshevik counter-intelligence service

1920 (30 June) · British Iraq · Sunni, Shi'ite and Kurdish insurrections against the British Mandate in Mesopotamia develop into a war of independence

1920 (September) · Russian Turkestan · General Frunze captures Bukhara and its Emir flees to Afghanistan

1920 · Russian Turkestan · The khanates of Khiva and Bukhara become People's Republics

1920 · Russian Turkestan · Peace ends between Bolsheviks and the Emir of Bukhara. People's Republic of Bukhara is established with the help of the Jadids

1920 · Soviet Central Asia · The Kazakh-inhabited northern part of Turkestan is split from the Autonomous Soviet Socialist Republic (ASSR) Turkestan and becomes the ASSR Kyrgyzstan

1920—1923 · Soviet Central Asia · Basmachi revolts in Central Asia enter a second phase

1920—1930 · Kingdom of Afghanistan · Thousands of Central Asian Tajiks, Turkmens and Uzbeks settle as refugees in northern Afghanistan

1921 (February) · Qajar Persia · After a period of anarchy, Iranian Cossack officer Reza Khan seizes power and establishes a dictatorship

1921 (23 August) · British Iraq · Exiled Arab Revolt leader Faisal is installed by the British as the King of Iraq

1921 · Russian Turkestan · The Red Army enters Dushanbe

1922 · The Kingdom of Afghanistan and France sign a convention to secure exclusive excavation rights for French archaeologists for thirty years

1923 (24 July) · Switzerland · Without a mention of the Kurds, the Treaty of Lausanne recognizes the Turkish state and establishes that the frontier between Turkey and Iraq shall be drawn in a friendly
arrangement to be concluded between Turkey and Great Britain

1924 · Soviet Central Asia · The khanates of Bukhara and Khiva are dissolved

1924 · Soviet Central Asia · The national delimitation and status of ASSR Uzbekistan and Turkmenistan are established

1924 · Soviet Central Asia · The national delimitation and foundation of ASSR Tajikistan and Kazakhstan are established

1924 · Soviet Central Asia · The Ferghana Valley is divided between the Soviet Republics of Uzbekistan, Tajikistan and Kyrgyzstan

1924 · Soviet Central Asia · The Tajiks are divided between newly formed Tajikistan and their homeland in today's Uzbekistan

1924 · Soviet Central Asia · The national delimitation and foundation of autonomous Kyrgyz and Karakalpak regions are established

1924 · Soviet Central Asia · Stalin purges communist parties in Soviet Central Asia from Jadids or Muslim nationalists and political deviationists

1925 · Soviet Central Asia · The ASSR Kazakhstan is established

1925 · Qajar Persia · Reza Khan announces that the Shah has been deposed and declares himself as the first Shah of the new Pahlavi dynasty

1926 · Soviet Central Asia · The Karakyrgyz Autonomous Oblast becomes the ASSR Kyrgyzstan

1928 · Soviet Central Asia · Beginning of industrialization and collectivization of private farms

1928 · Kingdom of Afghanistan · Nine months of Bacha ethnic Tajik rule in Kabul is terminated by Afghan Army

1929 · Soviet Central Asia · The Soviet Socialist Republic (SSR) of Tajikistan is established

1930 · Soviet Central Asia · The forced collectivization of Kazakh-Kyrgyz nomads results in tens of thousands being killed or migrating

1930 · Principiality of Hami · White Russians lend support against attacks in Xinjiang by the Dongan troops of warlord General Ma Zhongyin, also known as 'Great Horse'

1932 · Kingdom of Iraq · The British mandate in Mesopotamia ends and Iraq joins the League of Nations

1933 · British-mandated Palestine · After Hitler's accession the Mufti of Jerusalem offers his support and help to the German consul

1933—1934 · Turkish Islamic Republic of East Turkestan (TIRET) · Soviets carry out air raids. Red Army brigades attack General Ma's Dongan troops

1933 · Kingdom of Afghanistan · Interested in provoking British India and the Soviet Union, the Third Reich's scholars pursue the Nazi obsession with racial purity, and visit Nuristan's blond and blue-eyed population

1934 · Kingdom of Afghanistan · The USA establishes diplomatic ties with Kabul through its ambassador in Tehran

1936 · Soviet Central Asia · The autonomous Karakalpak region is transferred to SSR Uzbekistan

1936 · Soviet Central Asia · The SSR Kyrgyzstan and Kazakhstan are established

1936 · Kingdom of Iraq · After massacring a large number of the Assyrian community, the army stages the first of many coups

1936 · Kingdom of Iraq · The death of King Ghazi in an automobile crash is believed to be a British-instigated murder

1936 · Kingdom of Iraq · At the outbreak of World War II the USA advises the Iraqi government to cooperate with the British, leading Nationalists to see America as an enemy

1937 · Monarchy of Hami Oasis · The Soviet Red Army intervenes to stop Nationalist China's troops advance in Xinjiang

1939—1945 · The Kingdom of Afghanistan remains neutral during World War II

1941 (10 April–30 May) · Kingdom of Iraq · The pro-Axis Iraqi army is defeated in Baghdad's Shi'ite suburb by the British, aided by Assyrians and Jordan Legionnaires

1941 (22 June) · Soviet Union · Under Operation 'Barbarossa' 5.4 million troops of the Nazi-led Axis forces invade along a 2900 km front stretching from Archangelsk in the north to Astrakhan in the south

1941 (16 September) · Persia is invaded by British and Soviet forces

1941 · Kingdom of Afghanistan · After seeing Iran invaded by Soviet and British troops, Kabul complies with British and Soviet demands to evict 210 Germans

1942—1943 · Soviet Union · The Battle of Stalingrad is fought between the German Wehrmacht and the Soviet Red Army

1943 · Republic of China · The re-integration of Xinjiang into the motherland is declared

1944 · Soviet Central Asia · Accused of collaboration with Nazi Germany, Chechens and other Muslim peoples are deported from the Caucasus to Central Asia

1944—1945 · Eastern Turkestan Republic · Soviet air strikes are allegedly ordered against the Guomindang

After 1945 · The Kingdom of Afghanistan pursues a non-alignment policy during the Cold War

1947 · India · Declaration of independence from British rule. Muslim Pakistan splits from Hindu India resulting in an exodus of millions in both directions

1947 · 'Pashtunistan' · Pakistan's refusal of Afghan request to redraw the Durand Line gives rise to controversy about the division of the Pashtu people

1947 · Kashmir · After independence from British rule the first war takes place between Pakistan and India over Jammu and Kashmir

1947 (29 November) · Palestine · The UN General Assembly adopts a resolution for the partition of the city of Jerusalem into a Jewish state, an Arab state and a corpus separatum under international jurisdiction

After 1947 · Former Palestine · Fighting breaks out between Jews and Arabs, assisted by a volunteer force from Syria known as the Arab Liberation Army, and with the establishment of the state of Israel, the struggle for Palestine becomes the Arab-Israeli conflict, later to escalate into a series of wars that continues until today

1948 · Xinjiang · Kazakh refugees flee from communist rule to Tibet and eastern Kashmir

1949 · Pakistan and India · The Kashmir ceasefire line divides Pakistan and Indian controlled parts of Kashmir

1949 · People's Republic of China · Xinjiang is liberated from Nationalist rule by the People's Liberation Army

1949 · Soviet Central Asia · The first nuclear explosion takes place at the testing sites of Semipalatinsk in the Kazakh Steppe

1951 · People's Republic of China · The People's Liberation Army invades Tibet

1953 (16–19 August) · Persia · Operation 'Ajax', funded and led covertly by the American CIA and the British SIS, deposes Prime Minister Mohammed Mosaddeq and installs Reza Shah Pahlavi as Shah

1954 · Soviet Central Asia · The 'Virgin Lands' campaign is introduced by Khrushchev to enhance production in the Kazakh Steppes

1955 · People's Republic of China · Xinjiang is formally renamed in Xinjiang Uighur Autonomous Region

1955 · Iraq · The kingdom becomes a centrepiece for the Anglo-American Baghdad Pact with US Secretary of State J. F. Dulles demanding support in the Cold War

1955 and 1956 · Pakistan joins the anti-Communist SEATO (Southeast Asia Treaty Organization) and CENTO (Central Treaty Organization), a mutual defence pact that includes Iran, Iraq and Turkey

1955 · Kingdom of Afghanistan · Not being enlisted in CENTO because of its hostility towards Pakistan, the Afghans' request for arms is refused by the USA, who believe the country is indefensible against Red Army attack and strategically unimportant

1958 · People's Republic of China · Mao announces the Great Leap Forward and the Sinicization of Muslim Xinjiang begins

1958 (14 July) · Republic of Iraq · A military coup d'etat and revolution bring the monarchy to an end, and relations are established with the Soviet Union

1961 · Kingdom of Afghanistan · Pakistan closes its borders to Pashtu nomads after Afghan Prime Minister Daoud's continuing agitation of the 'Pashtunistan' issue

1961 · Kuwait · The Iraqis' territorial claim and threatening movements are encountered by dispatch of British troops

1962 · Xinjiang · 50,000 Kazakhs and other non-Han peoples join a mass exodus to Soviet Central Asia fleeing the communist party's Sinicization policy

1962 · India and People's Republic of China · War starts over the Himalayan borders in Ladakh

1965 · Kashmir · A second war begins between Pakistan and India over the divided state

1967 · People's Republic of China · The Cultural Revolution in Xinjiang is suspended

1971 · Kashmir · A third war begins between Pakistan and India over the divided state, leading to the break-up of Pakistan and the foundation of Bangladesh

1972 (3 July) · India · The Simla Agreement is signed by India and Pakistan, establishing the Line of Control as a notional border

1973 · Kingdom of Afghanistan · After a coup, Mohammed Daoud Khan becomes the first President of the Republic of Afghanistan and reduces the number of Soviet army advisers

1975 · Kashmir · An accord between India and Pakistan relinquishes the Kashmiri movement for self-determination

1978 (27 April) · Republic of Afghanistan · A Marxist military uprising removes Daoud and the Democratic Republic of Afghanistan is proclaimed

1978 (October) · Democratic Republic of Afghanistan · The People's Democratic Party of Afghanistan government announces reforms directly opposed to the socio-economic structure of rural society and provokes tribal revolts

1978 (December) · Democratic Republic of Afghanistan · The Treaty of Friendship and Good Neighbourliness is signed with the Soviet Union against background of a failing revolution in Afghanistan

1979 · Democratic Republic of Afghanistan · Under President Carter the US government begins covert funding of anti-Soviet forces despite warnings about provoking invasion

1979 (11 February) · Persia · After rebel troops overwhelm troops loyal to the Shah, the Pahlevi dynasty collapses

1979 (4 November) · Iran · Radical Islamist students take over the US embassy in Tehran in support of the Iranian revolution

1979 (December) · Iran · A new theocratic constitution is approved with Ayatollah Ruhollah Khomeini becoming leader of the Revolution and founder of the Islamic Republic

1979 (25 December) Democratic Republic of Afghanistan · Soviet Red Army units invade from Kushka, SSR Turkmenistan, and Termez, SSR Uzbekistan

1979—1989 · Democratic Republic of Afghanistan · An anti-Soviet jihad by CIA-funded mujaheddin forces of various ethnic backgrounds pulls the Red Army into a quagmire

1980 (24 April) · Iran · Operation 'Eagle Claw', ordered by President Carter to rescue American embassy hostages, fails in the desert near Tabas

1980 (22 September) · Republic of Iraq · In an attempt to restage the Arab vs Persian struggle of the first century of Islam, Saddam Hussein orders war on Iran, while the USA provides satellite imagery showing Iranian positions

1983 (December) · Republic of Iraq · Donald Rumsfeld, President Reagan's Special Envoy to the Middle East, visits Saddam Hussein and endorses the Iraqi cause on behalf of the American government

After 1983 · Republic of Iraq · America arranges supply of conventional weapons, cluster bombs, anthrax, and other biological weapons, as well as components for nuclear weapons and equipment for the manufacture of poison gas

1988 (20 August) · Iraq and Iran · After final confrontations in Khuzestan the UN Security Council-sponsored ceasefire brings the Iran-Iraq War or First Gulf War to an end without victory

1988 (16–17 March) · Iraq · In the course of the Kurdish campaign by the Baath regime, the use of chemical weapons in the town of Halabja results in 3–5,000 civilian deaths

1989 (15 February) · Democratic Republic of Afghanistan · The last Soviet Red Army units withdraw across the Friendship Bridge at Termez

1989 · Kashmir · The armed Muslim insurgency against Indian rule, to gain independence or unification with Pakistan, begins

1990 (2 August) · Kuwait · Iraqi troops invade Kuwait, 'returning' the Emirate to the homeland and giving Iraq access to the Gulf

1991 (January) · Saudi Arabia · King Fahd reluctantly agrees to invite American troops, ships and aircraft, including long-range bombers, to the Gulf

1991 (17 January) · Iraq · America launches a massive air assault

1991 (24–25 February) · Kuwait · The American ground offensive drives occupying Iraq forces from Kuwait and results in slaughter on the 'Highway of Death' unprecedented in the Middle East since Hulagu's capture of Baghdad

1991 (March) · Iraq · Anti-government revolts by the Shi'ite community are encouraged by Iranian and American governments. The collapse of the Kurdish uprising results in mass exodus towards Iran and Turkey

1991 (1 November) · Chechen Republic of Ichkeria · Djokhar Dudayev declares a northern Caucasian breakaway state from Russia

1991 (November) · Soviet Central Asia · The border with Iran, closed since the 1979 Revolution, reopens, permitting Turkmen barter trade

1991 (8 December) · Soviet Union · A treaty to disband the Soviet Union is drawn up without notification of the republican presidents of Central Asia

1991 (12 December) · Soviet Union · The republics of Kazakhstan, Kyrgyzstan, Tajikistan, Turkmenistan and Uzbekistan declare their independence

1991 (21 December) · Commonwealth of Independent States · The CIS is formed in the Kazakh capital Almaty with eleven of the fifteen former Soviet republics

1992—1993 · Islamic State of Afghanistan · Civil war between various Sunni mujaheddin factions and Shi'ite Hazara supported by Iran gives rise to warlordism

1992—1996 · Republic of Tajikistan · Civil war breaks out between forces of the United Tajik Opposition and the central government loyal to Moscow

1993 · Republic of Tajikistan · CIS collective peacekeeping forces are established

1994 (11 December) · Chechen Republic of Ichkeria · Assault by Russian troops and intense air bombardment begins

1994 · Islamic State of Afghanistan · The battle for Kabul between Dostum, Hekmatyar and Masud shuts down the air relief corridor and provokes a mass exodus of civilians

1994—1996 · Islamic State of Afghanistan · Political support by the USA through Pakistan's intelligence service and Saudi Arabia for the Taliban is viewed as anti-Shia, i.e. anti-Iran

1995 · Islamic State of Afghanistan · The Taliban emerges and campaigns against Hekmatyar, Masud, the Hazara and Ismail Khan and skirmishes with Iranian border troops

After 1995 · Kashmir · Increased militancy is fuelled by the infiltration and assumed support of Islamists by Pakistan's intelligence service

1996 (February) · Islamic State of Afghanistan · The Rabbani government signs an agreement with the Argentine company Bridas for a Trans-Afghanistan pipeline project

1996 (26 April) · People's Republic of China · The Treaty on Deepening Military Trust in Border Regions is signed by the heads of the Shanghai Five, i.e. the People's Republic of China, Kazakhstan, Kyrgyzstan, Russia and Tajikistan

1996 (May) · Iran · Completion of the railroad link joining the Transcaspian line built under the Tsars in Central Asia

1996 (May) · Islamic State of Afghanistan · Osama bin Laden, expelled from Sudan, arrives in Afghanistan

1996 (August) · Turkmenistan · Russian Gazprom and US Unocal/Delta sign agreements for a second Afghan pipeline project

1996 (26 September) · Islamic Emirate of Afghanistan or Taliban State · The Taliban captures Kabul and subsequently campaigns against Dostum and Masud

1997 · People's Republic of China · Uighur Muslim separatists demonstrating in Yining/Xinjiang against Chinese rule are crushed by government security forces

1997 (February) · USA · A Taliban delegation in Washington seeks US recognition and meets Unocal representatives

1997 (24 April) · Russia · The Shanghai Five sign the Treaty on Reduction of Military Forces in Border Regions

1997 (24–28 May) · Islamic Emirate of Afghanistan · The Taliban take and lose Mazar and Pakistan recognizes the Taliban government

1997 (12 June) · Islamic Emirate of Afghanistan · Ahmed Shah Masud forms the Northern Alliance to counter the Taliban after their renewed capture of Mazar-e-Sharif

1997 (8–12 September) · Islamic Emirate of Afghanistan · The Taliban recapture Mazar airport and Dostum returns from Turkey

1998 (14 March) · Islamic Emirate of Afghanistan · Fighting takes place in Mazar between Dostum's Uzbek forces and the Hazara

1998 (31 July) · Pakistan · Taliban leaders visit Dar-ul-Uloom Haqqania madrassa appealing for manpower and subsequently Pakistani fighters flow into Afghanistan

1998 (7 August) · Kenya and Tanzania · Simultaneous car bomb explosions linked to the al Qaeda terrorist network destroy the US embassies in Nairobi and Dar es Salaam

1998 (18 August) · Iran and Afghanistan · Ayatollah Khamenei accuses the USA and Pakistan of using the Taliban to plot against Iran. Mullah Omar announces protection for Osama bin Laden

1998 (20 August) · Islamic Emirate of Afghanistan · American missile strikes are ordered by President Clinton against al Qaeda camps in southern Afghanistan

1998 (1–6 September) · Iran · War exercises on the Afghan border deploy 70,000 troops, as the Taliban seek recognition by the UN

1998 (2 October) · Islamic Emirate of Afghanistan · Iranian aircraft violate the Afghan airspace of Herat and 200,000 troops take part in exercises

1998 (25 October) · Islamic Emirate of Afghanistan · The Taliban ban the use of landmines

1999 · People's Republic of China · Launch of 'Great Western Exploitation Plan' in Xinjiang

1999 (January) · USA · The Silk Road Strategy Act is passed by the US Senate to assist economic and political independence in the Central Asian republics

1999 (31 January) · Islamic Emirate of Afghanistan · A Chinese delegation in Kabul meets the Taliban

1999 (2 February) · Islamic Emirate of Afghanistan · An Iranian delegation meets the Taliban in Dubai and US Deputy Secretary of State Talbott meets them in Islamabad

1999 (February) · Kashmir · Pakistani Army units, possibly helped by Kashmiri guerrillas and Afghan mercenaries, re-occupy posts on the Line of Control in the Kargil region of
Indian-administered Kashmir

1999 (11 March) · Turkmenistan · Talks between the Taliban and opposition parties take place under UN mediation

1999 (7 April) · Tadjikistan · The Russian Defence Minister meets Masud and announces the building of a new military base in Tajikistan

1999 (10 April) · Islamic Emirate of Afghanistan · Mullah Omar rules out further talks with Masud's Northern Alliance

1999 (5 May) · Iran and Uzbekistan · Tehran and Tashkent issue statements opposing the Taliban takeover of Afghanistan

1999 (26 May–July) · Kashmir · An Indian patrol is ambushed, leading to the exposure of Pakistani infiltration across the Line of Control into Indian-administered Kashmir and subsequently
Indian Operation 'Vijay' mobilizes 200,000 troops

1999 (early summer) · Uzbek Sukh enclave in Kyrgyzstan · Used by Juma Namangani's Islamic Movement of Uzbekistan (IMU), the mainly Tajik-populated enclave becomes a hotbed of Central
Asian jihad aiming to reach the Ferghana Valley

1999 (8 June) · USA · As fears of attacks in the USA mount, the FBI places Osama bin Laden on their top ten list of wanted terrorists

1999 (6 July) · Islamic Emirate of Afghanistan · The Taliban prepares an offensive against the Northern Alliance with thousands of Pakistani and hundreds of Arab recruits joining the war

1999 (August) · Kyrgyzstan · Fearing that Uzbekistan's pressure on Tajikistan will force Dushanbe to disband his IMU forces, Namangani sends guerilla troops into Kyrgyz territory around the
Sukh and Vorukh enclaves taking hostages

1999 (August) · Uzbekistan · From their base in Afhganistan the IMU declares the launch of jihad to topple the Karimov regime and capture the Ferghana Valley

1999 (20 September) · Russia · Moscow claims that Afghanistan-based Afghans, Pakistanis and Arabs are fighting in Dagestan and Chechnya

1999 (25 September) · Islamic Emirate of Afghanistan · After the Taliban advance, heavy fighting takes place around the Northern Alliance's capital of Kunduz

1999 (1 October) · Chechen Republic · The Second Chechen War restores Russian federal control

1999 (12 October) · Pakistan · A military coup by General Musharraf overthrows the government of Prime Minister Nawaz Sharif

1999—2000 (winter) · Islamic Emirate of Afghanistan · IMU leaders Namangani and Yuldashev travel frequently to Kandahar for strategy talks with Mullah Omar and Osama bin Laden and
negotiations for supply of arms, ammunition and money.

1999—2000 · Tajikistan · Infiltrations and attacks by the IMU take place in Kyrgyzstan and Uzbekistan

2000 · Uzbekistan · The mining of borders coincides with the expansion of territory and air raids against alleged IMU targets in Tajikistan and Kyrgyzstan

2000 (February) · People's Republic of China · 'Go west, young Han' campaign is launched as part of a plan to develop China's western provinces, especially Xinjiang

2000 · Kyrgyzstan and Uzbekistan · An IMU campaign prompts massive international response, with China, France, Israel, Russia, Turkey and the US flying in supplies and
counter-insurgency equipment

2000 · Islamic Emirate of Afghanistan · Namangani withdraws his forces to Mazar-e-Sharif, with the IMU becoming a pan-Islamic force drawing fighters from Kyrgyz, Tajik and Uzbek youth, as
well as Chechens and Uighurs from Xinjiang

2000 (5 September) · Islamic Emirate of Afghanistan · Masud's HQ Taloqan falls after a month-long siege by the Taliban, with several hundred IMU fighters, 4,000 Pakistani Islamic militants,
600 fighters from bin Laden's 055 Arab Brigade, part of al Qaeda, as well as Chechens and Uighurs, with officers from Pakistan's Inter Service Intelligence and commandos from 1st Special
Services Group playing a major coordinating role

2000 (12 October) · Yemen · US destroyer USS *Cole* is attacked while refuelling in Aden harbour by two suicide bombers, veterans of the war in Afghanistan

2001 (15 June) · People's Republic of China · The Declaration of the Shanghai Cooperation Organization (SCO) is signed by the Shanghai Five, and Uzbekistan is admitted to the group aiming at higher level of cooperation

2001 (16 July) · Russia and People's Republic of China · The SCO's leading nations sign the Treaty of Good Neighbourliness and Friendly Cooperation

2001 (31 July) · Kyrgyzstan · IMU fighters, apparently sleepers based in villages, carry out attacks in the Batken region, providing proof of successful arms-smuggling during the previous winter

2001 (9 September) · Islamic Emirate of Afghanistan · Northern Alliance leader Masud is assassinated by two Algerian members of al Qaeda posing as journalists

2001 (11 September) · USA · Members of al Qaeda carry out terrorist attacks against targets in New York and Washington, D.C.

2001 (16 September) · USA · President George W. Bush vows to wage a 'crusade' against terrorism, this 'new kind of evil'

2001 (20 September) · USA and Islamic Emirate of Afghanistan · President George W. Bush addresses US Congress with a call to arms, and the Taliban respond with a call for Holy war against infidels invading an Islamic country

2001 (September 24–25) · Russia and Central Asian Republics · US forces are offered limited military facilities, intelligence cooperation, use of air space and landing rights for US aircraft in trouble

2001 (25 September) · USA · The codename for the US military campaign in Afghanistan is changed from 'Infinite Justice' to 'Enduring Freedom'

2001 (5 October) · Uzbekistan · Tashkent, lifting the ban on conducting combat missions from Uzbek soil, gives permission for US troop and aircraft presence in support of Operation 'Enduring Freedom' under an agreement reached by US Secretary of Defence Donald Rumsfeld, with President Islam Karimov receiving security assurances and an implied US commitment to ignore complaints about human rights violations in the country

2001 (7 October) · Islamic Emirate of Afghanistan · American and British forces attack Afghanistan as Al Jazeera television broadcasts Osama bin Laden's videotaped call for global jihad

2001 (15 October) · Kashmir · Indian artillery pounds Pakistani lines

2001 (19 October) · Islamic Emirate of Afghanistan · US commando raid invades Mullah Omar's headquarters compound in Kandahar

2001 (19 October) · Islamic Emirate of Afghanistan · US warplanes bomb Taliban frontlines north of Kabul

2001 (November) · Islamic Emirate of Afghanistan · Fleeing Taliban are met by forces of Ismail Khan, Dostum and Masud's successor Atta

2001 (5 November) · Islamic Emirate of Afghanistan · US warplanes drop Daisy Cutter bombs, which North Vietnam once protested were 'weapons of mass destruction', as well as thermobaric bombs on caves and tunnels at Tora Bora

2001 (13 November) · Islamic Emirate of Afghanistan · Northern Alliance troops enter Kabul and join battle for Kunduz against the Taliban combined with al Qaeda fighters and Chechen, Indonesian, Pakistani, Punjabi and Uighur volunteers

2001 (14 November) · USA · UN Resolution 1378 supports international efforts to root out terrorism in keeping with the Charter of the United Nations

2001 (26 November) · Islamic Emirate of Afghanistan · An uprising of Taliban prisoners in Qala Jangi prompts US air strikes and a six-day battle with Dostum's Uzbek forces

2001 (November) · Collapsing Islamic Emirate of Afghanistan · All the major players of anti-Soviet jihad and civil war factions assume their former positions

2001 (December) · Kyrgyzstan · Manas Airbase is opened for use as part of the US armed forces' Operation 'Enduring Freedom' in Afghanistan

2001 (December) · Afghanistan and Pakistan · Al Qaeda negotiates with the Afghan fighters organized by the US while Osama bin Laden clears the caverns of Tora Bora across the Durand Line into Pakistan's Federally Administered Tribal Areas (FATA)

2001 (5 December) · Germany · The Agreement on Provisional Arrangements in Afghanistan Pending the Re-Establishment of Permanent Government Institutions (the Bonn Agreement) aims to rebuild the State of Afghanistan and expresses appreciation to the Afghan mujaheddin for having 'defended the independence, territorial integrity and national unity of the country and having played a major role in the struggle against terrorism and oppression'

2001 (6 December) · USA · UN Resolution 1383 reaffirms its strong commitment to the sovereignty, independence, territorial integrity and national unity of Afghanistan and stressing the inalienable right of the Afghan people themselves freely to determine their own political future

2001 (7 December) · Collapsing Islamic Emirate of Afghanistan · Kandahar is abandoned by the Taliban

2001 (20 December) · USA · UN Resolution 1386 ensures the full implementation of the mandate of the International Security Assistance Force (ISAF) in consultation with the Afghan Interim Authority established by the Bonn Agreement

2002 (29 January) · USA · President George W. Bush delivers the State of the Union Address and declares that an 'axis of evil', comprising Iran, Iraq and North Korea, harbours terrorists

2002 (February) · Transitional State of Afghanistan · Battles take place between Ghilzai Pashtun tribes in Gardez and between Tajiks and Uzbeks for control over Mazar

2002 (2–13 March) · Transitional State of Afghanistan · Operation 'Anaconda' is supported by Afghan forces south of Khost, the first major battle of regular US Army troops since September 11

2002 (10–20 June) · Transitional State of Afghanistan · The Loya Jirga gives the Transitional Authority 18 months to hold second national assembly to adopt constitution and 24 months to hold national elections

2002 (September) · Republic of Ingushetia · The war in Chechnya spills over across the border for the first time

2003 (20 March) · Iraq · A massive air assault opens the US-led invasion and pre-emptive war, central to the Bush administration's ambition to remake the Middle East into a set of pro-Western market-oriented democracies

2003 (16 April) · USA · President George W. Bush declares Iraq 'liberated'

2003 (May) · Iraq · With the invaders unable to declare victory, despite having wiped out the Iraqi army, demonstrations lead to casualties, then more military-style attacks and escalating war

2003 (5 July) · Islamic Republic of Afghanistan · First NATO troops set off for Kabul

2003 (8 August) · Islamic Republic of Afghanistan · NATO takes command and coordination of International Security Assistance Force (ISAF), its first mission outside the Europe-Atlantic area

2003 (2 September) · Iraq · In defiance of a ban, crowds of Shi'ites march through Najaf and are fired upon. Subsequent attacks on troops gain civil war proportions

2003 (14 September) · Iraq · Without producing evidence, US Secretary of State Colin Powell claims the existence of up to 2000 foreign militants in the country

2003 (13 October) · USA · UN Resolution 1510 opens the way for the wider role of ISAF to support the government of Afghanistan beyond Kabul

2003 (31 December) · Islamic Republic of Afghanistan · The military element of the German-led Provincial Reconstruction Team (PRT) in Kunduz becomes subject to the ISAF chain of command as a pilot project

2004 · Iraq · The American-led Iraq Provisional Authority echoes the British system imposed in the 1920s

2004 (11 March) · Spain · Al Qaeda suicide bombers attack a Madrid railway station in an effort to urge Spain to withdraw its troops from Iraq and to restore al Andalus (southern Spain) to Muslim rule. Spanish troops being pulled out of Iraq are replaced by forces of private military firms who have flocked into the country to undertake 'security tasks'

2004 (4 June) · Islamic Republic of Afghanistan · NATO assumes a key role in expanding ISAF operations and four more PRTs are established against the regrouping of Taliban

2004 (July) · Iraq · American intelligence officers concede that at least 50 organizations with 20,000 combatants are involved in insurgency and attacking occupying forces at least 60 times a day

2005 (13 May) · Uzbekistan · Interior Ministry and National Security Forces kill several hundred protesters and claim they are members of Hizb ut-Tahir at a rally in Andizhan allegedly organized by the Islamic Movement of Uzbekistan but ostensibly a peaceful protest for the release of local businessmen charged with extremism, fundamentalism and separatism

2005 (7 July) · England · Four suicide bombers with connections to al Qaeda figures based in Pakistan's FATA carry out attacks on the London public transport network

2005 (19 December) · Islamic Republic of Afghanistan · Refusing to accept that the insurgency is expanding, US Secretary of Defense Donald Rumsfeld pulls out 3,000 US troops from the south as the largest Taliban offensive under the new insurgency is about to unfold

Since 2005 · Iraq · Sectarian and inter-religious violence brings the country close to a Sunni-Shi'ite civil war

2006 (22 February) · Iraq · Members of al Qaeda in Mesopotamia destroy Iraq's minority Shi'ite community's holiest Askariya shrine in Samarra

2006 (June) · Islamic Republic of Afghanistan · Forty-seven suicide attacks in the first six month indicate the 'Iraqization' of the conflict in Afghanistan

2006 (July–September) · Islamic Republic of Afghanistan · ISAF expands operations into six additional provinces in the South. Major battles take place between the Taliban and British and Canadian troops in Helmand

2006 (5 October) · Islamic Republic of Afghanistan · ISAF takes command of international military forces in eastern Afghanistan from the US-led coalition

2007 · Afghanistan, Pakistan and the world · Under Operation 'Enduring Freedom', the American-led campaign against re-emerging Taliban fighters in Afghanistan and in Pakistan's FATA continues as the 'war against international terrorism'

2007 · Pakistan · The Pakistan Taliban emerge operating inside the country

2007 (2 July) · Yemen · A car bomb attack by a member of the Islamic Jihad Union, a Central Asian terrorist group allied to al Qaeda, kills seven Spanish tourists near a temple linked to the ancient Queen of Sabah

2007 (July) · USA · The National Intelligence Estimate concludes that al Qaeda has re-established its central organization, training infrastructure and lines of global communication primarily due to safe havens in FATA

2007 (September) · Germany · Authorities arrest three German Muslims who have trained with the Islamic Jihad Union and al Qaeda and who wish to bomb the US air force base at Ramstein

2007 (September) · Pakistan · Militant Pakistanis operating under Baitullah Mehsud, a former member of the Taliban and protégé of Mullah Omar, seize Pakistani army convoy and force 270 Frontier Corps soldiers to surrender

2007 (December) · Pakistan · Forty extremist militia commanders in FATA and North-West Frontier Province set up the umbrella organization Tehreek-e-Taliban (Taliban Movement in Pakistan) and name Baitullah Mehsud as their Emir

2007 · Islamic Republic of Afghanistan and Pakistan · Taliban and other Islamic militants intensify cross-border operations from bases inside the FATA, believed to still contain al Qaeda's senior leaders Osama bin Laden and Ayman al-Zawahiri

2008 · Islamic Republic of Afghanistan · With the Iraq theatre cooling, well trained fighters join the Taliban insurgency contributing to growing overall violence

2008 (4 August) · People's Republic of China · Coinciding with the opening of the XXIX Summer Olympic Games in Beijing, suicide attacks take place against police forces in Kashgar, Xinjiang, allegedly committed by members of the Uighur's East Turkestan Independence Movement

2008 (8 August) · Georgia · Georgian forces attack the secessionist territory of South Ossetia, opening a window for Moscow to reassert its influence in the Caucasus and provoking the invasion of Russian forces

2008 (20 September) · Pakistan · A suicide truck bomber attacks the Marriott Hotel in Islamabad contributing to the chaos engulfing the country

2008 (October) · USA · After years of denial by President George W. Bush, America's intelligence agencies warn that Afghanistan is on a downward spiral and an optimistic prognosis predicts that another ten years is needed to stabilize what is called the real front line in the 'war on international terrorism'

2008 (4 October) · Islamic Republic of Afghanistan · The British ambassador in Kabul condemns ISAF's overall mission and calls the NATO coalition's military presence, consisting of troops from 41 nations, 'part of the problem and not of its solution'

WHAT NOW?

AS FAR AS WE KNOW

SUMMER 330 BCE

HAROYU HARAIAVA **ALEXANDRIA-IN-AREIA** HARI HARE HERAT

PHRADA PROPHTASIA-IN-DRANGIANA **ALEXANDRIA-IN-DRANGIANA** FARAH

ALEXANDRIA-IN-ARACHOSIA **ISKANDAHAR** **ISKANDARIYA** **KANDAHAR**

KAPISA-KANIS **ALEXANDRIA-AD-CAUCASUM** **ASKANDRIA-E-QAFQAZ** **ASKANDRIA PARO PAIZAD** **ALASANDRA** CHARIKAR

ZARIASTES BAKTRON BACTRA BALC BALCIA VALQ BALACH WALDACH BALKH

ALEXANDRIA-OXIANA AI KHANUM

XENIPPA NAKHSHAB NASAF KARSHI

AFRASIYAB MARACANDA SANMARCAN SAMARCADIA SAMARQAND

MARGIANA **ALEXANDRIA-IN-MARGIANA** ANTIOCHEIA-MARGIANA MARGIANIAN MERV MARY

CYROPOLIS CYRESCHATA SURUSHANA OSRUSHANA KURUS KATHA KURKATH

ALEXANDRIA-ESCHATE **ALEXANDRIA ULTIMA** KHUJANDRA KHUJAND

SPRING 327 BCE

RESERVOIR AFTER TWO YEARS OF DROUGHT | ARGANDABAD VALLEY | AFGHANISTAN 2001

WAR IS A MISERABLE BUSINESS

AGS-17 30MM AUTOMATIC GRENADE LAUNCHER
AK47 AVTOMAT KALASHNIKOV
ARQUEBUS
ARROW
BALLISTA
BARRETT .50 CAL SNIPER RIFLE
BOW
CANNON
CATAPULT
CROSSBOW
DAMASCENE STEEL
FLAME THROWER
FN FAL AUTOMATIC RIFLE
FRAGMENTATION HAND GRENADE
GENERAL-PURPOSE MACHINE GUN
GPS-READING JDAM SMART BOMB
GREAT LONG-RANGE CROSSBOW
GRENADE
GROUND RATS
HACKENBÜCHSE
HAND GUN
HELLFIRE AIR-TO-GROUND MISSILE
HIGH EXPLOSIVE NITRATE GUNPOWDER
INFANTRY LONGBOW
INFANTRYMAN'S SWORD
JAVELIN
KALIKOV AK74
LANCE
LACQUERED CAVALRY LANCE
LASER-TARGET-DESIGNATOR'S BINOCULARS
LEE ENFIELD 303
LIGHT MACHINE GUN
LONG STEEL-HEADED ARROW
MACEDONIAN PIKE
MANGONEL
MATCHLOCK MUSKET
MAKAROV OFFICER'S SIDE ARM
MENG-HUO YU (FIERCELY BURNING OIL)
MILITARY ROCKET A.K.A. HUO-CHIEN (FIRE ARROW)
MULTI-LAUNCHER ROCKET SYSTEM
NAFT OR HIGH EXPLOSIVE NITRATE GUNPOWDER
NAPHTA OR GREEK FIRE
NOMADS' WHISTLING-HEAD ARROW
PREDATOR DRONE
ROCKET-PROPELLED FIRE ARROWS
RPD SOVIET SNIPER RIFLE
RPG-7 ROCKET-PROPELLED GRENADE LAUNCHER
RPG-18 ANTI-TANK ROCKET
RPK-74 SOVIET LIGHT MACHINE GUN
SA-80 STANDARD ISSUE BRITISH RIFLE
SABRE
SAGGER AIR-TO-GROUND MISSILE
SHIELD
SHORT-MAGAZINE LEE-ENFIELD
SHOULDER-FIRED STINGER
SKS SOVIET SIMONOV ASSAULT RIFLE
SOVIET 82-MM MORTAR M1937
SPEAR
SPIGOT ANTI-TANK MISSILE
SWORD
TACTICAL INTERVENTION SPECIAL SNIPER RIFLE SLING
TA-SHIH KUO (GUNPOWDER)

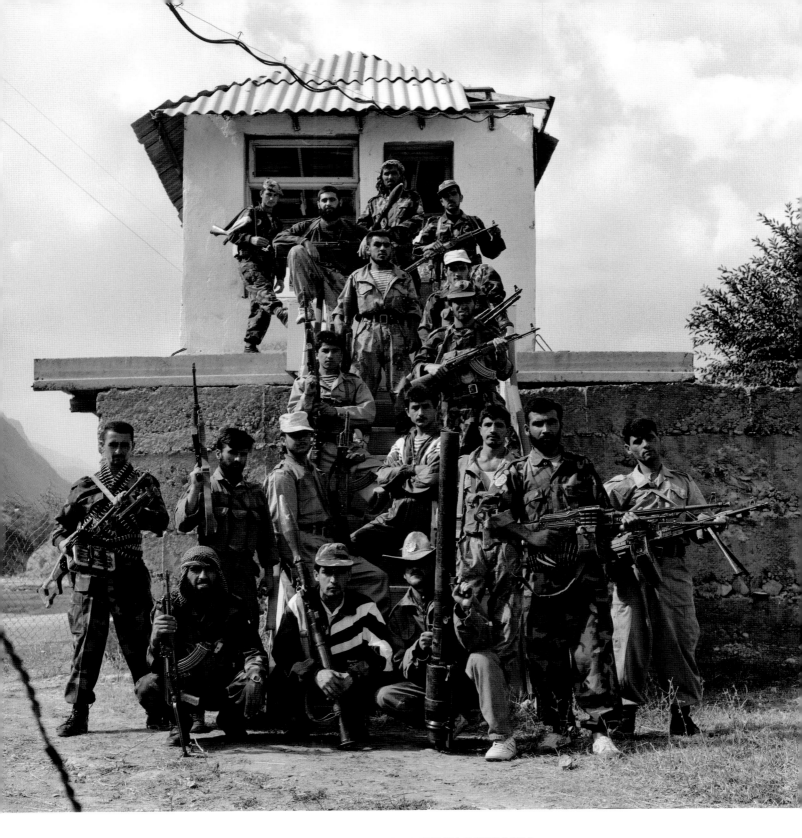

MULTINATIONAL OPPOSITION FORCE | BADAKHSHAN | TAJIKISTAN 1996

240

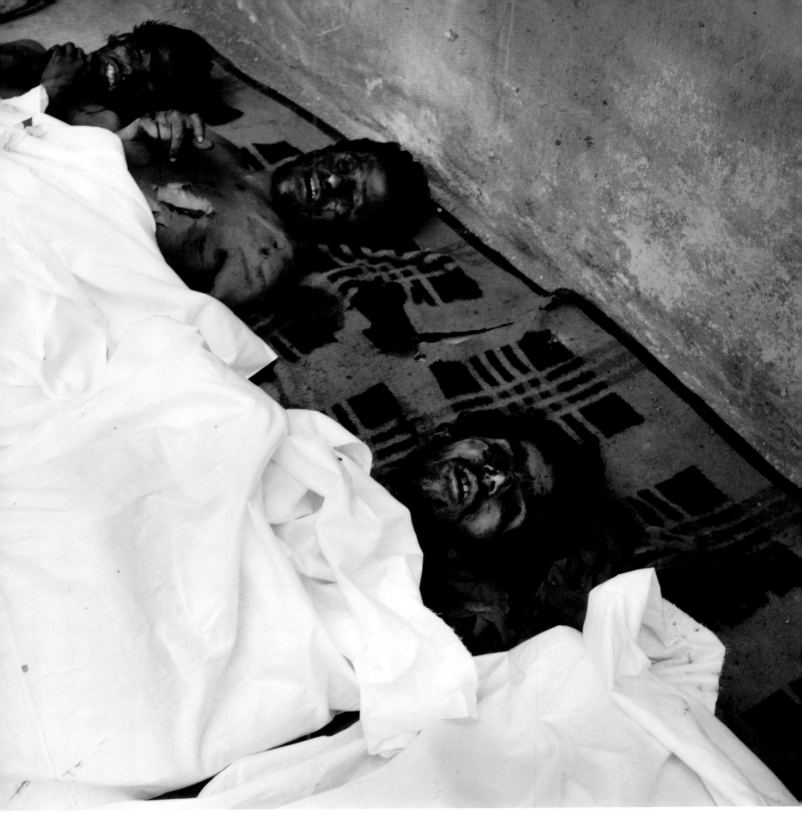

ISLAMIST FIGHTERS KILLED IN ACTION | KASHMIR | INDIA 2000

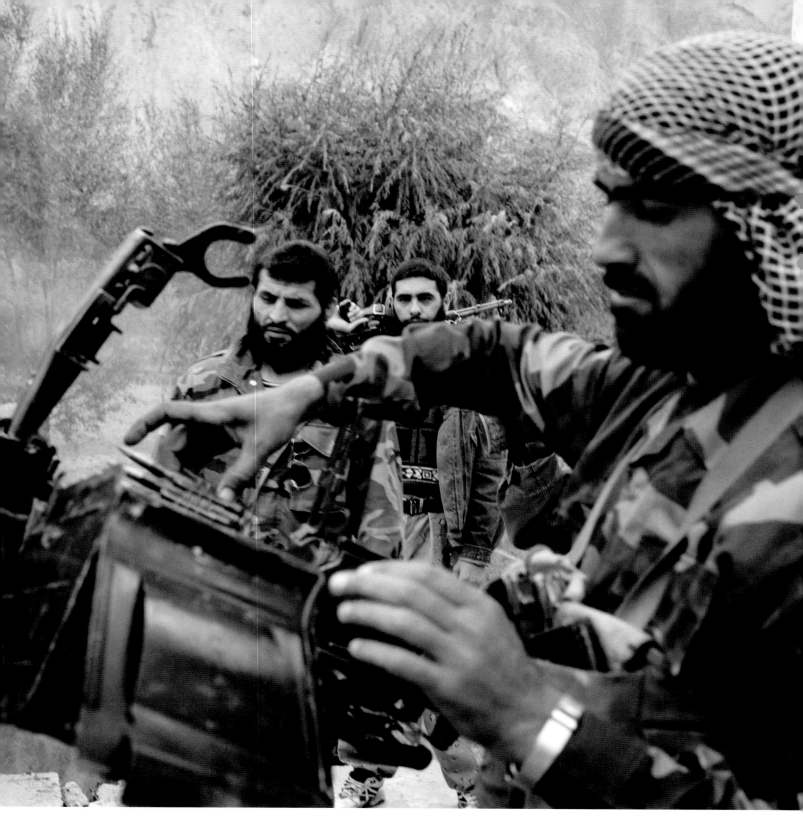

MULTINATIONAL OPPOSITION FORCE | BADAKHSHAN | TAJIKISTAN 1996

ON AN ORDINARY DAY

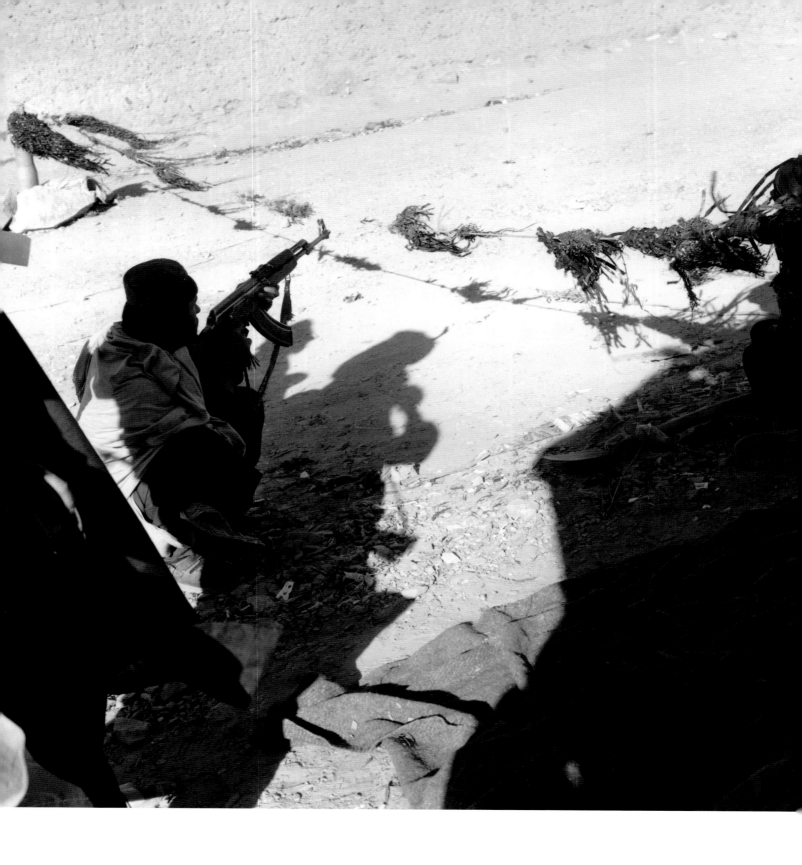

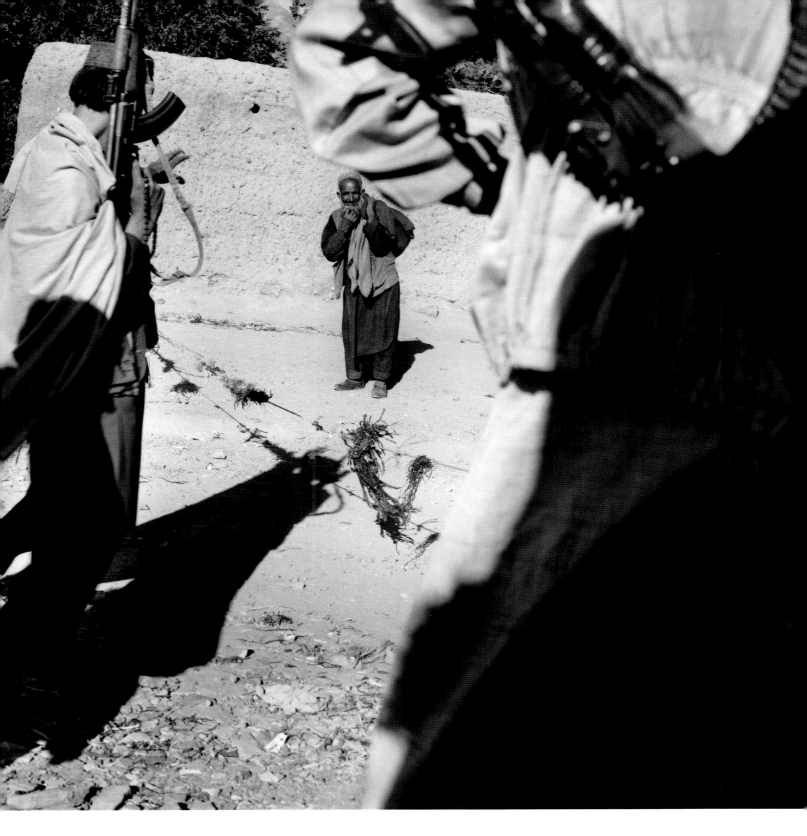

TALIBAN FRONTLINE MADE OF MUSIC TAPES | TAGAB VALLEY | AFGHANISTAN 1998

PLUNDERED COINS ROOM | NATIONAL MUSEUM | KABUL | AFGHANISTAN 1998

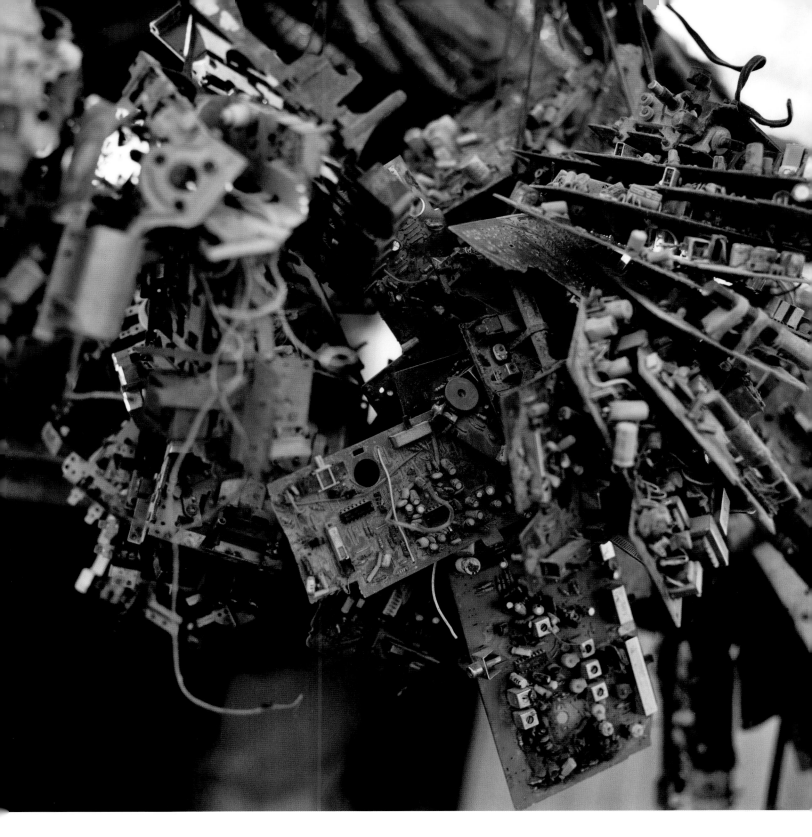

TV CIRCUIT BOARDS | MAZAR-E SHARIF | AFGHANISTAN 2002

248

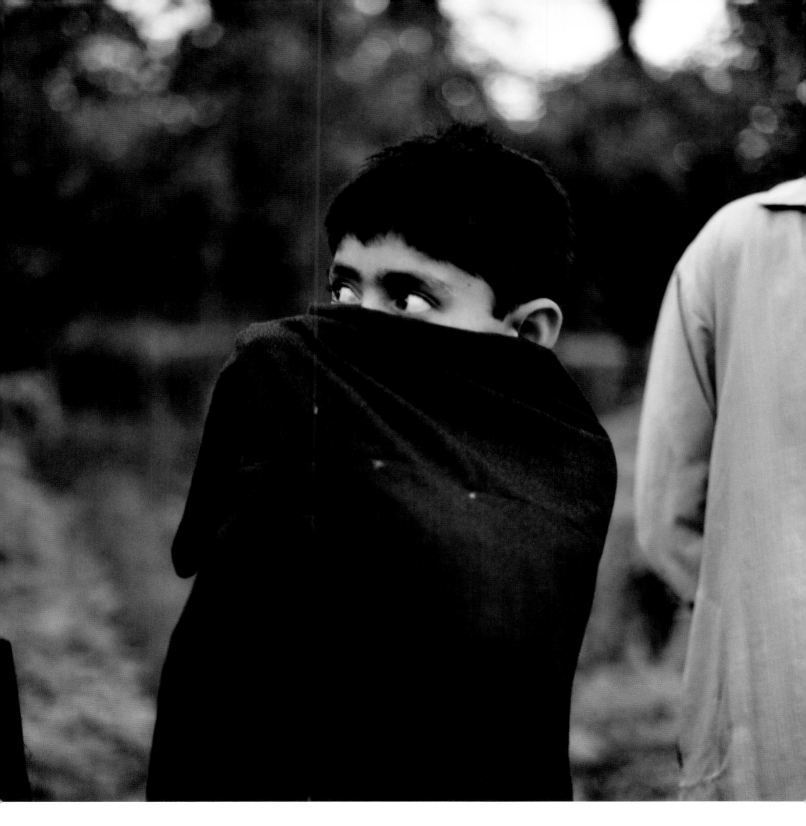

PASSING BY
OBJECTS FROM
THE REMOTE PAST
AND CONDITIONS
OF UNCERTAIN
OUTCOME

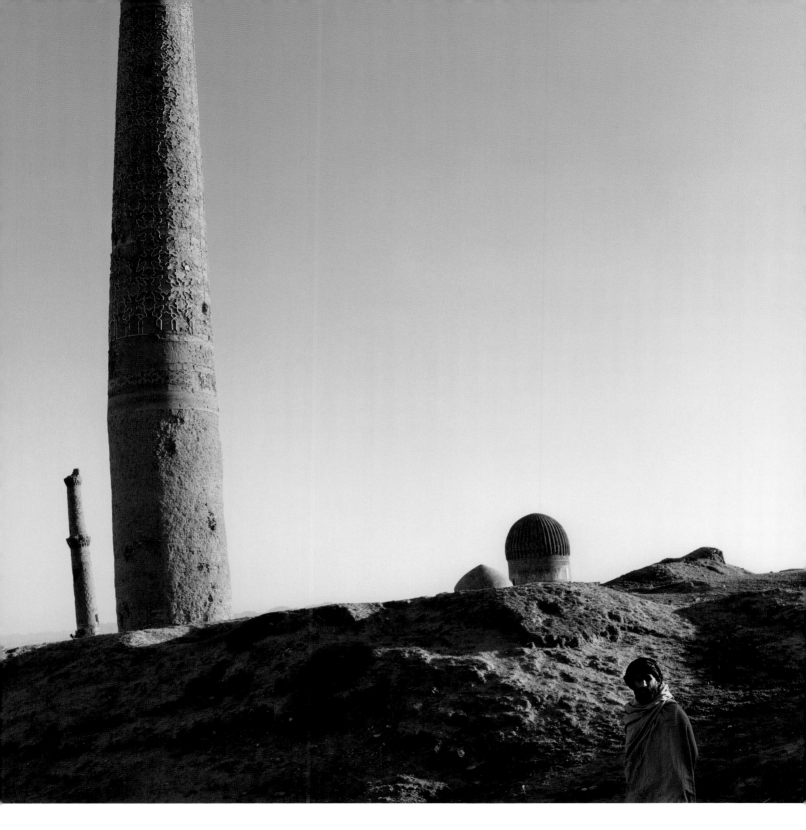

TIMURID MINARET AND MAUSOLEUM DOME | HERAT | AFGHANISTAN 2001

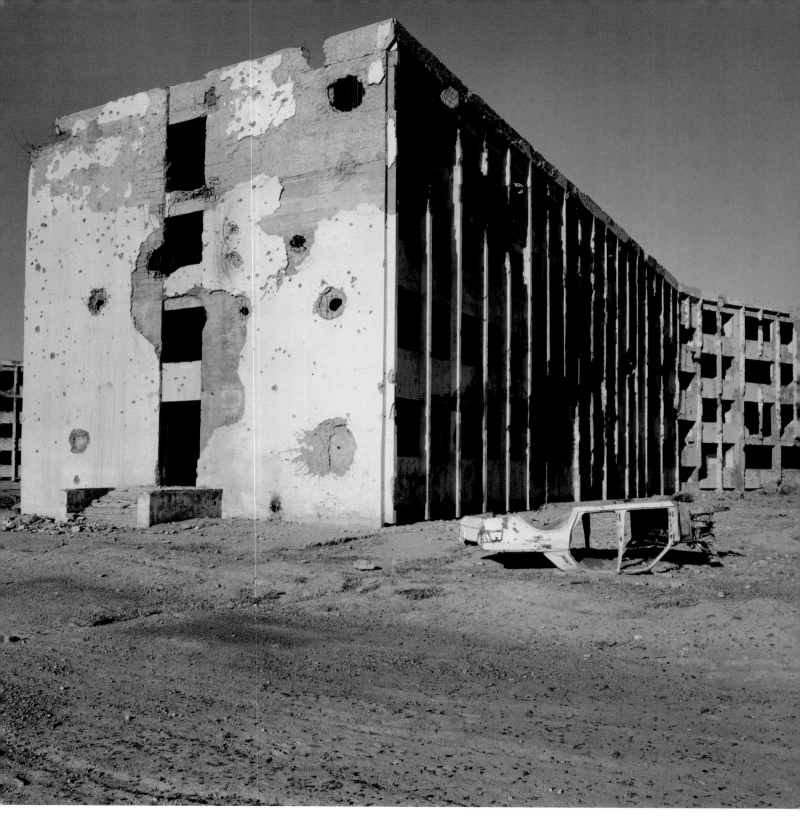

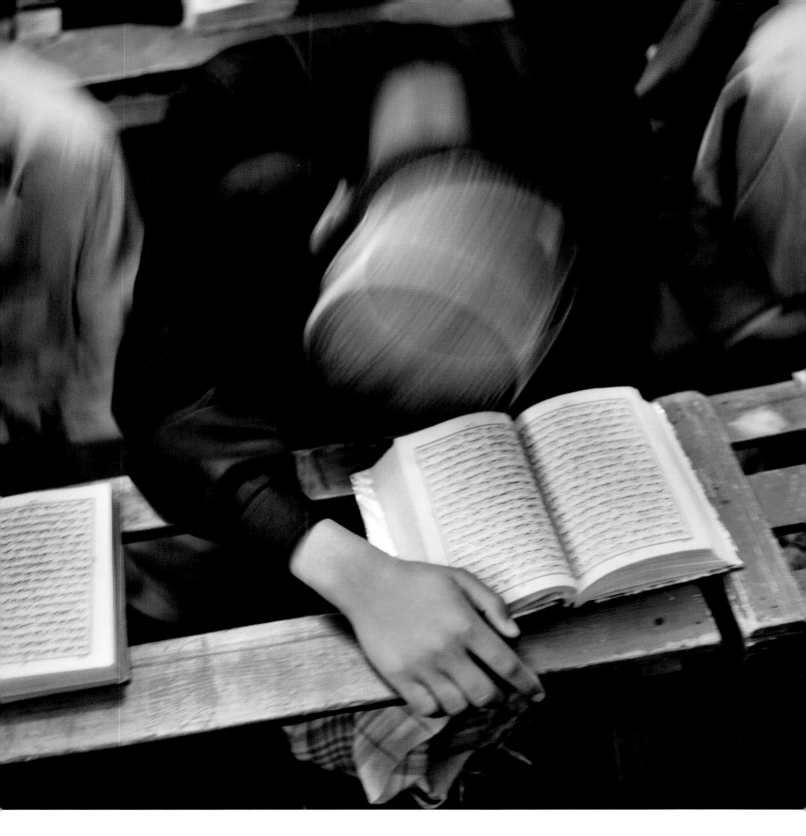

STUDYING THE HOLY KORAN | DARUL ULOOM HAQQANIA MADRASA | AKORA KHATTAK | PAKISTAN 2001

TERRITORY OF THOUGHT

256

TRUE BEGINNING OF THE ROAD

TO BE FOUND BY SPIRITUAL WANDERERS

TRAVAILS OF ACTUAL TRAVELS

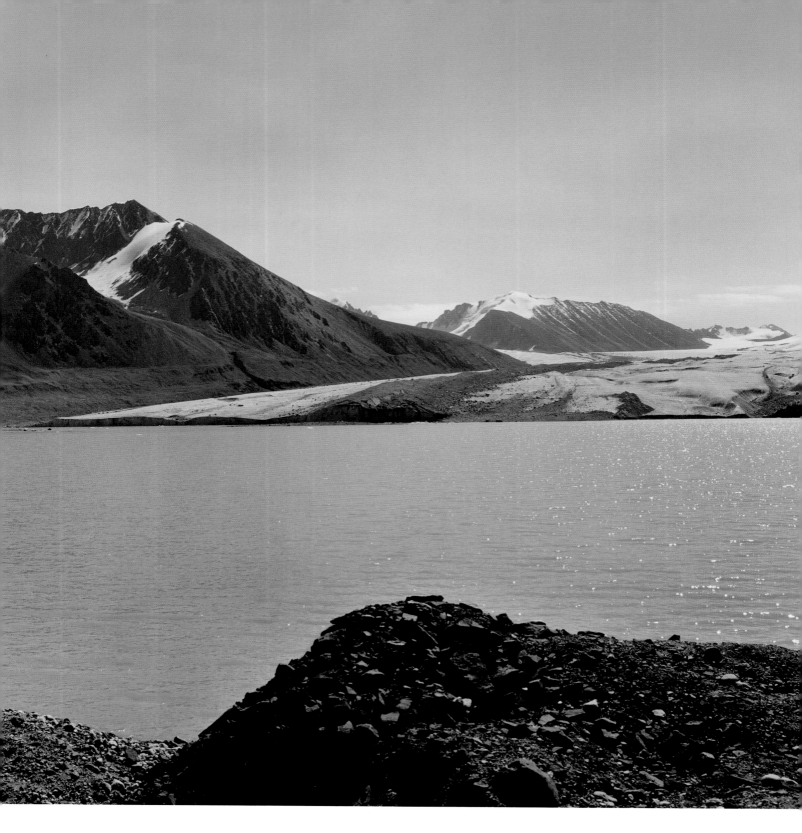

GLACIER LAKE | TIAN SHAN | KYRGYZSTAN 2004

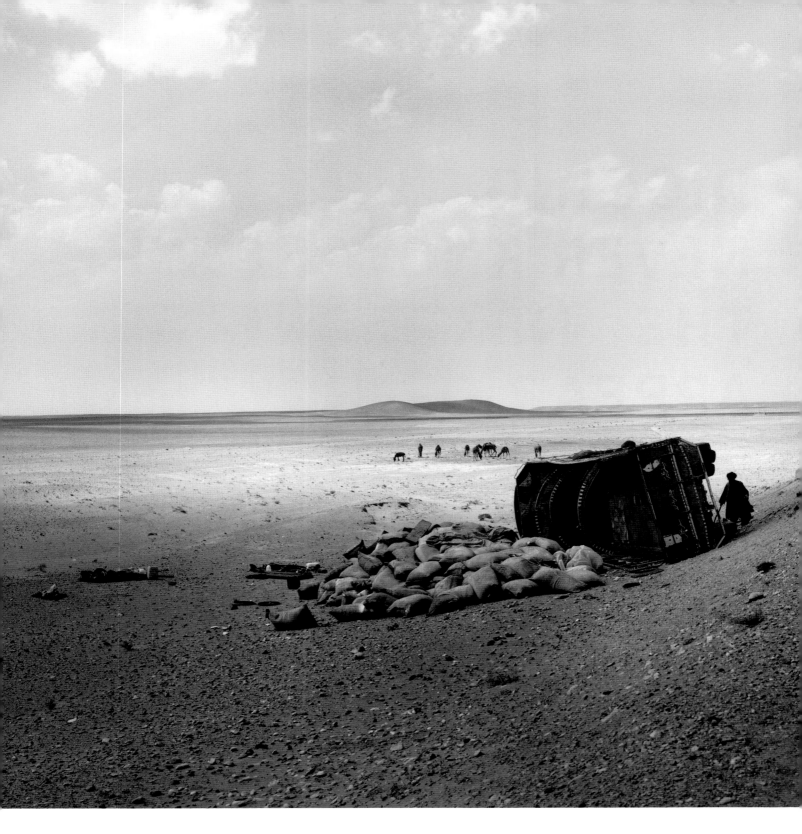

NEAR KANDAHAR | AFGHANISTAN 2001

DIGGING UP IMAGES NEVER KNOWING WHEN THE NEXT ONE WILL **APPEAR** OR HOW MANY WILL **ESCAPE** MY ATTENTION

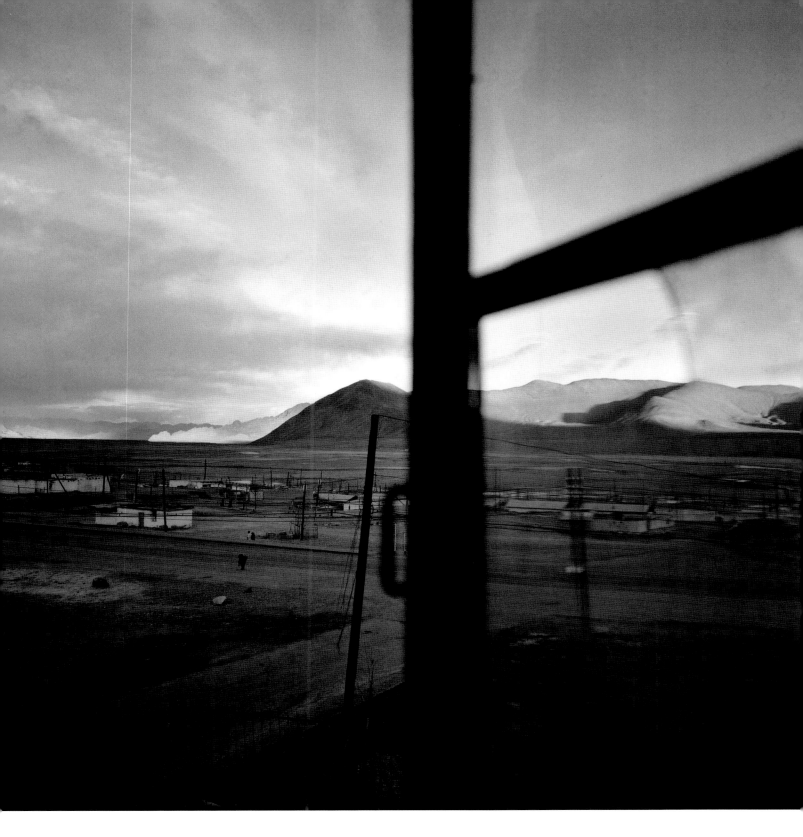

VIEW TOWARDS CHINA AND PAKISTAN | MURGAB | PAMIR HIGHWAY | TAJIKISTAN 1996

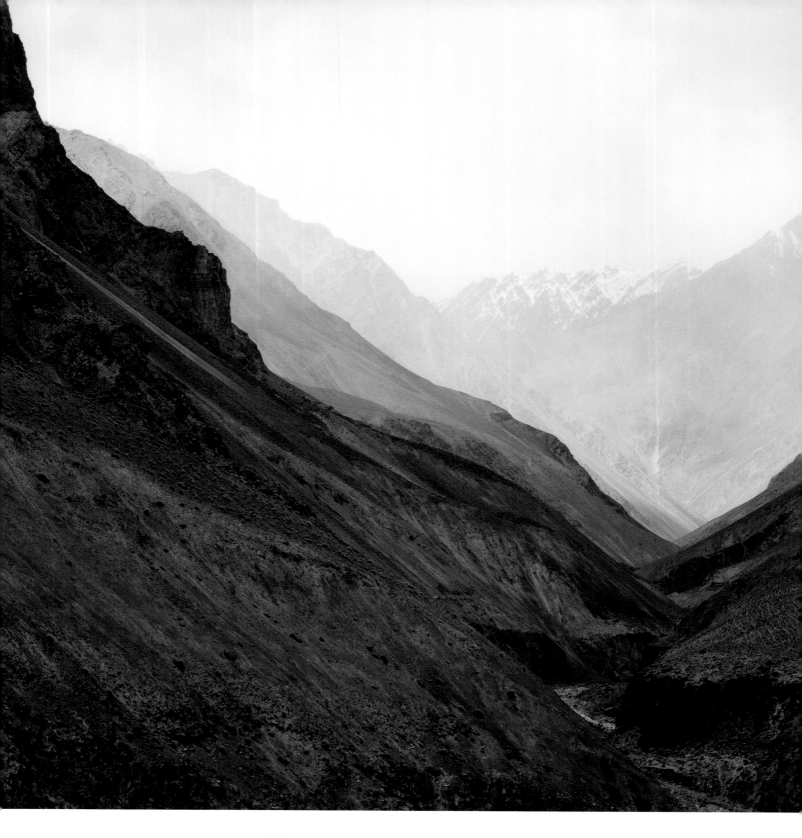

BELOW THE KHUNJERAB PASS | KARAKORAM HIGHWAY | PAKISTAN 2001

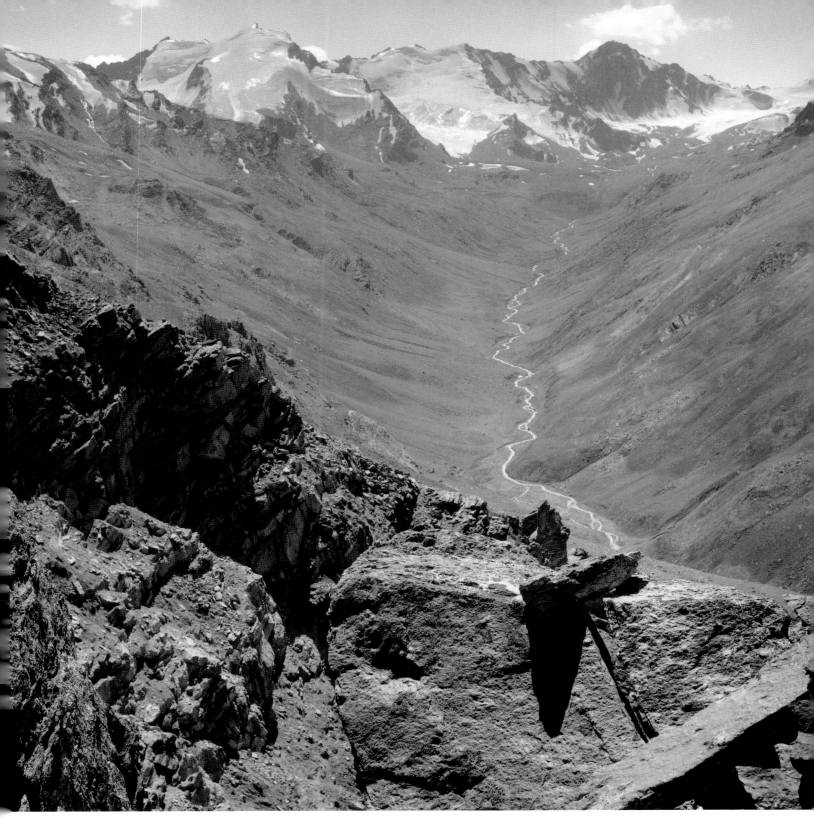

TOUSJION-DARA VALLEY | BADAKHSHAN | TAJIKISTAN 1996

ROOF OF THE WORLD

SILVER AND GOLD MINES AND LAPIS LAZULI AND RUBIES IN ABUNDANCE
INTREPID GROUPS OF TRAVELLERS AND MIGRATING PEOPLES
CONNOISSEUR AND CONQUEROR CARVING TEXTS AT SITES OF INSPIRATION

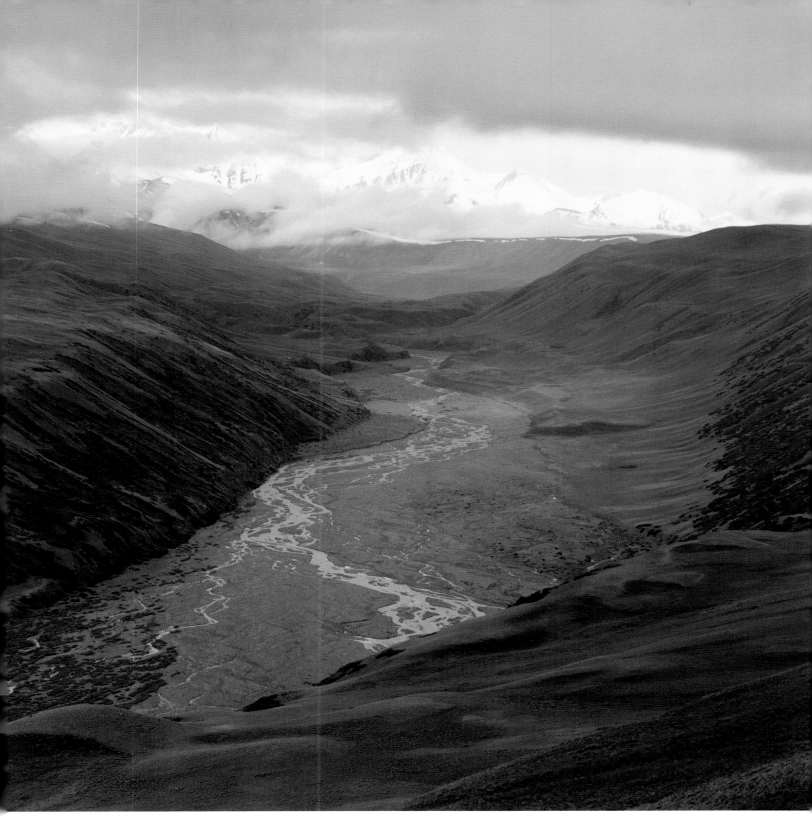

CHINA WATERSHED | ALAI CORRIDOR | KYRGYZSTAN 2004

READING A VALLEY LIKE A BOOK

SPINES OF BOOKS CAN CRACK

VALLEY FLOORS DEEPEN

BOULDERS FALLEN FROM HIGHER UP LYING AT SOME DISTANCE

MARKED BY BUDDHIST ROCK CARVINGS

FIVE THOUSAND INSCRIPTIONS IN TEN WRITING SYSTEMS DATING FROM

PREHISTORIC TIMES TO THE PERIOD BEFORE CONVERSION TO ISLAM

CHINESE SOURCES REFERRING TO LOCAL INDO-ARYAN PEOPLES AS WESTERN

BARBARIANS

HERODOTUS NARRATING WHAT HE HAD HEARD ABOUT WARLIKE TRIBES COLLECTING

GOLDEN MOUNTAIN SAND

A GOLDEN RACE MENTIONED IN AN INDIAN FABLE AND TIBETAN TEXTS

COPIES OF THE PASSPORT PHOTOGRAPH OF A VANISHED MODERN TREKKER ON

DISPLAY

BOULDERS CRACKING IN THE HEAT SPLIT BY ICE

XINJIANG

TAIZONG

QIANGLONG

MAO ZEDONG

ADMINISTRATORS OF THE PERIPHERIES

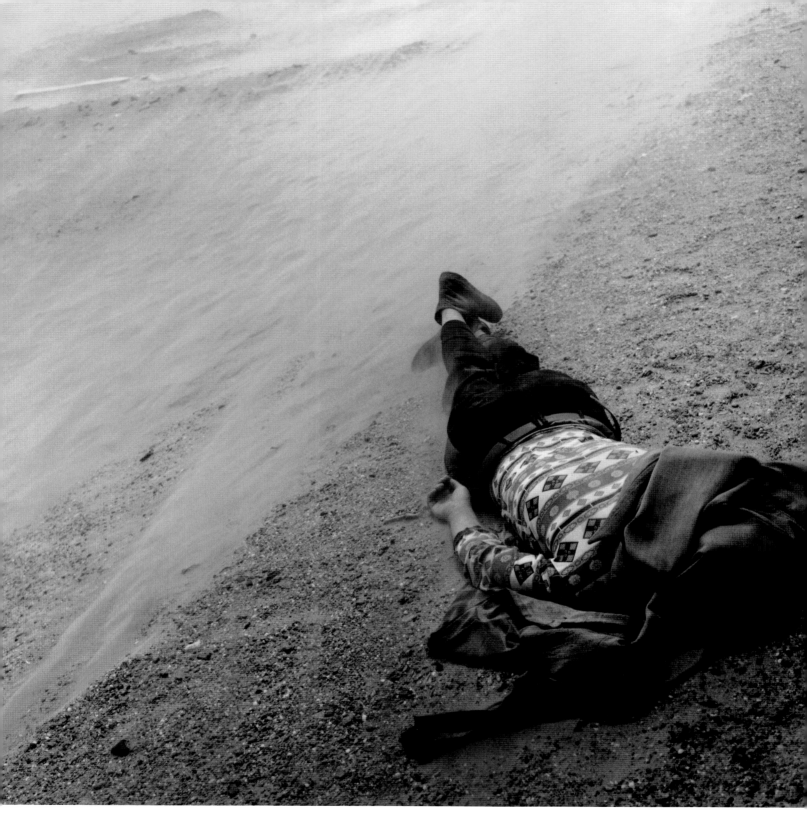

AT THE EDGE OF THE TAKLAMAKAN | XINJIANG | CHINA 2001

TARTARY

GIBBON

HERDER

VOLTAIRE

TRAVELLERS IN NO MAN'S LAND

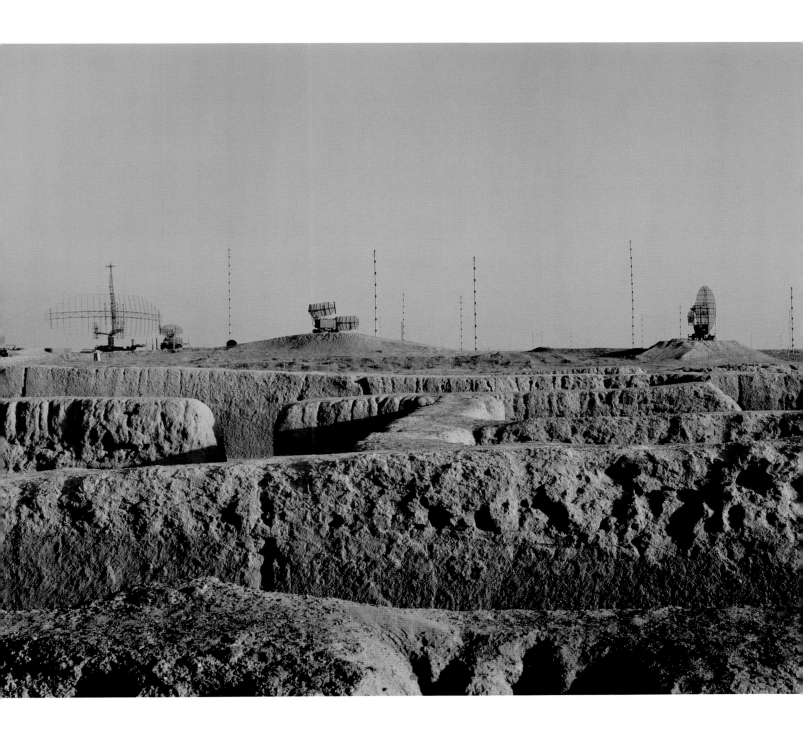

IFF (IDENTIFICATION FRIEND OR FOE) SYSTEM AND EARLY BUDDHIST RUINS | TERMEZ | UZBEKISTAN 2002

MAWARANNAHR

AL BIRUNI

TAMERLANE A.K.A. TIMUR

ZAHIRUDDIN MOHAMMAD BABUR

VISIONARIES IN SEAS OF SAND

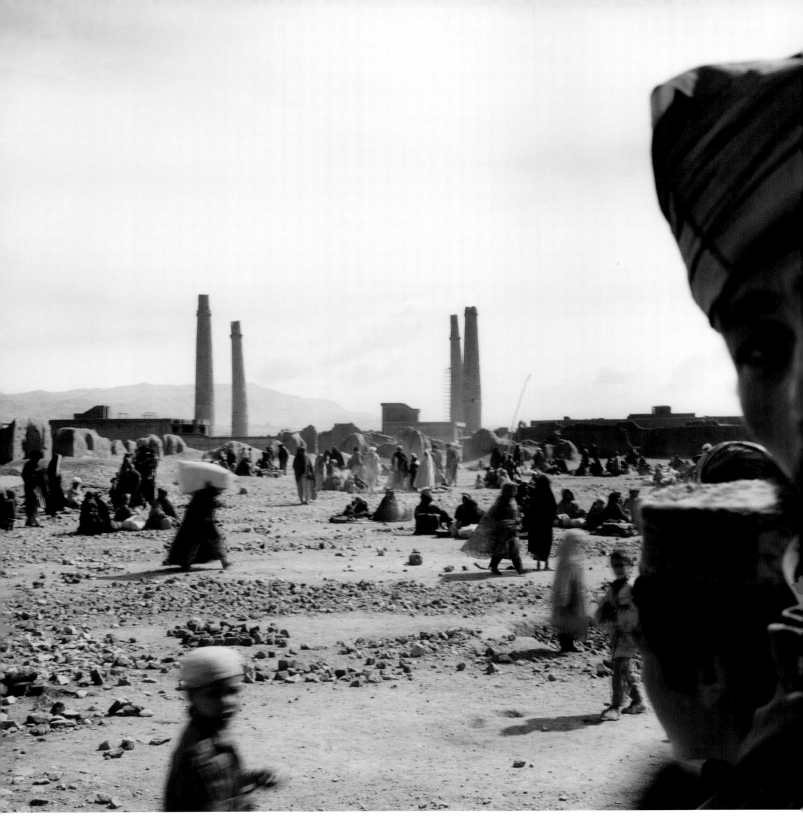

TIMURID MINARETS AND REFUGEE CAMP | HERAT | AFGHANISTAN 2001

WAITING FOR DRINKING WATER | AFGHAN REFUGEE CAMP | PESHAWAR | PAKISTAN 2001

TIME AND PLACE

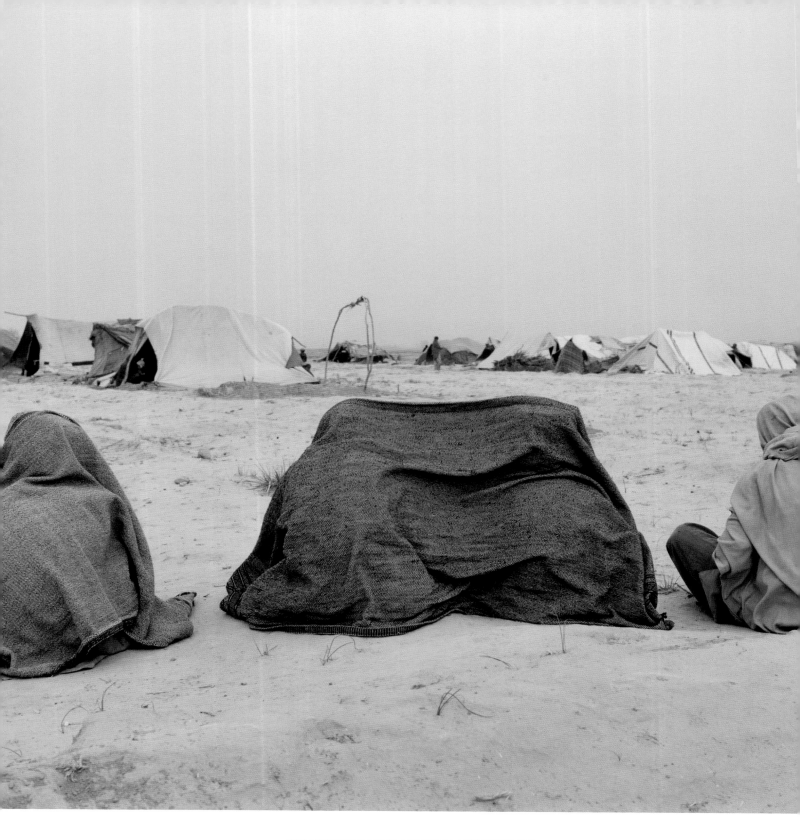

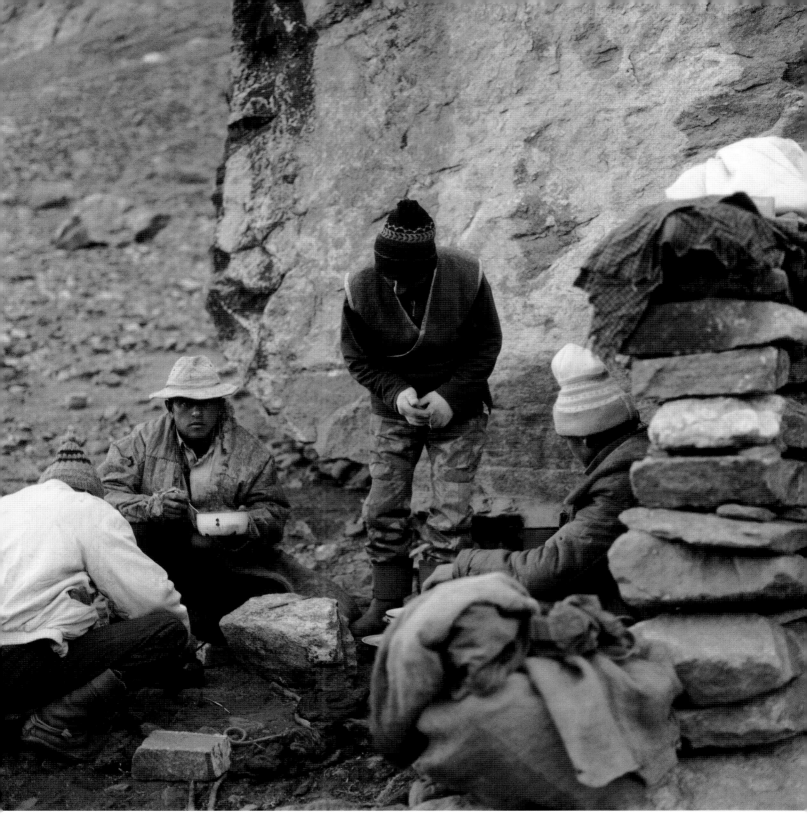

RUBY MINERS' CAMP | BADAKHSHAN | TAJIKISTAN 1996

TERRITORY OF THOUGHT

LAO ZI WANDERING OFF TO THE WESTERN REGIONS
A BORDER GUARD RECOGNIZING THE SAGE
ASKING HIM TO SET DOWN HIS THOUGHTS IN WRITING BEFORE LEAVING THE WORLD OF MEN
LAO ZI LEAVING BEHIND THE *DAO DE JING – THE CLASSIC OF THE WAY OF VIRTUE*
FIVE THOUSAND CHINESE CHARACTERS

FIVE HUNDRED YEARS LATER AT THE OTHER END OF THE SILK ROAD
PUBLIUS OVIDIUS NASO BANISHED FOR LIFE BY AUGUSTUS IN EXILE AT TOMI ON THE BLACK SEA
WRITING *THE LETTERS FROM PONTUS – EPISTULAE EX PONTO*
FOUR BOOKS CONTAINING FORTY-SIX OPEN LETTERS TO FRIENDS IN ROME

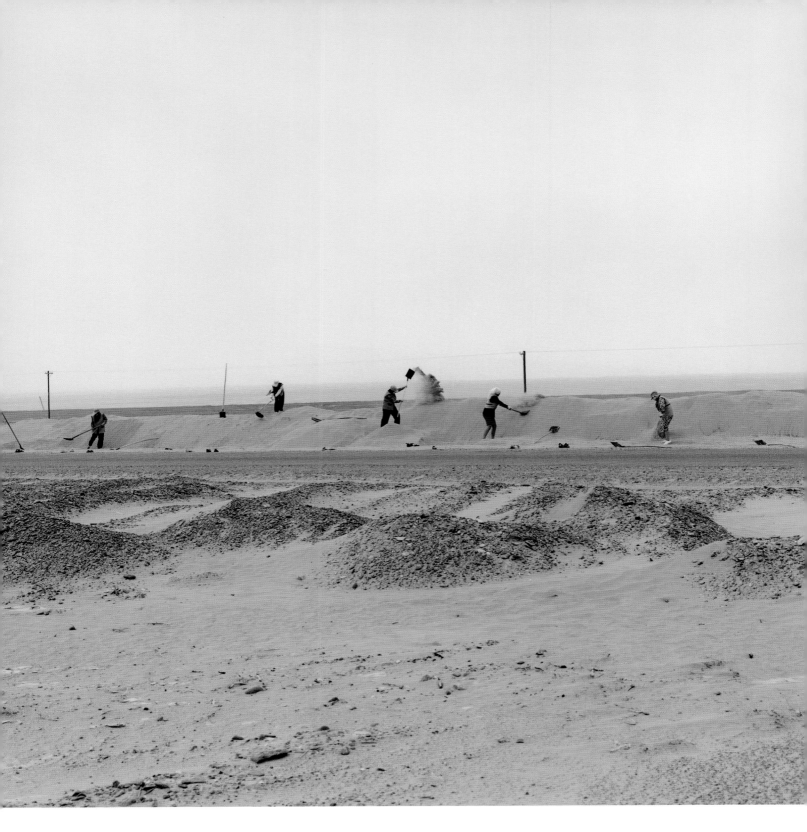

FREEING THE SILK ROAD FROM SHIFTING SAND DUNES | TAKLAMAKAN | XINJIANG | CHINA 2001 [ABOVE AND FOLLOWING PAGES]

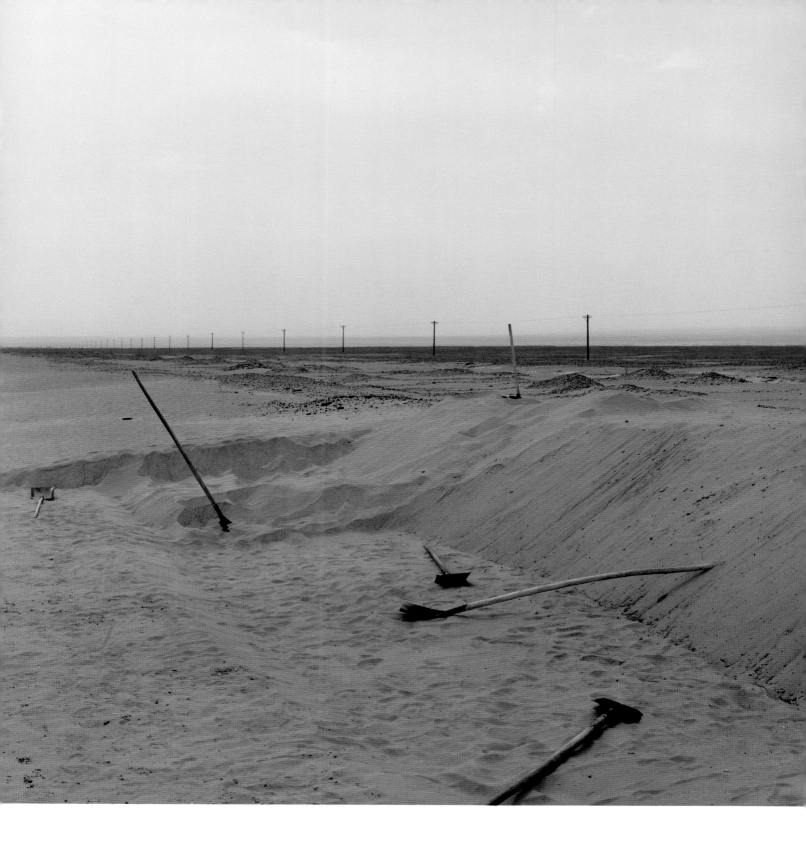

GEOGRAPHY

POMPONIUS MELA ABU ZAYD AL-BALKHI ABRAHAM ORTELIUS ANTWERPIANUS

THEIR THOUGHTS

APPROPRIATING CONTEMPORARY KNOWLEDGE

THEIR WORKS

EVIDENCE OF EVOLVING CENTRAL ASIA

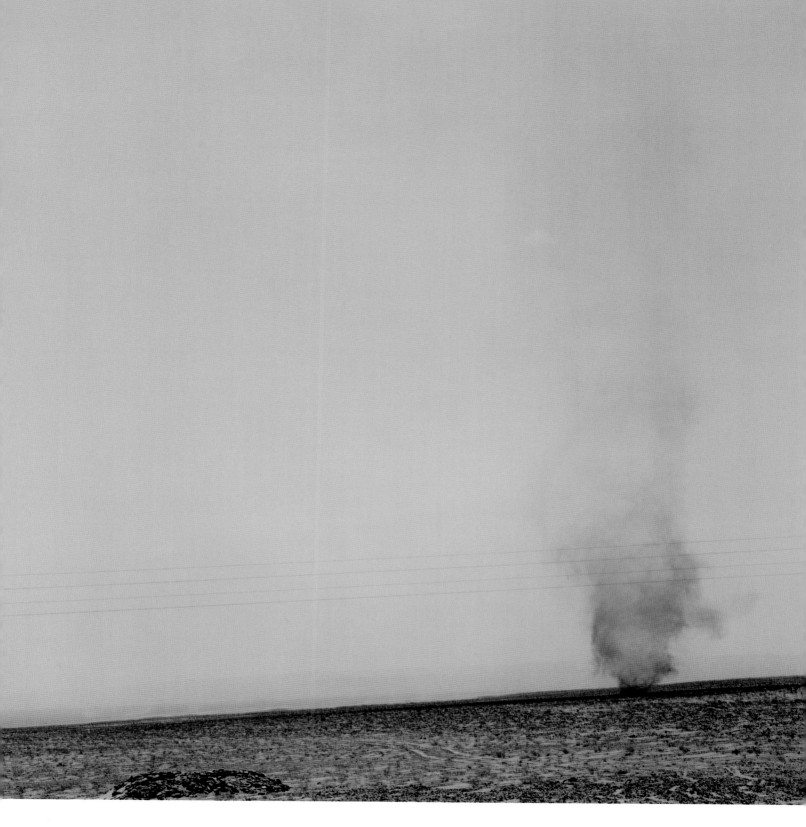

TWISTER | TAKLAMAKAN | XINJIANG | CHINA 2001

HISTORIOGRAPHY

HERODOTUS SIMA QIAN IBN KHALDUN

THEIR WORKS

SPINE BY SPINE ON THE BOOK SHELF

THEIR THOUGHTS

COINCIDING IN THE DEPTHS OF CENTRAL ASIA

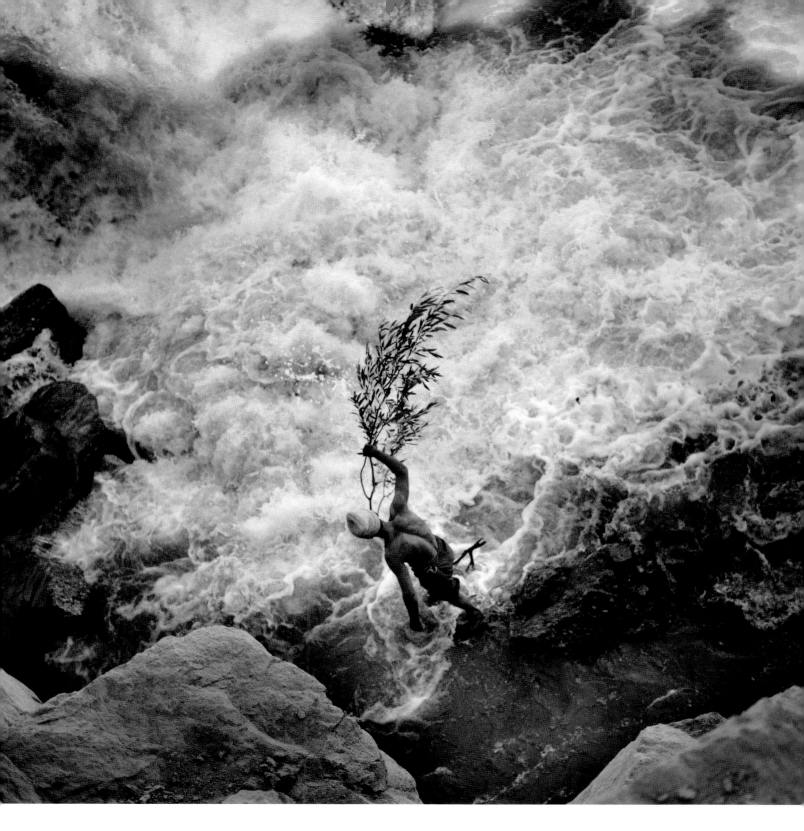

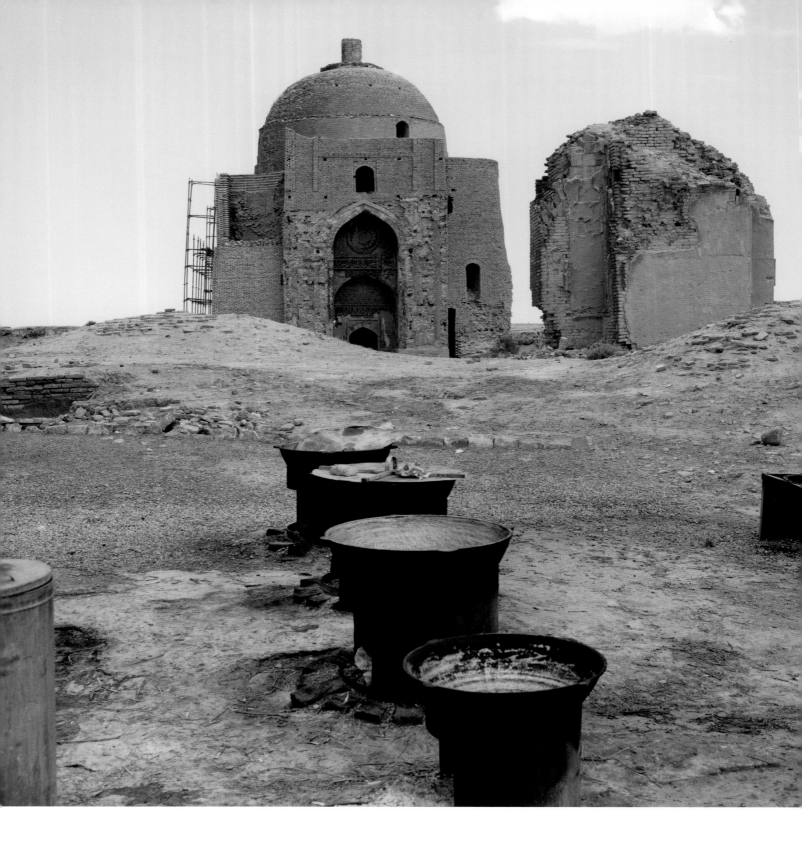

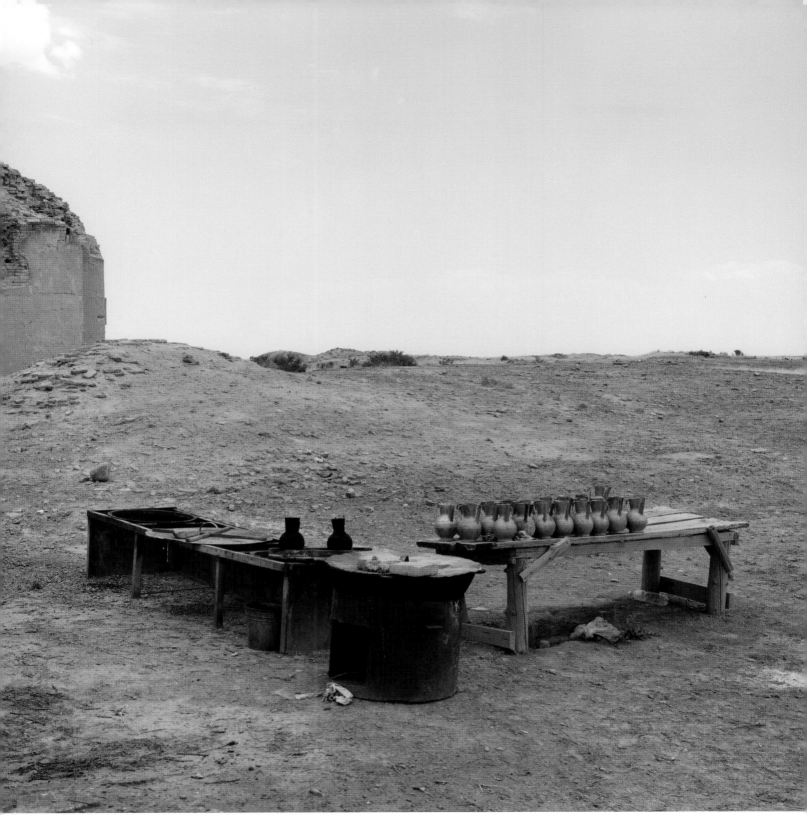

ACKNOWLEDGMENTS

Just as with previous books, this book owes its existence to the judicious attention of its publisher. In fact this privilege has now been extended further: the author, after documenting the floating habitat of the river deltas of the Far East, was not to lose his way in environments of an even more deceptive nature. Instead, he was directed to a region where so many worlds intersect and overlap: Central Asia.

Central Asia has been the meeting place of Western and Eastern cultures since the Bronze Age. Later, in the thirteenth century, the exchange and diffusion of information between nomadic and settled communities was accelerated by the lightning war that swept up from the Mongolian Steppes; when the transcontinental campaigns had subsided, the circumstances of Pax Mongolica ensured that in the border regions of the so-called heartland and beyond, in China, Europe, India and in the Islamic world, this information became more integrated. In this way, experiences became imaginative elements, and facts became evidence. This integration was more than discovery. It showed the emergence of a unified picture of a single world, and finally of a commonly shared concept. Individual geographies, histories and cultures coordinated with each other, and the information circuit that was set in operation thereafter embraced a single continuous world history (as explored by S.A.M. Adshead, *Central Asia in World History*, 1993).

The publisher's partiality for the heartland was therefore entirely logical – having pondered an early and somewhat bold outline of a project about the increasing interweaving of cultural, economic and political strands of globalization, there was a need to focus. However, Central Asia was also a logical place to start in another context: in this distant region lies the western end of the Great Wall of China, the subject of a complicated photographic adventure which the author published in book form two decades ago. For this new project, as he stepped away from the shadow of the ramparts of brick and rammed earth, and travelled down from the Pamir Mountains, the Karakoram and the Hindu Kush, into the ancient landscapes of Bactria and Sogdia, the Chinese Tarim Basin and the hot desert regions of Transcaspia, Kandahar and Iran, the author was confronted directly by history, ever-present in the social, geo-economic and political power processes of today.

Such material cried out to be portrayed not only in pictures, but also – again at the publisher's suggestion – in words. So while work on this book was coming to an end, the photographer was about to make his debut as a writer, with *Schnee in Samarkand* (published by Eichborn Berlin, Frankfurt, in 2008). That book sets out, on the floor of the teahouse, as it were, the protagonists of 3,000 years of world history in Central Asia. *Travelling through the Eye of History* takes its title from Flemish cartographer Abraham Ortelius's epigraph to his atlas *Theatrum Orbis Terrarum* (1570), 'Historiae Oculus Geographia' ('geography is the eye of history'), and recalls the dominant role of geography throughout the course of history. The gates and barriers of Central Asia are inevitable. They belong not just with the countless older trails of caravans and armies, but also with the routes of today's military adventures, and of the fibre optic cable that now crosses this vast geographical expanse.

During the course of his work the author has received support from the following organizations: Bundesamt für Kultur, Bern (1998); Kantonales Kuratorium für Kulturförderung Solothurn (2000); UBS Kulturstiftung, Zürich (2000 and 2004); Calle Services Management Ltd, Zürich (2008); CR Innovations AG, Baar (2008) and Renova Management AG, Zürich (2008). The author would like to thank all those responsible, and also former and present members of the editorial staff of du, Facts, GEO, Lettre International and Neue Zürcher Zeitung.

The author has also been expertly guided across new terrain, that of the word pieces, by Monica Burger-Häfeli, Lorenz Boegli and Bronwen Saunders. The photographic prints used for the book were made by Ursula Heidelberger, Regula Müdespacher and Sabine Wagner, Laboratorium, Zürich. They also produced the black and white carbon pigment and colour inkjet prints for the exhibition, and the oversize formats of those prints in co-operation with Image Factory, Zürich. The author would like to thank them, together with those at Thames & Hudson, London, and Steidl, Göttingen, for all the great care they have taken with the book; and especially Simon Maurer, Helmhaus Zürich, whose decisive initiative allowed the exhibition to happen.

The exhibition 'Travelling through the Eye of History' is to be held at Helmhaus Zürich, 17 April–14 June 2009, and Martin-Gropius-Bau, Berlin, June–October 2010.